Artwalks in New York

Artwalks in New York

Delightful Discoveries of
Public Art and Gardens in
Manhattan, Brooklyn, Queens,
the Bronx, and Staten Island

THIRD EDITION

Marina Harrison and Lucy D. Rosenfeld

Illustrations by Lucy D. Rosenfeld

NEW YORK UNIVERSITY PRESS
New York and London

NEW YORK UNIVERSITY PRESS
New York and London
www.nyupress.org

Library of Congress Cataloging-in-Publication Data
Harrison, Marina, 1939–
Artwalks in New York : delightful discoveries of public art and
gardens in Manhattan, Brooklyn, Queens, the Bronx, and Staten
Island / Marina Harrison and Lucy D. Rosenfeld ; illustrations
by Lucy D. Rosenfeld.—3rd ed.
p. cm. Includes index.
ISBN 0–8147–3660–2 (cloth : alk. paper)—
ISBN 0–8147–3661–0 (pbk. : alk. paper)
1. Public art—New York (State)—New York—Guidebooks.
2. Gardens—New York (State)—New York—Guidebooks.
I. Rosenfeld, Lucy D., 1939– II. Title.
N8845.N7H3 2004
709'.747'1—dc22 2004008280

Front cover art: *Bust of Sylvette* by Pablo Picasso; Ford Foundation
Building greenhouse; *Atlas* by Lee Lawrie; Solomon R. Guggen-
heim Museum by Frank Lloyd Wright; *LOVE* by Robert Indiana;
Bryant Park; Church of the Holy Cross stained glass window;
Lincoln Center fountain by Philip Johnson; New York Public
Library lion by Edward C. Potter.

Back cover art: *Threshold Configuration* by Jean Arp; Chrysler
Building by William Van Allen; *Three Times Three Interplay* by
Yaacov Agam; *Daily News* Building lobby by Raymond Hood;
Grand Central Terminal; *The Red Cube* by Isamu Noguchi.

New York University Press books are printed on acid-free paper,
and their binding materials are chosen for strength and durability.

Manufactured in the United States of America

c 10 9 8 7 6 5 4 3 2 1
p 10 9 8 7 6 5 4 3 2 1

Contents

Preface

This is a brand-new edition of *Artwalks in New York,* a book of exploration. Our first two editions have been well received and have become familiar companions to tourists and native New Yorkers alike. We were astonished when we undertook the task of updating the book at how much had changed in the past five years: new museums, new parks, new public art, as well as the loss of some beloved art institutions.

We hope that if you have a taste for visual beauty and enjoy walking, you will discover many wonderful new sites to pique your fancy in our city. We have brought together eclectic outings that will introduce you to the rich and diverse treasures of public art. Although well known as one of the world's greatest cultural capitals, New York has amazed us with its wealth of art and natural beauty—not only in Manhattan, but in the outer boroughs as well. Parks, lobbies, plazas, gardens, atria, and workshops, as well as the city's great museums, are all home to the visual pleasures of public art.

What do we mean by public art? To us this phrase includes the many forms of the visual arts to be enjoyed for little or no charge in outdoor or indoor public spaces. Our walks include everything from traditional paintings to performance art and auctions, from works in progress to outdoor sculptures, from tapestries to stained-glass windows, from WPA murals to contemporary installations. In addition, the natural beauty of New York's wonderful public gardens—such as those with Japanese, Colonial, or Shakespearean themes—add another aesthetic experience to our collection.

Our book includes as large a variety as possible of styles and eras of art. Whether you are a fancier of the latest contemporary works, ethnic artifacts, or arts of the past, we think you will find outings that will inspire you.

In no way can this be a comprehensive guide to all the wonderful works of art in New York. We expect that most of you are already familiar with the great museums of the city. Obviously, the city has hundreds of galleries that sell art. But we have decided not to include most commercial galleries in this book. Nor do we pretend to cover thoroughly every style and era of art gracing our city. There are many books designed for those with specific interests in one period or style. Instead, we hope our walks will arouse your curiosity and lead you to further exploration.

These walks cover diverse neighborhoods and distances, as well as varying kinds of art. All are accessible by public transportation; directions, hours, and occasional fees are listed. You will find that some walks are thematic, while others explore an entire neighborhood. Walks are of varying length and can be combined with museum visits in most areas.

These walks should appeal to anyone with a taste for art, whether connoisseurs or those who simply enjoy visual stimulation while walking.

Bear in mind that our city changes constantly; accordingly, works of art come and go regularly. This continuing evolution has been especially marked since the great tragedy of 9/11, and we expect to see great artistic and architectural additions to Lower Manhattan in the coming years.

We have had a wonderful time working on this book and are grateful to the following people for their help and encouragement in our efforts to explore New York's art treasures: Adrian Benepe, Susan Olsen, Marina Rosenfeld, Marilena Christodoulou, Donald Rubin, Peggy Hammerle, Peter Rosenfeld, and James Harrison.

Manhattan

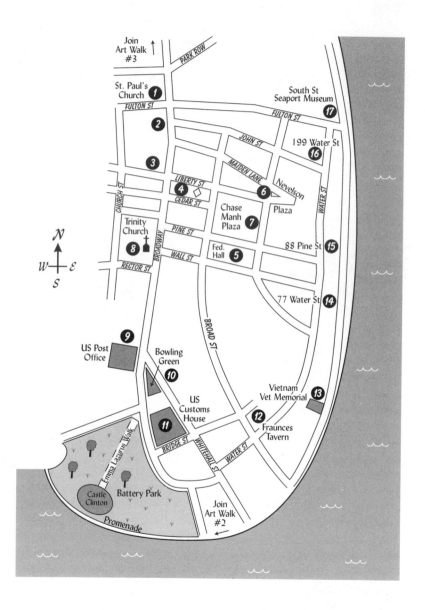

Join
Art Walk
#3

St. Paul's
Church **1**

FULTON ST

2

3

PARK ROW

South St
Seaport Museum
17

FULTON ST

JOHN ST

MAIDEN LANE

6

LIBERTY ST

4

CEDAR ST

Nevelson

Plaza

199 Water St
16

WATER ST

CHURCH ST

BROADWAY

Chase
Manh
Plaza **7**

Trinity
Church
8

PINE ST

WALL ST

Fed.
Hall **5**

88 Pine St **15**

RECTOR ST

N
W — *E*
S

77 Water St **14**

BROAD ST

9

US Post
Office

Bowling
Green
10

US
Customs
House

Vietnam
Vet Memorial **13**

12

Fraunces
Tavern

11

Emma Lazarus Walk

BRIDGE ST

WHITEHALL ST

WATER ST

Castle
Clinton

Battery Park

Join
Art Walk
#2

Promenade

1

The Tip of Manhattan

The Financial District to the South Street Seaport

HOW TO GET THERE
Subway: 4 or 5 train to Fulton Street; 2 or 3 train to Park Place; N, R, or W train to City Hall.

This is a walk filled with surprises and contrasts. Dramatic modern sculptures contrast with the narrow historic streets of Lower Manhattan, while more-traditional art ornaments some of the sleekest of contemporary corporate headquarters. There are examples of Art Deco design, an unexpected fourteenth-century Italian triptych, and several plazas of striking sculptures, many by some of the best known artists of our time. As you make your way though the winding streets of the Wall Street area and down to the lovely park at the tip of Manhattan, you are never far from the water, despite the crowded sidewalks and closely packed cityscape. There are many places to stop for a moment on this route, including two of New York's historic graveyards and several small parks, in addition to Battery Park. We suggest you choose a bright day and set out walking from Broadway and Fulton Street, the location of one of the city's most historic sites.

St. Paul's Chapel ❶ is our first stop. Its cemetery is one of the tiny oases in Lower Manhattan and one of the oldest graveyards in New York. Many of the tombstones date from the eighteenth century; Revolutionary War heroes are buried here as well as within the chapel. Although most of the carved designs have long since vanished, this is a good spot to absorb the juxtaposition of old and new typical in this part of Manhattan.

Stand in the cemetery about midway to the back entrance of the church and face Vesey Street, the northern boundary of the plot.

Across the street, at 20 Vesey Street, you'll see the **Garrison Building** (1906), home of the *New York Evening Post* between 1907 and 1930. In addition to the charming Art Nouveau rooftop, note the four unusual statues decorating the front of the building. Known as the *Four Periods of Publicity,* these languid and expressive figures are by **Gutzon Borglum**, the American artist who created the gigantic Mount Rushmore presidential heads, and **Estelle Kohn**, the architect's wife. (Another example of Borglum's interest in making large-scale building sculpture can be seen on the façade of the Cathedral of St. John the Divine, where he sculpted the Twelve Apostles.) This building and these four rather Gothic sculptures are now preserved by the City Landmarks Commission.

Walk through the back entrance of St. Paul's and directly into the church to see the oldest remaining church building in Manhattan. (Its cornerstone was laid in 1764.) The light, spacious interior with fluted Corinthian columns and a barrel-vaulted ceiling is airy and delicate, though you might find the recent color scheme rather saccharine. On the west wall is a bust of John Wells by **John Frazee**, one of the earliest American sculptors and a tombstone carver. The pew in which George Washington worshiped is marked. Notice also the glory above the altar, which is by **Pierre Charles L'Enfant**, the French military engineer, architect, and city planner who came to America to fight in the revolution and stayed in the country to plan Washington, D.C.

As you exit the church, turn right and walk south on Broadway to 195 Broadway, the **Kalikow Building** ❷ (formerly the AT&T building). In the impressive lobby you'll find yourself surrounded by forty massive columns reminiscent of an Egyptian temple. Against the wall is a bronze sculpture of a winged Mercury with marble figures in relief by the American sculptor **Chester Beach**. There are also some benches for a moment's rest.

Walk three blocks south on Broadway, passing Dey and Cortlandt streets, to Liberty Street. As you cross the bustling square called **Liberty Plaza** ❸, you will be surrounded by people reading on benches and hurrying across the pavement. Do not miss one of the readers—an inconspicuous bronze, life-size statue on one of the benches, who not only is dressed exactly like his real-life counterparts in this financial district, but whose open briefcase contains such sculpted amenities as a calculator, a tape recorder, some pen-

cils, and whatever else passers-by donate. This piece, called *Double Check* (1982), is by **Seward Johnson**, a sculptor noted for his lifelike all-American figures.

Find your way to the plaza of the **Marine Midland Building** ❹ on Liberty Street to view one of the best-known outdoor sculptures in all of New York City, the famous orange-red cube by **Isamu Noguchi** (1967). This fascinating structure, with its hole through the center, balances amazingly on one corner, looking as though it might topple at any moment. *The Red Cube* is really a rhombohedron, a six-sided figure whose opposite sides are parallel at oblique angles; this distortion creates the illusion of dramatic force, as well as providing contrast with the bland glass façade of the tower behind it. Noguchi commented that a cube on its point was like chance or rolling of the dice.

From here walk south a couple of blocks on historic Nassau Street to **Federal Hall National Memorial** ❺ on the corner of Pine and Nassau. This site is filled with historic significance: here Washington took his oath of office; Congress enacted laws to create the departments of State, Treasury, and War, as well as the Federal Court system; and here, too, the Bill of Rights was enacted. The present building, dating from 1842, is in the Greek Revival style, inspired by the Parthenon. It is operated by the National Parks Service as a museum of historic prints, a fine library of Americana (with a diorama showing the Washington inaugural), and a beautiful central hall with Corinthian columns. A new addition is the advent of fine visiting exhibitions—the first from Florence's Uffizi Gallery. Outside the Pine Street entrance to this building is an imposing statue of George Washington by **John Quincy Adams Ward**.

Walk east to William Street and turn left. At the intersection of William and Liberty streets (two blocks north) you'll find **Louise Nevelson Plaza** ❻. This small triangular plot, set in the midst of a busy downtown area of intermingling winding streets, contains seven black steel sculptures of varying sizes and shapes, called *Shadows and Flags* (1978), that form a cohesive outdoor environment. Although each sculpture could be regarded as a separate entity able to stand on its own as a work of art, the group was conceived as a harmonious whole. When commissioned to design sculpture for the plaza (created when streets were widened),

Nevelson said she wanted to place the sculptures on poles so they might appear to "float like flags." Always concerned with the interaction of lights and darks and the relationship of art to the total environment surrounding it, Nevelson constructed these 40-foot-high pieces in black, geometric shapes that echo modern city forms. Squares, cylinders, angled bars, and jagged planes intersect one another high above eye level, forcing the visitor to view from below. A small park in the plaza also has benches where you can sit and enjoy your surroundings in comfort.

Walk back (west) on Liberty Street to the next corner, where the large **Chase Manhattan Building** occupies the block ❼. There is a lot worth seeing here (though some of the fine contemporary collection has been dispersed). On the south face of the bank, you'll find one of downtown's masterpieces: **Jean Dubuffet**'s giant sculpture, *Group of Four Trees,* installed in 1972. This 43-foot, 25-ton sculpture is supported by a steel skeleton and made of aluminum, fiberglass, and plastic resin covered with polyurethane paint. Perhaps the sculpture looks more like enormous mushrooms than trees, but its overall appearance is fanciful and bright, and the visitor can walk through and around it to view it from many different angles. Dubuffet called it an "hourloupe," meaning "some wonderful or grotesque object . . . something rumbling and threatening with tragic overtones." Dubuffet did not characterize his works as painted sculpture; he called them "unleashed graphisms" or "drawings which extend and expand in space." Dubuffet's *Group of Four Trees* dominates Chase Manhattan's plaza and provides a striking contrast to the tall and sleek buildings of corporate New York. The curious placement of the work of one of the art world's most antiestablishment artists as a centerpiece of one of America's most hallowed capitalist symbols adds to the fascination.

Here you can also view **Noguchi**'s sunken garden from above; the design of rocks from this vantage point seems quite different from the view below. Elegantly composed of black basalt rocks, lily pads, trickling water, and an unerring sense of design, this garden can be viewed from the lower level or from above—two entirely different perspectives. Noguchi wanted to show how art and nature could be successfully integrated into an urban setting. The floor of the area is contoured with patterns that suggest waves (much like traditional Japanese raked gardens), and the rocks (brought from Kyoto) are set in a design that relates them to the

uneven ground surface. When the fountain is in operation, the rocks seem to be rising out of the water; Noguchi describes them as bursting forth, "seeming to levitate out of the ground." (But when it is dry, the garden is rather bland.) Although you cannot enter this garden, the varying views of it can suggest any number of landscapes to you, from seaside to moonscape, from traditional Japanese sunken garden to desolate winter scenery. Inside the lobby of the Chase Manhattan building you'll see a sculptural tribute to the rescue dogs of 9/11; another sculpture is on the plaza in front of the entrance.

Walk west on Pine Street back to Broadway to see **Trinity Church** ⓼, one of the most beloved of New York landmarks. This church, the third on the site, was built in 1839. Explore the graveyard either before or after seeing the interior; here are the graves of Alexander Hamilton, Francis Lewis, and Robert Fulton, among many other notable Americans. Inside the building you'll find a number of artistic gems. On the north wall of this lovely Gothic Revival building designed by **Richard Upjohn**, note the baptistry triptych. With the traditional gold background and the unmistakable colors and style of the early Renaissance, this triptych is indeed a find. Also of note within Trinity Church are three sets of bronze doors that resemble Ghiberti's doors to the Florentine baptistry; note particularly the pair on the west portal by **Karl Bitter**, a well-known carver of architectural details in many historical modes. The large stained-glass window above the altar, completed in 1846, is strikingly beautiful on a clear day; the designer was the architect Richard Upjohn, one of the leading designers of Gothic ecclesiastical buildings in America. For more information on Trinity Church, visit the church's small museum, which offers an interpretive slide program as well as a history of the building and its many well-known parishioners.

Proceed south on Broadway to number 25, the **Old Cunard Building** (1921) ⓽, now housing the Post Office. As you enter, look up to the ceiling. A relatively modestly decorated entrance hall leads to an overwhelmingly ornate Great Hall, which is said to have been inspired by Raphael's style. The main dome, 65 feet high and rising majestically above the octagonal hall, is aglow with impressive frescoes, by the American mural painter **Ezra Winter**, representing various shipping scenes: the Viking vessel of Leif Erikson, Columbus's galleon, the crossings of Sir Francis Drake,

and John Cabot amid turbulent seas. The interior of this building is one more example of the exuberance of 1920s design in New York.

As you leave this building we suggest you walk across Broadway to see the giant bronze bull ⑩ placed in front of 26 Broadway. It is by **Arturo Di Modica**. This realistic, massive bull is, of course, a symbol of good times in the financial district.

You will now find yourself at tiny Bowling Green Park. Here you can sit on a park bench and get a good view of the **U.S. Customs House** ⑪, which directly faces you. This imposing 1907 Beaux-Arts-style granite palace, now the National Museum of the American Indian of the Smithsonian Institution, is said to stand on the site where the first European settlers in New York built their crude shelters in 1624. It is graced with an impressive flight of steps, forty-four Corinthian columns, a fine arched entrance, but, most especially, with one of the city's most impressive works of sculpture. A group of four monumental statues by the American sculptor **Daniel Chester French** adorns the front of the building; the group represents four of the continents. Each statue consists of a seated female figure surrounded by other symbolic attributes. America's attitudes and impressions of the rest of the world at the turn of the century are clearly defined by these allegorical ladies. Placed prominently and significantly nearer or farther from the center of the building, each bears small symbols to suggest her continent's character. To our twentieth-century eyes, they are predictably biased historical curiosities. The four figures are all seated, but differ in subtle ways; you'll enjoy reading their allegorical messages.

America and Europe are in the center. To the left of the doorway sits America, the most idealistic and fervent, as she holds the torch of prosperity, her left arm sheltering a strong crouching man who turns the wheels of labor. She stares dramatically into the future, prepared to inspire and lead. On the other side of the doorway we find Europe, representative of the past, but nonetheless regal in a Grecian gown, surrounded by symbols of knowledge and ancient glory. She wears a crown, signifying royalty, and her arm rests on both a book and a globe. But, unlike America with her steady gaze into the future, Europe stares straight ahead, arms and legs equally balanced, the representation of solid, classical values. On the outer edges, Africa and Asia are less able to deal with the modern world. On the far right, Africa is portrayed in a state of

slumber, leaning against an Egyptian sphinx and a lion from the jungle. The nearly naked figure holds no other symbols of past or present; she is the personification of the dark and sleeping continent. Asia, on the far left, is the most formal of the group. She holds a small Buddhist figure and a lotus flower; she is the mother of religion and mysticism. But surrounding her emaciated figure are emaciated and prostrate bodies, and her foot rests on human skulls. Asia is unable to care for her masses, this sculpture tells us, and the figure turns away in its meditative trance.

In addition to these impressive symbolic works in front of the Customs House, be sure not to miss the cornice sculptures at the roof's edge. Made in 1907, there are twelve statues that symbolize both ancient and modern nations engaged in sea trade. Each figure wears a much-embellished national costume and gazes rather severely down at us. In keeping with the building's Beaux-Arts style of elegant sculptural ornamentation, the statues were made by leading artists of the time: *Holland* and *Portugal* by **Augustus Saint-Gaudens**, *France* and *England* by **Charles Grafly**, *Greece* and *Rome* by **Frank Edwin Elwell**, *Phoenicia* by **Frederick Wellington Ruckstull**, *Genoa* by **Augustus Lukeman**, *Venice* and *Spain* by **Mary Lawrence Tonetti**, *Denmark* by **Johannes Gelert**, and *Belgium* by **Albert Jaegers**.

The Customs House is the new site of the **National Museum of the American Indian**. This extraordinary museum, a small part of the vast Smithsonian Institution, was founded in 1916 by George C. Heye. It is devoted to the collection, preservation, and exhibition of all things having to do with the Native Americans in North, Central, and South America—from the Arctic to Tierra del Fuego. This New York–branch collection is varied and motley, but it is now much smaller than the major collection in Washington, D.C. You can see such items as Huron moose-hair embroidery, Pomo feather baskets, two-thousand-year-old duck decoys, Sitting Bull's war club, Crazy Horse's feather headdress, and Apache playing cards. You can also enjoy ancient Pueblo pottery, Iroquois silver jewelry and beadwork, and animal figurines from Central America. The exhibitions are colorful and varied; they will also interest children who are intrigued by American native cultures. ☎ 212-825-6700.

From here go east two blocks on Bridge Street to find the historic **Fraunces Tavern** ⑫ at the corner of Broad and Pearl streets.

Built around 1719 for a merchant named Stephen Delaney, it was converted by Samuel Fraunces to a tavern in 1762. Its long and illustrious history, including visits by Washington and other notables, is well preserved and commemorated. But today's Fraunces Tavern is mostly a reconstruction. Downstairs there is still a pretty eating place; upstairs houses the museum with a number of prints and dioramas that relate to old New York. The museum, which is quite small, presents a series of exhibitions and other events. Although the building itself is a charming reminder of the past, it is not only dwarfed by its surroundings but seems somewhat touristy, and the art inside is generally of a minor sort. There is a fee for entry. ☎ 212-425-1778.

From Fraunces Tavern head north on Water Street; about one block away is a major site, not to be missed. The recent **New York Vietnam Veterans Memorial** ⓭ is more than a sculpture. It is a lovely plaza devoted to the memory of those lost in the war, with their own words from letters written home etched into green glass blocks. There are also many fine flowers and a general air of serenity in this fast-paced section of the city. A number of artists collaborated on the site, including **Peter Wormser**, **William Fellows**, **John Ferrandino**, and **Timothy Marshall**.

Continue north to 77 Water Street ⓮ (near William Street) to see four contemporary lobby sculptures of the 1970s: works by **Rudolph de Harak**, **Victor Scalo**, **George Adamy**, and **William Tarr**. Stay on Water Street; at its intersection with Pine Street at 88 Pine ⓯ is more interesting municipal art. Here you'll find a large fountain in the plaza by **James Ingo-Freed** (1973) and one of downtown's favorite works, **Yu Yu Yang**'s *Untitled,* a deceptive geometric work of 1969. The 4,000-pound disc appears to fit within the large square. (You'll probably see people taking pictures here.) Our last lobby on this artwalk is just north at 199 Water Street ⓰, where the entrance area boasts a series of three murals by **Frank Stella**.

Leaving this building, walk east toward the river and you'll find yourself in one of New York's most pleasant tourist areas: the South Street Seaport Historic District. There is lots to see and do (and eat) here, much of it related to the area's former fame as a seafaring center, including two sailing ships and many delightful old buildings. Of particular note to art lovers is, of course, the **South Street Seaport Museum** ⓱, which occupies two sites in

close proximity. All tickets are purchased at the museum between Beekman and Fulton Streets. Here is a series of displays concerning ocean travel of bygone days. The newer space houses art relating to other marine subjects. You'll find an extensive collection of posters and other nautical visual material such as scrimshaw. A recent addition to New York's museums is **New York Unearthed** (17 State Street at Pearl Street). This glass-enclosed museum is actually an underground laboratory, which displays material from the South Street Seaport Museum's holdings and objects found from archeological digs in Lower Manhattan, which are being worked on as you watch. ☎ 212-748-8600.

2

The Tip of Manhattan

A Waterside Artwalk from Battery Park City to Battery Park

HOW TO GET THERE
Subway: 1, 2, 3, 9, A, or C train to Chambers Street.

Begin your walk at Chambers Street and Hudson River Park. A walk along the river in this wonderful area, with its new art and spectacular views, will afford even the most jaded visitor unusual delights. This is a fairly recent park, with great variety: it is both a planned community of new highrises and an old area of faded piers and ferry slips. There are many small gardens with sculpture and environmental art throughout. All the art was commissioned by the city. The designing of artworks to enhance the site has been a part of the project from the beginning, and works by **Mary Miss**, **Ned Smyth**, **R. M. Fischer**, **Richard Artschwager**, and **Scott Burton** (among others) are very much in evidence. The Battery Park City Fine Arts Program has become a sort of test laboratory for the combination of architecture, city planning, and art at a spectacular site; it is fascinating to view this contemporary version of an ancient idea.

Your first enjoyable site is *The Real World* by sculptor **Tom Otterness ❶**. **Battery Park Playground** is a children's playground and a great site for kids, who can discover his sculptural whimsy, with art and games mixed together.

Head south (with the river to your right) to find a brick columned work, *The Pavilion* **❷**, facing the water; this is a 1992 creation of **Demetri Porphyrios**.

Continue to the next art site: a pond and small waterfall **❸** with Asian plantings, goldfish, and ducks, surrounded by a marble wall with poetry on it. There are words by Seamus Heaney, Mark Strand, and others. This quiet, contemplative site is a nice contrast to the urban scene so nearby.

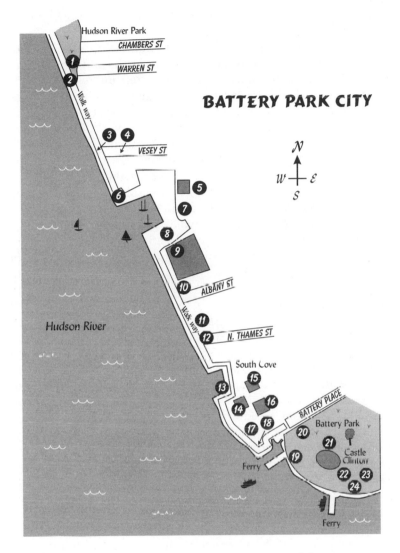

BATTERY PARK CITY

Hudson River Park

CHAMBERS ST

WARREN ST

VESEY ST

Walk way

Hudson River

ALBANY ST

Walk way

N. THAMES ST

South Cove

BATTERY PLACE

Battery Park

Castle Clinton

Ferry

Ferry

Turn toward the city for a few steps to see one of the most recent (and most provocative) art sites in the city: the **Irish Hunger Memorial** by **Brian Tolle** and **Gail Wittwer** (2002) ❹. This large installation includes an entire Irish landscape consisting of a reconstructed cottage and native Irish plantings amid rocks and ruins, all cantilevered above an interior with a theater and walls of quotations.

It's an evocative and contemporary—but at the same time a very traditional—memorial. Don't miss it!

From here, head south to the **World Financial Center** ➎ with its marina and its glass **Winter Garden**. Walk into the atrium, which is open to the public; there are often interesting artistic events here, and the site itself, with its great height and indoor palms rising to the glass ceiling, is well worth a visit.

Within the plaza ➏, itself an environmental work of art designed by **Cesar Pelli**, **M. Paul Friedberg**, **Siah Armajani**, and **Scott Burton**, are several pieces of art; of particular interest are two pylons by **Martin Puryear** (1995), next to the water's edge; they resemble giant, imaginary fruits. Also within the plaza are a sleek waterfall, a long fence with words by Frank O'Hara and Walt Whitman ➐, and a **Police Memorial** ➑ with granite walls and a sunken pool.

On the far side of the plaza is a children's playground (the more traditional sort). Within it you'll see a startling sculpture of Ulysses by **Ugo Atardi** ➒, made in 1997. On your left as you continue along the river is one of the best-known Battery Park City works: *The Upper Room* (1984–87) by **Ned Smyth** ➓. It is one of the more intriguing outdoor sculpture complexes to have been placed in the city's open spaces in years. Made of a pinkish combination of stone, mosaic, cut glass, and cast concrete, its forms are definitely ancient, somewhat Egyptian, a touch classical Roman, with here and there a Renaissance arch. The spacing and design of the series of columns, the seating areas (there are eleven inlaid chessboards), a kind of altar, and the arcade, as well as the varied textures of the stone, are fanciful and appealing. The view of the promenade along the river and of the far shore adds to the tranquility of the spot. Smyth tried to create what he called a "space of respect"; he also wanted his work to relate well to the architectural complex of the new community being constructed around it. Gestures of postmodernism in the buildings are echoed in his arches and details, and the pinkish color of the sculpture picks up the warm brick tones of the architecture. It's a nice place to interrupt your walk for a few moments and imagine yourself surrounded by ancient (but crisply new) ruins.

Not far along the path is **Rector Gate** ⑪. This whimsical, airy, aluminum gate-cum-sculpture with curlicues and circles and trapezoids was created by **R. M. Fischer** in 1988. It affords another

entrance to the river walk. Nearby is **Richard Artschwager**'s *Sitting/Stance* ⑫, two abstract wood and metal forms resembling chaise lounges on granite platforms. It was created in the late 1980s. One of the major environmental art sites in the city is your next stop.

All of the art at Battery Park City was commissioned by the city and was chosen expressly to enhance the new site. One of the most important and successful of these commissions is environmental artist **Mary Miss**'s design for the esplanade called **South Cove** ⑬. Her proposal for the shoreline included a lookout, pilings that rise and fall with the river tide, wisteria-covered wooden archways, boardwalks lit with blue lanterns, and Japanese-style rock gardens. The architect, **Stanton Eckstut**, and a landscape architect, **Susan Child**, helped execute the Miss design. While the design surely alters the natural shoreline (you can see what the banks originally looked like, just over the fence at the edge), it is a major attempt to balance the sophisticated urban setting on the shore with the Hudson's rather wild and somber coastline. From the top of the curving steel staircase, you can enjoy an extraordinary view of the shapes and patterns of Mary Miss's design, as well as of the city, the river, and New Jersey.

Three new museums have opened on this route in the past year or so. The first is one of the newest: the **Museum of Jewish Heritage** ⑭. (The entrance is just to your left along the walkway.) In addition to the museum's primary displays concerning Jewish culture and history, a mesmerizing new art site has also been added on its rooftop.

Dramatically perched atop a new wing of the museum, with spectacular views of Ellis Island and the Statue of Liberty, *Garden of Stones* features eighteen giant granite boulders of various sizes (some weighing more than 13 tons), which have been artistically arranged to create narrow pathways for the viewer. From the top of each rock, a tiny dwarf-oak sapling unexpectedly emerges, swaying in the breeze. With time, each tree is expected to reach 12 feet, its trunk eventually fusing with its stone anchor. The artist **Andy Goldsworthy** created this work as a tribute to the struggles, hardships, and overwhelming tenacity of Holocaust survivors. As such, it is highly symbolic, from its actual number of boulders (eighteen, which corresponds to "life" in Hebrew), to its

representation of life's ephemeral yet timeless quality. We found it an inspiring spot to spend some reflective moments away from the city's frantic pace. The Garden is open from Sunday–Wednesday, 9–5; Thursday, 9–8; and Friday, 9–2. ☎ 212-968-1800.

Just beyond this building are the new **Museum of Women** ⑮ and the **Skyscraper Museum** ⑯.

Continue south and see the next sculpture along the walkway: *Ape and Cat at the Dance,* a 1993 work by **Jim Dine** ⑰. This fanciful piece will delight kids as well as grownups. On the next corner of the walkway is a provocative sculpture by **Louise Bourgeois**, *Eyes* ⑱, whose two orbs were created in 1995.

You now come to the tip of Manhattan; the next, rather startling image, by **Marisol** (1991), is actually in the water! Her *American Merchant Mariner's Memorial* ⑲ is a striking, half-submerged figure reaching up for help to three rescuing figures.

As you turn into **Battery Park** itself, there are some twelve different permanently installed works of art to discover, as well as several changing exhibits.

Among our favorites is the **Korean War Memorial** ⑳, with its giant cutout figure, by **Mac Adams**.

Don't miss *The Immigrants,* by **Luis Sanguino** ㉑. Created in 1981, it is a strong and impressive near-naturalistic work depicting America's immigrants, who came across by the thousands from Ellis Island at this very point, once the Immigrant Landing Depot, now Castle Clinton. Sanguino's sculpture shows a variety of ethnic figures, including a freed African slave, an Eastern European immigrant, a priest, and a mother and child, all seeking a better life. With its rough-hewn style and social message, this work is in a distinctly different mode from other outdoor sculptures one sees in public parks. Instead of conquering heroes in smooth marble, or the sleek modern designs of abstract sculpture, Sanguino has attempted a synthesis of naturalism and historical interpretation.

At the end of the short walkway (well lined with benches), you'll find a small museum of immigration and a reconstructed fortress. Walk through to the promenade along the water and turn left.

Other park sculptures that you can see as you wander in the area are a bronze statue (1909), by **Ettore Ximenes**, of Giovanni da Verrazano ㉒, the first European to sail into New York Harbor; the 1947 *U.S. Coast Guard Memorial* ㉓ by **Norman M. Thomas**, depict-

ing two guardsmen supporting an injured man; and **Wopo Holup**'s *River That Flows Two Ways* ㉔, consisting of gates that overlook the river.

You can also enjoy a variety of happenings and other events in Battery Park, one of the city's liveliest venues on a bright day. Here, too, you can get on the Staten Island Ferry for a beautiful ride (or to visit sites on the Island). Or continue your exploration of Lower Manhattan with the walk in chapter 1.

. . . And in Addition

On the north end of the residential towers of Battery Park City in Teardrop Park, a new installation by **Michael Van Valkenburgh** will soon be completed. In this 2-acre site, a wall made of Hudson River bluestone with cascading water will be divided by a tunnel through which viewers can walk.

There are also changing exhibits of new sculpture at several sites along this route. On the western corner of Battery Place, on the terrace in front of the Ritz-Carlton Hotel, you'll find a site for changing sculpture exhibits provided by Creative Time Inc.

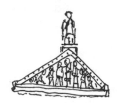

3

The City Hall Area

The Heart of Downtown

HOW TO GET THERE
Subway: 4 or 5 train to Fulton Street; 2 or 3 train to Park Place; N, R, or W train to City Hall.

A lot of people, including New York's legion of municipal employees, are unaware of the wealth of art that is collected in the concentrated downtown City Hall region. Much of it is "official art" commissioned by the city beginning in the late eighteenth century, and a great deal of it is related architecturally. There are numerous allegorical sculptures gracing the city's official buildings and there are statues everywhere, including an occasional contemporary work. Traditionalists and history buffs will particularly enjoy this outing. Wherever you turn you'll see examples of art demonstrating nineteenth- and twentieth-century exuberance and civic pride.

Begin your walk at the corner of Broadway and Park Place, just opposite City Hall Park. Here is the **Woolworth Building** ❶, the tallest building in the world (729 feet, 1 inch) when it was finished in 1913. Designed by **Cass Gilbert**, it is an extraordinary example of Gothic Revival architecture and, particularly, interior decoration in the age of magnificence. Woolworth's love of display is evident in the brilliant mosaic patterns, the vaulted ceilings, and the golden marble (quarried on the isle of Skyros in Greece). The mosaic patterns of birds and flowers recall Italian designs; the brilliance is still dazzling ninety years later. Murals by **Paul Jennewein**, representing Commerce and Labor, can be viewed on the mezzanine level or from the center hall downstairs; they are a good example of the stylized academic tradition in American art of the time. Don't miss the grand marble staircase and carved marble balustrade at the end of the entrance corridor. Finally, note the

sculpted figures beneath the arches leading to the hallways near the Broadway entrance. Among the figures is Woolworth himself, clutching a large nickel in his hand.

As you leave the building, cross Broadway to the small triangular park called **City Hall Park** ❷. Much like a town common, the park has been used in many different ways through the years: as a burial ground for paupers, a site for public executions, and the setting for ceremonies (and riots). Though no longer open for visitors to walk around, the park nonetheless has several interesting sculptures to see. Look through the fence to see a statue of Nathan Hale by **Frederic MacMonnies**.

Walk toward **City Hall** ❸, itself a jewel of a palace on a small, intimate scale. It stands serenely within an urban landscape as a reminder of a more gracious era. Although it seems almost dwarfed by its giant neighbors, it is one of the loveliest buildings in the city. This refined Georgian Renaissance–style edifice, built between 1803 and 1811, is rich with artistic and architectural interest.

As you walk toward the building, be sure to notice the figure at the very top of the cupola. It is a statue of Justice, the third such statue to occupy the site. The first, made of wood, burned in 1858 after a rooftop fireworks display; the second, also of wood, rotted by 1878; and the current statue of white-painted copper has been at its present location high above the park for more than a hundred years (since 1878). Its designer is unknown; it comes from a commercial producer of public statuary (William H. Mullins Company of Ohio). But it serves its purpose well. This stately representation of justice resembles white stone and is a graceful addition to this beautiful building. The figure of Justice holds one arm aloft (not unlike the Statue of Liberty). In her hand is a scale, at her side, a sword. Like so much of our nineteenth-century public sculpture, this symbolic figure is vaguely ancient looking, from her drapery to her classical face and traditional pose.

On the east side of the park is Park Row. Across Park Row you will see **Pace University** and a statue of a much-loved American, Benjamin Franklin ❹. Sculpted in 1872 by **Ernst Plassman**, a German who had settled in New York, this representation of the statesman, inventor, diplomat, and printer stands, appropriately, on a spot known as **Printing House Square**. The original buildings of three New York newspapers used to be near this site, and Franklin is shown here in his guise as printer, holding in his hand a copy of the *Pennsylvania Gazette* newspaper. The bronze figure was a gift to the press and printers of New York City. Its unveiling was a major event, at which Horace Greeley, editor of the *Tribune* (see stop 6 of this walk), made the principal address and Samuel F. B. Morse swept off the "star-spangled" covering of the statue. The statue is set high above eye level, which is just as well for the viewer, as this is a corner of great activity and many pedestrians. Pace University's plaza is also the site of *Setting the Pace* by **Mike Melville** ❺, a sculpture of a police dog in brilliant blue and yellow with geometric motifs on his back.

Crossing Park Row again, you'll see the northern section of **City Hall Park**. Here you'll find a bronze of another giant of nineteenth-century America, the editor of the *New York Tribune*, Horace Greeley ❻. Sculpted by **John Quincy Adams Ward**, this statue captures Greeley's appearance: his rumpled clothing, distinctive chin whiskers, and relaxed seated position with newspaper resting in his lap. Greeley's statue was made in 1890, and the sculptor revealed that he had used a death mask of the famous man's wide face to capture the peculiarly shaped dimensions of the head. The statue even looks at us somewhat sideways, a typical gesture of Greeley's. It was considered by those who knew him to be an excellent likeness. Ward, the grandson of President John Quincy Adams, was one of the first well-known American sculptors to study at home rather than in Europe.

Cross Chambers Street and, at 31 Chambers Street, you'll find **Surrogate Court**, also known as the Hall of Records ❼. This building has lavish sculptural ornamentation in keeping with its era and with its function as a government building meant to inspire civic pride. The sculptures that profusely decorate its façade are thus both symbolic and elaborate in design and number; in fact, there are forty-two of them. The main ones, dating from 1903 to 1908, are all by **Philip Martiny**, a Frenchman who settled in New York and worked in the studio of Saint-Gaudens. Martiny was apparently a very busy man; both of the major groupings are his, as are twenty-four figures on this building, and you'll see two other allegorical works of his in Foley Square, where you'll find both *Justice* and *Authority* (see stop 10 of this walk). The two major groups by Martiny on this Surrogate Court building flank the entrance. On the right is a group with a woman clutching books and wearing a headdress of feathers. She represents New York in its infancy. To the left of the doorway is another group with a female figure holding both a globe and a torch and wearing a helmet. She is New York in Revolutionary times. All are made of granite. The twenty-four cornice figures high up on the building are either portraits or allegories. Such notable New Yorkers as Peter Stuyvesant, De Witt Clinton, and a number of the city's mayors (whose names are familiar from the street names of downtown New York) appear on the Chambers Street façade. On the Centre Street side are eight female figures representing such subjects as Medicine,

Commerce, and Industry; on the Reade Street side, you'll find figures representing either virtues such as Justice and Tradition, or symbolic figures of Electricity, Printing, Painting, Sculpture, and Force. (This interesting amalgam certainly suggests some national preoccupations of America's early twentieth century!) Other decorations high on the building are the work of **Henry Kirk Bush-Brown**, and they represent the Four Seasons, as well as such traditional subjects as Philosophy, Poetry, and Maternity. We know of almost no other building in the city so lavishly decorated with sculpture on the exterior. It is interesting to keep in mind that the American emphasis on growth and grandeur included public art for all to enjoy; unlike the Woolworth (see stop 1), this building was not designed to celebrate one man's empire, but to inspire and please the public at large. However, this lavish Beaux-Arts building was constructed during the same exuberant era as the Woolworth, as was the U.S. Customs House on Bowling Green. Originally intended to serve as a storage place for municipal records, the Surrogate Court building has recently functioned as a court dealing with guardianships and trusts.

The inside of this elegant building is as spectacular and ornate as the outside. You walk into a marble foyer, where, above the doors, sculptured reliefs by **Albert Weinert** depict scenes from the early period of New York City. Note the unusual windows laced with wrought-iron designs. On the ceiling you'll see a wonderful mosaic in deep, rich shades, by the muralist **William de Lefwich Dodge**, showing Greek and Egyptian allegorical beings representing Justice, Sorrow, Labor, and Retribution. But the most spectacular architectural elements within are the grand Piranesi-like marble staircase dominating the central lobby and the impressive colonnaded rotunda above.

From the Surrogate Court you'll see the giant **Municipal Building** 🎱 directly across the street. This mammoth structure has numerous exterior sculptures, including *Civic Fame* (1913–14) by **Adolph Alexander Weinman**. A gold-leaf copper statue sits atop the tower of the building, and, surprisingly, it is the largest statue in Manhattan. (No, the Statue of Liberty is not in Manhattan.) *Civic Fame* is a graceful and unusually charming sculpture in the allegorical style of municipal-building decorations. She balances delicately on a globe and holds aloft a crown that has five turrets to

symbolize the city's five boroughs. Best seen from a distance, you might want to back up into the park for a better view or use binoculars for a detailed look.

Civic Fame is 582 feet above the street. Made of about five hundred pieces of hammered copper over a steel frame, the statue was installed in 1914. But this is not Weinman's only contribution to the decoration of the building, which bears many other sculptural ornaments, including a series of medallions, leaf patterns, coats of arms, and several major groups of figures. You guessed it: there are figures representing such virtues as Civic Pride, Progress, Guidance (left of the entrance), Executive Power (right of the entrance), and Prudence. And on the second-story level, you'll find bronze relief panels showing Water Supply, Building Inspection, Records and Accounts, and a number of additional municipal functions. Most of these allegorical and illustrative works date to the first part of the twentieth century. This building is another example of that period's use of architectural sculpture for the "edification" of the public.

For a jolt from all the virtuous Justice and Authority statuary of this part of town, walk through the Municipal Building (take the pedestrian walkway that is to the right of the entrance), and you'll find yourself in **Police Plaza**, a rather new-looking brick-faced area. Here you can't miss **Tony Rosenthal**'s *Five in One* ❾, a 30-foot-high, 75-ton steel sculpture consisting of five large, abstract, intersecting discs. Made of Cor-Ten steel in 1974, the sculpture sits in an area that is supposed to be improved with artistic brickwork and other amenities, but we found it harboring an immense amount of junk and trash in and around its forms, as well as a goodly amount of graffiti.

Leave Police Plaza and walk along Pearl Street to Foley Square. The **New York County Courthouse** ❿ is on your right. Elegant columns and stone steps lead up to its entrance, where two large granite statues sit on either side of the doors. Like many sculptures at the Surrogate Court building, these statues are by **Philip Martiny**, the French-American sculptor of so many allegorical figures. Here we find *Authority* and *Justice*. On the right is *Justice*, a seated female figure once again holding a shield and scroll. On the left is *Authority*, who holds a scroll and the Roman fasces, the emblem of official power. Curiously, these seated figures have a sort

of modern simplicity of shape, despite the traditional symbolism; their stoic expressions and large forms bring to mind more contemporary sculpture (these were made in 1906).

In the center of **Foley Square** is a striking black steel sculpture, **Lorenzo Pace**'s *Triumph of the Human Spirit* ⓫, an evocative slavery memorial with African imagery. This site is just across from the recently discovered **African Burial Grounds** and the artwork commemorating it next-door.

Across Foley Square on Duane Street you'll find the plain grassy site of the Burial Ground, and directly next door, at 290 Broadway, is the large **Federal Office Building** ⓬. Here, a series of interesting artworks relating to the Burial Ground are on display. Outside, on the wall of the building, is **Clyde Linds**'s *America Song,* a work using concrete, granite, stainless steel, fiber optics, and electronics.

The lobby has several works: of primary interest is **Barbara Chase Riboud**'s impressive and evocative sculpture called *Africa Rising* (1998). Also in the lobby is a silkscreen mural by **Tomie Arai** called *Renewal*; it commemorates the discovery of the African Burial Ground in a series of collaged images. At the Duane Street entrance is a mosaic installed high on the sky-lit wall: dozens of faces, some skeletal, are portrayed by **Roger Brown**. *The New Ring Shout* is a floor installation commemorating the Burial Ground. It features a 40-foot-round illuminated terrazzo and polished-brass dance floor, designed as a tribute to the thousands of Africans, Indians, and Europeans buried beneath the building. (There is a great deal of material available in the lobby on these many commemorative artworks.)

Just across Duane Street, facing Broadway, is another massive edifice, the **Jacob Javits Federal Building**. A number of distinguished artworks dot the plaza surrounding it. Of particular interest are **Alexander Calder**'s large, red, steel piece called *Object in Five Planes* ⓭ and rough-textured iron columnar works by **Beverly Pepper** on the north and south corners (facing Broadway).

Walk around this large building on Worth Street to Centre Street; turn left to find the **Civil and Municipal Court Building** ⓮. On the Centre Street side, you'll find *Law,* a sculpted relief by the twentieth-century artist **William Zorach**. Appropriately, it depicts a family surrounding the central figure of a judge. The relief is in the style for which Zorach was well known, with its large, rather primitive, stylized groups of figures reminiscent of murals

and reliefs from the 1930s. Though Zorach began as a modernist painter, he soon turned to sculpture and to more-representational works. A traditionalist in method, Zorach insisted on using a chisel and working from a solid mass to create his monumental bas-reliefs. This granite work, made in 1960, graces a large, dull wall of the court building—Zorach's was an optimistic view of the law's ability to aid the ordinary people entering this hall of justice.

Walk south through the small park connected to this building to see the corresponding bas-relief on the Lafayette Street side. You might want to take a moment to rest your feet in this vest-pocket park. The Zorach sculpture's counterpart on the Lafayette Street façade is *Justice,* made in 1960 by **Joseph Kiselewski**. Like the Zorach, it is a bas-relief set into the bland wall of the building. Kiselewski's work is a more allegorical scene than Zorach's, but both bear the same distinctively stylized look as public murals and reliefs made in the pre–World War II era. *Justice* is a less tightly knit composition than is *Law*; in it a "floating" female figure bearing scales hovers above a baby and a snake, perhaps protecting the innocent from harm.

To go back uptown, walk north to subways at Canal Street and Broadway, or to Tribeca art sites.

4

Exploring Soho and Tribeca

Bustling Streets and Art Installations

HOW TO GET THERE
Subways: A, C, or E train to Canal Street.

In the last few years, Soho and Tribeca have changed dramatically. Once the center of New York's avant-garde art world, with more than thirteen hundred art-related spaces, these two architecturally inviting neighborhoods no longer command the same attention for galleries and museums.

Soho was once the heart of Manhattan's manufacturing district. It then became home to many of New York's leading artists and craftspersons in this downtown area (Soho is a nickname for South of Houston) and in Tribeca (Triangle Below Canal). Along narrow cobblestone streets filled with the rumble of trucks are giant spaces, including lofts in old manufacturing buildings (many with unusual architectural details and cast-iron fronts). These spaces were first converted to studios and galleries by artists during the Abstract Expressionist era. Looking for space in which they could work on oversized canvases and sculpture, artists found Soho's un-partitioned manufacturing space and away-from-it-all charm perfect. The city legalized lofts for artists some years ago. By the late 1960s, giant galleries had sprung up, and the epicenter of New York's avant-garde art world was to be found south of Houston instead of in the posh Upper East Side.

But, as so often happens, the artists' colony was joined by trendy boutiques and restaurants, as well as dozens of commercial enterprises. Today high rents have driven out many in the art world. However, among the many commercial establishments that once housed galleries in former warehouses and factories, you'll still find a number of sites of interest.

A brief exploration of Soho's bustling streets can introduce you to remaining galleries, including purely commercial ones, and a

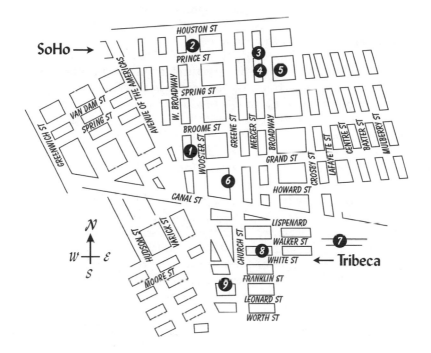

few small worthwhile art museums—not to mention dozens of hip emporiums. We recommend walking between Prince and Grand streets (north and south) and between West Broadway and Broadway and visiting the following sites of artistic interest.

Start at the **Drawing Center** ❶ at 35 Wooster Street. This attractive gallery presents some of the finest works on paper shown in New York. A recent exhibition featured selected works on paper from the Tate Collection. Hours: Tuesday–Friday, 10–6; Saturday, 11–6. ☎ 212-219-2166.

Walk north on Wooster Street to our next stop, the **Dia Center for the Arts** ❷, at 141 Wooster Street (between Houston and Prince, on the second floor). Here, a longstanding exhibit called *New York Earth Room,* by **Walter De Maria**, has been on view for more than twenty years. Dia has several other locations, including one in Chelsea. The most recent (and stunning) is its new museum in Beacon, New York (about one hour north of the city), a not-to-be-missed experience ☎ 212-989-5566.

Walk east on Prince Street, stopping to see, on the southwest corner of Prince and Broadway, a trompe-l'oeil mural by **Richard Haas** ❸, which was sponsored by City Walls Inc. in an effort to enliven the city's drab outdoor surfaces. This witty mural reproduces in paint some of the architectural details of the building.

On the adjoining block of Broadway is the **New Museum of Contemporary Art** ❹, at 538 Broadway, between Houston and Prince. An eclectic mix of multimedia art and cutting-edge works can be found in this attractive museum. The museum will occupy a temporary location in Chelsea before moving to its new building at Bowerey and Prince streets. Hours: Tuesday–Sunday, 12–6; Thursday, 12–8. ☎ 212-219-1222.

Cross Broadway to see several gallery buildings ❺. On the east side of Broadway between Houston and Spring streets, you'll find several excellent galleries. Take the elevator from floor to floor in numbers 560, 568, 578, and 584–588 Broadway.

To get a good taste of Soho's inviting streets, walk from here west on Spring Street to Greene Street, and turn left (south). You'll pass galleries, boutiques, and a variety of interesting sights on your way to our last Soho art site. **Artists Space** ❻, at 38 Greene Street, third floor, is a multi-artist gallery space that exhibits recent works, including such group shows as Painting as Paradox . . . From the Digital to the Figural. Hours: Tuesday–Saturday, 11–6. ☎ 212-226-3970.

Tribeca is the neighborhood south of Soho, below Canal Street. It too has lost some of its art venues to chic stores, but you will still enjoy visiting its arty streets. For a quick taste of Tribeca's gallery scene, walk down Church Street (just opposite Greene Street) to Walker Street, turning left. One of the best sites is **Art in General** ❼, at 59 Walker Street. Here some of the most thought-provoking exhibitions and events take place, ranging from dance performances to shows using analog technology or blueprints. Hours: Tuesday-Saturday, 12–6. ☎ 212-219-0473.

Walk one block down to Broadway and White Street, one of the major arty streets in Tribeca. Walk west (right), stopping at the **Synagogue for the Arts** ❽, at 49 White Street. This stunning contemporary synagogue (designed in 1967 by **William N. Breger**) is also known as the Civic Center Synagogue. In addition to its worthwhile series of exhibitions, you won't want to miss the un-

usual sanctuary above the basement exhibition space. Hours: Monday, Wednesday, and Thursday, 1–7. ☎ 212-966-7141.

At the next corner (White and Church streets) walk south to Franklin Street. Cross Church to visit several galleries on Franklin, including the **New York Academy of Arts** ❾, at 111 Franklin Street. Here, in the heart of avant-garde Tribeca, a group of artists dedicated to figurative and representational art (among them, Andy Warhol) established a school of art in 1982. The Academy exhibits a few works in its lobby gallery, including some nineteenth-century plaster casts of ancient and Renaissance sculpture. ☎ 212-966-0300.

Complete your taste of Tribeca's art scene by walking up West Broadway toward Canal Street. En route, you'll find many galleries.

5

From Cooper Square to Washington Square to Lower Fifth Avenue

HOW TO GET THERE
Subway: 6 train to Astor Place; N, R, or W train to 8th Street/NYU.

This is a walk that encompasses lower Fifth Avenue, Cooper Square, and the Washington Square area—a historic district with several university campuses as well as a smaller art school—which provide unusual settings for artworks of major importance. A significant private collection, two offbeat galleries, and two historic churches add to the interest of this walk. Sculpture lovers, especially, will find much to excite them, as will those who particularly admire the most contemporary art. But on this tour you'll find everything from nineteenth-century stained-glass windows to a famous outdoor **Picasso**.

Our first stop is Cooper Square ❶ (East 7th Street and Third Avenue), which is dominated by the grand mid-nineteenth-century Italianate building that houses **Cooper Union** for the Advancement of Science and Art. This institution was founded in 1859 by the prominent philanthropist/industrialist Peter Cooper to offer free education in the arts and sciences for deserving students. An eloquent statue of the great man, by **Augustus Saint-Gaudens**, stands in front ❷.

Inside the building you'll find—in addition to classrooms, studios, and exhibition spaces—the famous Great Hall, where such luminaries as Mark Twain, Andrew Carnegie, and Abraham Lincoln once galvanized rapt audiences. Cooper Union hosts a variety of changing art exhibits, concerts, and lecture series, all open to the public. ☎ 212-353-4100.

Walk about a block over to **Astor Place**, at Lafayette and 8th Street. Here you'll find **Tony Rosenthal**'s *The Alamo* ❸, a giant, black, rotating cube resting on its point, notable as one of the first abstract works to be permanently installed in city property.

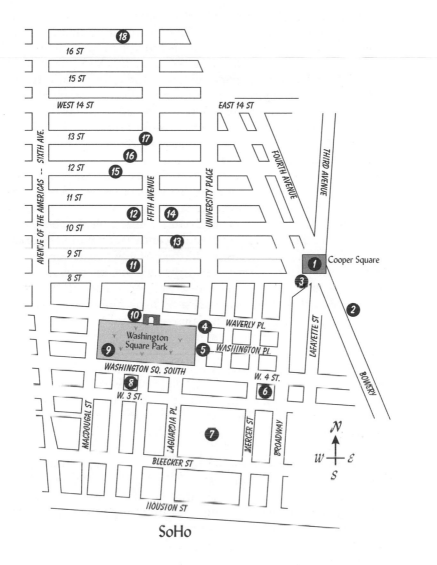

SoHo

Our next stop is the **Grey Art Gallery** ❹, at 33 Washington Square East, New York University's very elegant professional gallery. A series of exhibitions—most with unusual and original themes—is open to the public (small donation requested, but not required). The modern, well-designed gallery makes you wish

more museums and art spaces had its dimensions, lighting, and size, for it is not too large and each item is well documented. The unusual themes of past shows have included handwritten and illustrated letters by famous persons, retrospectives by Sonia Delaunay and David Hockney, contemporary Indian art, caricatures from the French Revolution, and modern Iranian art. One of the gallery's five or so exhibitions a year is devoted to works from its own collection, which includes more than four thousand items. Incidentally, don't miss the display windows, which present art in a striking, nontraditional way. ☎ 212-998-6780.

Walk next-door to **80 Washington Square East Galleries** ❺, another NYU gallery open to the public. On either side of the front door outside you'll find two charming terra-cotta medallions representing the Muses of Art and Music. As the plaques beneath them indicate, they are late-nineteenth-century anonymous works donated to the university. Inside, in the attractive, well-lit rooms, you will more often than not see works by students (mostly graduate) or faculty, although there is a well-regarded annual Small Works exhibit that attracts participants from all over the world. Note that the gallery is open Tuesday–Saturday, after 11 a.m. ☎ 212-998-5747 for further information.

Continue south to 4th Street and the heart of the NYU campus. At **Gould Plaza**, just outside Tisch Hall, is **Jean Arp**'s stainless-steel construction called *Threshold Configuration* ❻. Twenty-nine years ago it was given to the Metropolitan Museum, which recently loaned it to NYU. The statue, a large and rather ambiguous form, is reminiscent of the shapes found in Arp's paintings of the 1950s.

You'll find the most stunning of NYU's artworks in the open space surrounded by the university's housing: **Pablo Picasso**'s *Bust of Sylvette* ❼. To get there, walk through the university's courtyard area to La Guardia Place and West 3rd Street. One more block south on La Guardia Place will bring you to Bleeker Street. On your left before you reach Bleeker you'll see the high-rise buildings of NYU's housing, and in the center court sits the massive Picasso sculpture. Sylvette was a young French woman of whom Picasso made some eighteen different portraits. This colossal sculpture, a reproduction of Picasso's 1954 2-foot-high Cubist work, combines a simultaneously frontal and profile view of a young woman's head, neck, ponytail, and shoulders. The monumental version was

executed in 1967 by a Norwegian artist named **Carl Nesjar**; its 60 tons are sandblasted concrete and black basalt. In conjunction with **I. M. Pei**, the architect, Nesjar and Picasso worked together to make this giant artistic landmark a centerpiece of NYU's campus, though it stands in what seems to be somewhat isolated splendor in a big, empty space.

Walk north on La Guardia Place to Washington Square South, then walk to your left one block. Facing the park is **Judson Memorial Church** ❽, an amber-colored Italian Romanesque–style building with a square bell tower. This turn-of-the-century landmark building was designed by **Stanford White** (like so many others in New York) and features symmetrical rows of rounded arches and graceful moldings. Inside, in the auditorium, past bulletin boards filled with information of social concern and upcoming events, you'll find an imposing **John LaFarge** creation, a large stained-glass window, which is obviously best seen on a sunny day. LaFarge's stained glass, for which he used his knowledge of the techniques of the Renaissance tradition, was influential in bringing a revival of this art to America. He was also noted as a painter and muralist; later in this walk you will see one of his murals, based on the designs by the famous American sculptor **Augustus Saint-Gaudens**.

As you leave Judson Memorial Church, cross over to **Washington Square Park** ❾, the historic and beautiful (if frequently very crowded) oasis of downtown New York. Near the south entrance to the park you'll see a large and very strange tree, now carved by unknown artists into a somewhat grotesque totem pole. This was once the Hanging Tree, from which unfortunate New Yorkers ended their days.

On the eastern side of the Square and in a completely different mood stands the peculiar statue of Giuseppe Garibaldi, sword in hand. Made by **Giovanni Turini** in 1888, it purportedly took only three weeks to sculpt. It is indeed an awkward, curiously unheroic figure for its time and for its most romantic subject—the great revolutionary Italian general of the Risorgimento. There is one other statue in the park, an elaborately mounted bust, by **John Quincy Adams Ward**, of Alexander Holley, an engineer of Bessemer steel fame.

But the park itself deserves to be admired as a work of art in its own right, with its geometric-patterned paths, its circular sunken

sitting areas, its fine trees and shrubbery. And on weekends and nice days you'll find frequent art shows and performances; occasionally you might see an artist or filmmaker at work.

Of course, **Washington Square Arch** ⑩ is the central landmark of Washington Square. Walk under it (once its renovation is completed), and then stand back to admire it. While the Square may be the heart and soul of Greenwich Village, the Arch is its gateway and symbol. The Arch was the inspiration of **Stanford White**, who designed it in 1892; it also represents the works of several notable sculptors. The winged figures above the circular interior arch are by **Frederick MacMonnies**. On the right side of the Arch you'll find George Washington in front of two figures representing Wisdom and Justice; this work is by **A. Stirling Calder** (mobile-maker Alexander's father and a noted artist). On the left column you'll find **Hermon MacNeil**'s sculpture of Washington, this time dressed as the General. The other parts of the Arch bear traditional designs suitable to its grand proportion and imposing setting at the entrance to the Square.

Walk north up Fifth Avenue to 8th Street and turn left to 8 West 8th Street. One of the joys of wandering around in this part of Manhattan is discovering relatively little-known art galleries, artists' studios, or art centers. In our meanderings we visited the **New York Studio School of Drawing, Painting, and Sculpture** ⑪. This landmark building has quite an intriguing history. Originally a stable, it was remodeled by the sculptor, art lover, and patron **Gertrude Vanderbilt Whitney** to become her personal studio and gallery. It then evolved into the Studio Club, a place where Whitney arranged for artists to meet and exhibit their works. From 1931 to 1949 the building housed the collection of the Whitney Museum of American Art before it was permanently moved to its present uptown location. Finally, in 1964 the building became the home of the Studio School.

The school calls itself "an alternative to prevailing trends in American art schools" and, as such, is appealingly uncommercial. The atmosphere is serious, industrious, vibrant, yet unpretentious and friendly. The pleasant smell of fresh paint is noticeable as you wander through, as are other signs of works in progress. Although visitors don't normally have access to the working studios, they are invited to stroll through the attractive, airy galleries where one-person or group shows are regularly on display. These often

(but not always) feature works by faculty and students. We liked the intimacy and charm of the school and recommend it as a different place in which to view sculpture, painting, or drawing in a creative environment. ☎ 212-673-6466.

Return to Fifth Avenue and walk to the corner of 10th Street. Now you are standing in front of the **Church of the Ascension** ⓬, a Gothic Revival Episcopal church that is the oldest church on Fifth Avenue (1840). The church has surprisingly short visiting hours (noon–2 p.m. and 5–7 p.m. daily), so plan your time accordingly. Designed by **Richard Upjohn** and later redecorated by **Stanford White**, it contains two artworks certainly worth seeing: a large, dark, muted mural, *The Ascension,* by **John LaFarge**, and two facing sculptured angels over the main altar, by **Louis Saint-Gaudens** or his more famous brother, **Augustus** (the church isn't sure which). We were shown around by the enthusiastic and obliging rector, who invited us to hear in rehearsal the fine organ and to admire the acoustics. (The church sponsors many splendid concerts.)

Cross Fifth Avenue and walk to the attractive brownstone at 16 East 10th Street, home of the **Pen and Brush** ⓭. This active organization for women artists and writers regularly sponsors painting and sculpture exhibits. The shows, which are judged by a jury of prominent artists, include member artists as well as men and women artists from the outside. You'll enjoy ambling through the high-ceilinged Victorian rooms; the atmosphere is friendly and comfortable, almost like being in someone's home. There is no entrance fee and the gallery is open in the afternoon daily, except Monday. ☎ 212-475-3669.

Go around the corner to another nice brownstone at 47 Fifth Avenue, occupied by the **Salmagundi Club** ⓮, the oldest private club for artists in the nation. It has been at this location since 1917, and the interior has the ambience of old-time clubbiness (with the resident art much the same). The bottom two floors are open free to the public daily including Sundays, when you can view the dimly lit living room, dining room, and hall with its unidentified portraits and landscapes, as well as the two imposing exhibition galleries. The galleries house a series of large group exhibitions. While the Salmagundi Club was once home to many of America's most distinguished artists, its rosters now include amateurs as well as professionals; the club sponsors a number of activities for art lovers, including lectures, demonstrations, and auctions, which

might be considered somewhat conservative by today's tastes or standards. It is a nice stop on your artwalk for a brief reminder of another time and taste.

Across the street at 66 West 12th Street (between Fifth and Sixth avenues) is the main building of **New School University** ⑮. Its somewhat unprepossessing 1930s modern façade belies the surprising wealth of artistic works inside, unbeknownst to many a passing New Yorker. The most impressive of these is surely the spectacular five-wall fresco by the Mexican master muralist **José Clemente Orozco**, which he painted in the 1930s. Newly restored after years of neglect, these brilliantly bold images depict the broad themes of revolution, oppression, and freedom. You can distinguish the faces of Gandhi, Lenin, and Stalin amid enthusiastic crowds of workers, soldiers, and rallying citizens. The idealistic values represented in these panels reflect Orozco's sympathetic feelings for Leftist politics and for the New School, which was at that time a haven for intellectuals fleeing Nazi Germany. (The work was commissioned by Alma Reed, partly as a tribute to her fiancé, who was assassinated during the Mexican Revolution.) The panels incorporate the richness of Mexican folk art with their bright colors and geometric shapes, as well as the simplicity and starkness of Italian Renaissance art (which Orozco had also studied).

Amazingly, this 300-square-foot work is more or less hidden away in an upstairs classroom—room 712—on the seventh floor (once the cafeteria). To view the panels you must first inquire in the lobby at the entrance of the building, or check the nearby bulletin board to find out whether a class is in session or whether the room is free.

After seeing the murals, you might wish to make several stops on your way back down to the main floor to see assorted works of art displayed on walls outside classrooms or in hallways. (Note that many of these works are moved around periodically, which makes it more interesting for the students and faculty who pass by them regularly.) On the fifth floor, down some steps from the elevator, you'll see a number of current works that the New School has either purchased or received as gifts. These are mostly hanging on corridor walls outside classrooms where the light is not always the best, but at least they are displayed. On the fourth floor you'll see a glass-enclosed bridge connecting two sections of the building; it provides a choice space for smaller visiting exhibitions.

From the passageway you have a fine view of the sculpture garden on the ground floor below, as well as of adjacent rooftops. Take the elevator to the third floor. On the wall facing you is more art; when we were there we found three aquatints by **Sol LeWitt**, *Untitled* (1987). Beneath them was a wonderfully shaped bronze sculpture by **Isamu Noguchi**, *Jocasta's Throne* (1945). This whimsical abstraction of a Shaker rocking chair was used in Martha Graham's first production of *Appalachian Spring*. To the right of these works was another interesting wall piece, **Carol Hepper**'s *Comet* (1988). This large, basketlike sculpture is made of wood, wire, and nails.

On the ground floor of the New School are several works of art worth seeing. Before you go through the glass doors to the sculpture garden, look around in the lobby at the exhibits. Our visit included a bold, vertical sculpture by **Petah Coyne**, *Untitled* (1987–88). Made of wood, barbed wire, hay, mud, rope, and cotton cloth, it is a sober yet striking work. On the wall next to it, we found an ocher and brown aquatint, *Untitled,* by **Julian Schnabel**. And on the wall facing the glass doors was a large, striking geometric mosaic mural, also called *Untitled,* by **Gonzalo Gonseca**.

Walk through the glass doors to the sculpture garden in the courtyard. Immediately on your left is an abstract wall piece in stainless steel, *Untitled* (1977), by **Guy Miller**. Unfortunately, the remaining sculptures in the garden are not identified. In front of you, somewhat to the right is **Noguchi**'s *Garden Elements,* two medium-size granite structures punctuated by geometric holes. To your right is **Chaim Gross**'s *Acrobats—Family of Five,* a vertical bronze column made up of intertwined human figures. One of our favorite sculptures is *The Little Dinner* (1968), by **William King**. This delightful rendition of two couples seated at the dinner table is made of cast aluminum.

As you leave the New School building via the regular doors (not the revolving doors), note on your left a curious, somewhat mysterious enshrouded figure. This is **Muriel Castanis**'s fiberglass *Clothed Figure.* It is easily overlooked if you don't know it is there. The New School is open daily Monday–Saturday. Except for the Orozco murals, all other works of art can be seen during regular school hours. For art information, call ☎ 212-741-5955.

Walk to 62 Fifth Avenue, the stately home of the **Forbes Magazine Galleries** ⑯. This unusual museum, which exhibits the

private collection of late publisher Malcolm Forbes, is much more vast and varied than you might imagine. Forbes's eclectic tastes are revealed in this amazing potpourri of objects: from ship models to trophies to toy soldiers to presidential papers to fine works of art. Visiting the galleries requires some planning. They are open Tuesday–Saturday, 10–4 (except legal holidays), but Thursdays are reserved for group tours, and entry is limited to nine hundred persons per day on a first-come, first-served basis. These limitations make viewing the collections uncrowded and pleasant. There is no admission fee. ☎ 212-206-5548.

The first gallery features quite a collection of ship models (including reproductions of yachts owned by the Forbes family), from pleasure crafts to military vessels of the 1870s to the 1950s. Nostalgia buffs might enjoy seeing the panels on display from the ocean liner *Normandie*. In the On Parade gallery, which comes next, hundreds of toy soldiers are exhibited in dioramas of various periods. The Trophies room is just that: almost two hundred of them, in all sizes and shapes—not necessarily "art," but certainly a curiosity. In the next gallery you can see some of the literally thousands of American historical documents that are part of this vast collection. One of the most engaging displays was that of the four miniature room constructions taken from late-eighteenth- and early-nineteenth-century American history: Washington's headquarters in Virginia, John Adams's law offices, Jefferson's bedroom, and Grant's dining room. Note the incredible detail in these rooms—from the flowered chintz curtains to the moldings on the walls to the faithful rendition of furniture styles.

The collection also includes the extraordinarily luxurious objects Forbes was able to gather—from the whimsical music boxes to the most elaborate of jewels and decorated objects in unusual shapes and configurations. All of these intricate objects are more than dazzling to our modern eye.

Finally you can wander into the picture gallery, where a miscellany of American paintings and photographs is exhibited on a rotating basis. Here you have the opportunity to experience the entire gamut of American art (or one family's views of what is representative of American art). You might see such masters as **Thomas Hart Benton**, **Milton Avery**, **Thomas Eakins**, **Gilbert Stuart**, **John Singer Sargent**, and **Reginald Marsh**, to name a few. More recent works include those of **Andy Warhol**, **Jack Nelson**,

Loren Munk, and an interesting construction by **Nancy Grossman**.

On the corner of Fifth Avenue and 13th Street is the **Parsons School of Design** ⑰, a division of the New School. The monthly shows in its two elegant and spacious galleries display works by the most promising students, as well as by faculty and alumni. One gallery is at 2 West 13th Street; the other is around the corner at 66 Fifth Avenue. Walk through the doors of the school's main entrance to the space directly in front of you. The quality of exhibits in this more intimate place is of particularly high caliber, featuring shows by faculty and others within the Parsons community. There is no entrance fee at either gallery, and hours are Monday–Saturday, 9–9. ☎ 212-229-8900 for information.

Your last stop of this outing is a new addition to New York's burgeoning cultural scene. At 15 West 16th Street, just west of Fifth Avenue, is the multi-arts site of the **Center for Jewish History** ⑱. Here, in an elegantly spacious setting, are five organizations, including the **Yeshiva University Museum** and the **Yivo Institute** (formerly on the Upper East Side). Both have provocative exhibitions and a variety of study centers, programs, and mixed-media events. Exhibitions range from early photographs to modern quilts. The museum is open Tuesday, Wednesday, and Sunday, 11–5; Thursday, 11–8. Tours are also offered. For information, ☎ 212-294-8301.

... And in Addition

☞ **New School for Social Research**: lectures, special events. ☎ 212-229-5600.

☞ **Grey Art Gallery and Study Center**: lectures, symposia, seminars, and other special events in connection with each show. ☎ 212-998-6780.

☞ **Salmagundi Club**: auctions, demonstrations, and lectures. ☎ 212-225-7740.

☞ **New York Studio School**: art lectures, usually on Wednesday evenings. ☎ 212-673-6466.

☞ A **George Segal** sculpture has been placed in **Christopher Park** at Seventh Avenue South and Christopher Street. It depicts, in Segal's ultrarealistic style, two couples—one male, one female.

☞ **Madison Square Park**, Fifth Avenue and 23rd Street: In this urban space are nineteenth-century statues by **Augustus Saint-Gaudens** (Admiral Farragut), **John Quincy Adams Ward** (Roscoe Conkling), **Randolph Rogers** (William H. Seward of "folly" fame), and **George Edwin Bissell** (President Chester A. Arthur). A more contemporary work consists of three tilted slabs of steel, called *Skagerrak,* by **Antoni H. Milkowski**.

☞ *Radicals of the Left* mural, at West Street and Charles Street in the West Village: This outdoor mural on the side of the **Pathfinder Press building** took eighty artists from twenty countries two and a half years to complete. It includes portraits of numerous political notables of the left from Marx, Trotsky, and Lenin to Sacco and Vanzetti, Bishop Tutu, Nelson Mandela, and Che Guevara.

☞ **Union Square**, between Broadway and Park Avenue and 14th and 16th streets: A number of notable sculptures dot this urban park. Of particular interest are an evocative statue of Mohandas Gandhi by **Kantilal B. Patel**, a dramatic Lafayette by **Frederic-Auguste Bartholdi**, a pensive Abraham Lincoln and a heroic equestrian George Washington, both by **Henry Kirke Brown**.

☞ **Chaim Gross Studio Museum**, 526 La Guardia Place: This free museum, the sculptor's studio and home for thirty-five years, is open by appointment only. ☎ 212-529-4906.

☞ The **Center for Architecture**, 536 La Guardia Place: This brand-new center is an architecturally stunning three-story, 12,000-square-foot site, open to the public. It features galleries with the latest in urban design, as well as many programs. Hours: Monday–Friday, 8–8; Saturday, noon–4. ☎ 212-358-0640.

☞ The **Hebrew Union College–Jewish Institute of Religion Museum–New York**, 1 West 4th Street, is another new addition to the city's expanding list of special museums. Here you'll find a series of contemporary and traditional exhibitions relating to Jewish culture, as well as a fine permanent collection of art and artifacts ☎ 212-674-5300.

6

Vibrant Chelsea

The New Art Scene

HOW TO GET THERE
Subway: C or E train to 23rd Street.

If you really want to experience New York's vibrant art scene, pick up a monthly Gallery Guide (free at any gallery in the city) and note what evenings the newest openings are scheduled. You won't want to miss the heady atmosphere of openings to new shows (free to the public and you're invited), as well as the trooping of hundreds of people to all the exhibitions in the neighborhood. From six o'clock in the evening on weekdays (but not Mondays), and all day on Saturdays, art lovers tramp through the streets of Chelsea, pouring in and out of buildings, up and down the streets of this once desolate neighborhood way over on the west side. There is also a regional guide available at all the galleries, called ChelseaArt; this flyer has a small map and the names of every single gallery.

Not so long ago the blocks between Tenth and Eleventh avenues from 19th Street to 27th Street were an industrial mix of warehouses and garages, hardly likely candidates for a brand-new artistic neighborhood. But rising rents and gentrification in Soho led the art world to look for a new region of big interior spaces—in Chelsea they found some of the best art spaces you could imagine.

These giant, raw interiors, which obviously once housed massive machinery and trucks and loading docks, turned out to be ideal for today's art. (It should be added, however, that many artists feel that the monumental spaces dwarf their work and force them to produce ever larger canvases, sculptures, and installations.) Nonetheless, these vast, nearly empty spaces—which often do make the art seem rather small in comparison—form an integral part of Chelsea's appeal.

Seeing every one of the sights (there are presently more than 170 galleries, and the area is expanding southward toward 14th Street as we write) without spending many days at it is just about impossible. So we have come up with a tour that will fill an interesting, eclectic, and, we hope, inspiring afternoon.

This is a very concentrated area, with some buildings housing as many as twenty galleries. If you have the stamina to see most of it, you might follow the route outlined below. If, on the other hand, you just want a taste of the Chelsea art scene, go on a Saturday afternoon to West 24th, 25th, and 26th streets and do those particularly saturated art blocks. Or choose an opening to attend and visit the adjacent galleries as well. (Of course, if you specifically want to see only multimedia art, or only sculpture, or works by particular artists, we suggest you study your Gallery Guide carefully to see who shows what and plan your route accordingly.) For those of you unaccustomed to gallery etiquette, it is acceptable to walk in and out at random, eat hors d'oeuvres at openings, and ask for prices at the desk if you wish.

Our suggested tour (which takes in all kinds of art, but all of it comparatively recent—no old masters in sight) begins at Tenth Avenue and 26th Street. Walk west toward Eleventh Avenue. In that one block alone you'll find a terrific mix of styles and media. A major building of galleries is at 526 West 26th Street; among them are galleries showing contemporary art (**Greene-Naftali**), architectural works (**Henry Urbach**), and prints (**International Print Center**). On the same block are a number of other interesting galleries (don't forget to notice the vast and evocative spaces that house the art, particularly in ground-floor galleries).

Cross Eleventh Avenue to see another major site: 601 West 26th Street. Here the **Sherry French Gallery**, **Art of This Century**, and many other galleries occupy what was once as out-of-the-way a location as you can imagine in Manhattan, but is now bustling with art shows.

Walk back toward Eleventh Avenue and south one block to West 25th Street. Head east toward Tenth Avenue; several buildings on this block house multiple galleries on various floors, and there are street-level galleries as well. Visit buildings at 555 and 511 West 25th Street; at 534 you'll find the well-known **Pace Wildenstein Gallery**, showing major figures in contemporary art. At the end of the block, look up at the old High Line railroad viaduct. Here you

might see a large piece of conceptual art, usually in the form of a sign reading, perhaps, "Subjectivity is the master of all art forms" or "News Alert in art . . . nothing is new."

Back on Eleventh Avenue walk south toward West 24th Street, stopping at 210 Eleventh Avenue, where a dozen galleries are located. Turn at the next corner, walking east on West 24th Street. At 555 West 24th Street you'll find the chic **Gagosian Gallery**, showing notables such as **Richard Serra** in a spectacular setting. At 541 West 24th Street you'll find the cutting-edge **Mary Boone Gallery**, and at 531 West 24th Street the **Luhring Augustine Gallery**.

The next block south is 23rd Street, which has only a couple of galleries, but 22nd Street is one of the major venues for art in the city. On the corner of Eleventh Avenue is the new **Chelsea Arts Museum**, showing international artists. At 548 West 22nd Street you'll enjoy a visit to one of the city's premier avant-garde centers, the **Dia Center for the Arts**. One of the first arty denizens of the neighborhood, Dia in Chelsea is part of a larger organization; its gallery here has both shows and contemporary artist books, and all sorts of interesting things going on. At 535 West 22nd Street look in on **Electronic Arts Intermix**, which is noted for its seventies archive. At 536 West 22nd Street the sophisticated **Sonnabend Gallery** shows contemporary art. There are several interesting galleries at 530 West 22nd, too.

Few galleries have opened yet on West 21st Street, so walk down to West 20th Street between Tenth and Eleventh avenues, another major site. One building in particular, 529 West 20th Street, houses over twenty galleries (enough to fill an entire day all by itself). Don't miss **Dorffman Projects**, a multi-artist venue of well-known artists like **Andy Warhol** and **Roy Lichtenstein**, and the **ACA Galleries**, a long-time showcase of American art.

Our last block is West 19th Street, where you'll find **The Kitchen Center** at 512 West 19th Street. The Kitchen has the latest in multi-media works. An internationally known showcase for avant-garde art, it also specializes in performances of dance and music. ☎ 212-925-3615.

Also on West 19th Street, but farther east, is the noted **Marlborough Gallery** at 211 West 19th Street, now the eastern outpost of the Chelsea gallery scene.

Continuing east you will have a change of pace if you visit the **Fashion Institute of Technology**'s gallery space. At 17th Street

and Seventh Avenue, this modern building houses a two-level exhibition area that shows both the works of noted fashion designers and historic costumes. These are usually stunningly conceived and presented shows, well worth a visit. (You may wonder if this venue fits into a gallery walk, but we recently saw exhibited an installation of women's shoes at one gallery in Chelsea, and the juxtaposition was not so far-fetched.) ☎ 212-217-7999.

Needless to say, this write-up is subject to change, for nothing changes faster than an art scene in a particular neighborhood. As of this writing, there were already trucks filled with art unloading in front of several unlikely venues in Chelsea, so don't be surprised if many new and interesting galleries appear in the region. In the meantime, we guarantee that your conception of contemporary art will be expanded by this little tour.

... And in Addition

New York Gallery Tours will take visitors to what they consider the most provocative exhibitions in a 2-hour walking tour. ☎ 212-946-1548.

7

An Asian Odyssey

Himalayan, Chinese,
Japanese, and Korean Delights

HOW TO GET THERE
Rubin Museum of Art, by Subway: 1 or 9 train to 18th Street.
Asia Society and Museum and China Institute Gallery, by Subway: 6 train
to 68th Street/Hunter College.

Outside of Asia, few places equal New York City for its wealth of
Eastern art. There are museums, galleries, cultural centers, shops,
and neighborhoods to explore—more than you might expect.
Here are a few of our favorites.

Foremost is a brand-new (opening fall 2004) and most stylish ad-
dition to New York's museum scene—a veritable treasure-trove of
Himalayan art. The **Rubin Museum of Art**, at 17th Street and Sev-
enth Avenue (located in the former Barney's store) provides some
25,000 square feet of gallery space on five floors surrounding a
glamorous spiral staircase preserved from the previous interior.
Within this dramatic space (designed by **Milton Glaser**, **Tim Cul-
bert**, and **Celia Imrey**) you can admire a remarkable collection of
tangkas—the Himalayan paintings in brilliant tones of deep red,
gold, and green on cloth, which depict Buddhist iconography and
landscapes—from the twelfth through the nineteenth centuries.
You'll also find magnificent statuary, woodblocks, murals, and
some examples of Hindu art. Future exhibitions include Female
Buddhas: Women of Enlightenment in Tibetan Mysticism; Par-
adise and Plumage: Chinese Connections in Tibetan Arhat Paint-
ing; works by photographer Kenro Izu; and Tibet: Treasures from
the Roof of the World. The museum offers visiting exhibits, cul-
tural programs, and special events relating to Nepal, Tibet, and
other regions of Central Asia. ☎ 212-620-5000.

For a more intimate taste of Tibetan art, we recommend a visit
to the **Jacques Marchais Center for Tibetan Art** on Staten Island

(see page 224 for a description and directions); and the **Tibet House Gallery**, at 22 West 15th Street, which shows works inspired by Tibetan and other Buddhist cultures. ☎ 212-807-0563.

The **Asia Society and Museum**, at 725 Park Avenue and 70th Street, is another leading venue for art of the many Asian countries. This elegant building (designed by **Edward Larrabee Barnes** and dedicated in 1981) houses a true museum collection of Asian art, from stone Buddhas to Chinese ink paintings, Japanese ceramics, and Nepalese statuary. This is a rare collection in which you can spend a long or short time, as you wish. A recent, very successful renovation has brought a number of commissioned works to this already rich collection. On the lobby floor, for example, you'll see **Yoshi Waterhouse**'s curving Shoji screens made of glass, wood, and metal screening; and hanging from the ceiling in the Garden Court (the café) you'll see three extraordinary flying angels encased in translucent fabric cocoons, by Indonesian artist **Heri Dono** and titled *Flying in a Cocoon*. Also in the café is *Scholars' Rocks* by the noted Chinese artist **Xu Guodong**. Other artists whose works were commissioned include **Sarah Sze**, **Shazia Sikander**, and **Yong Soon Min**, as well as calligraphic art by **Xu Bing**. The Asia Society combines exhibits from its permanent collection with changing shows, such as its recent, exquisite Hunt for Paradise: Court Arts of Iran: 1501–1576. Hours: Thursday–Sunday, 11–6; Friday, 11–9. ☎ 212-288-6400.

For those with a deep interest in Asian art in general, the **Metropolitan Museum of Art** collection is, of course, indispensable. Here you will find many galleries dedicated to art from all of Asia. (See chapter 14 for further discussion.) If your interest is specifically in Chinese art, visit the **China Institute Gallery**, at 125 East 65th Street. This little gem of a place offers rotating exhibitions, as well as events whose aim is to introduce Chinese art to Westerners. Scholars and other experts on Chinese art are occasionally featured at public symposia. The China Institute Gallery is open Monday–Saturday, 10–5; Tuesday and Thursday, 10–8; and Sunday, 1–5. ☎ 212-744-8181.

The **New York Chinese Scholar's Garden** at Snug Harbor (Staten Island) is another site not to be missed. See page 221 for a full description and directions to this relatively new and very special addition to New York's cultural scene.

At St. John's University in Queens, visit the **Chung-Cheng Art Gallery** in Sun Yat-Sen Hall, where works by local and Chinese artists are shown. ☎ 718-990-6161.

A visit to Manhattan's Chinatown will also add to your Chinese experience in New York.

For a taste of Japanese art, visit the **Japan Society**, at 333 East 47th Street. Its gallery displays Japanese prints, sculpture, and decorations of many centuries. The Society also sponsors programs of interest, open to the public. ☎ 212-832-1155.

Tenri Cultural Institute of New York, at 43A West 13th Street, is an organization devoted to Japanese cultural enrichment. In an unusually attractive environment, it includes an arts gallery featuring six shows of contemporary Japanese art each year, as well as classes, symposia, and concerts. ☎ 212-645-2800.

Two venues for viewing Korean art are the **Korean Cultural Service Gallery**, at 460 Park Avenue and 57th Street, sixth floor (☎ 212-759-9550); and the **Brooklyn Museum**, which contains one of the most significant collections of Korean art in the country (The Museum is also noted for its Persian Qajar Dynasty art. See page 208–209 for museum information and directions.)

8

An Art Deco Walk

New York's 1930s Heritage

HOW TO GET THERE
Subway: 6 train to 33rd Street.

New York City is filled with examples to delight Art Deco aficionados. Throughout the city there are prime examples of the American take on the style, most of them preserved from the late 1920s and the 1930s, when Deco was both new and very fashionable. To create an Art Deco building or interior indicated a forward-looking, streamlined attitude.

Deco came to New York on a wave of European stylishness. In 1925 the Exposition des Arts Decoratifs et Industriels Modernes opened in Paris, and its heady combination of graceful swirls and swoops with hard-edged geometry grabbed the attention of designers everywhere. Quickly abbreviated to "Art Deco," it involved all the visual arts at once, creating an overall stylish ambience. Not long after, artists and architects in the United States were producing their own version of the style, combining the European with a streamlined, machine-oriented Americanism.

As we will see in this outing, many of the characteristics of American Art Deco can be seen in a few midtown buildings. (Another prime location is the Wall Street area, where several major examples can be found.) In midtown, where we plan this brief tour, there are architectural wonders (like the Chrysler Building), as well as more modest buildings, which nevertheless illustrate the Art Deco style quite brilliantly.

Before we set out, here are a few words to describe Art Deco and what to look for. Art Deco was strongly influenced by Art Nouveau, which preceded it. From Art Nouveau come the graceful swirls and symmetry. By the early decades of the twen-

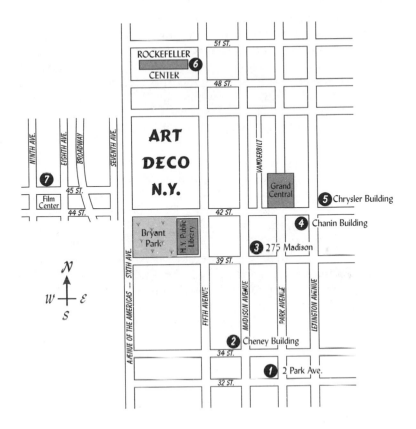

tieth century, Cubism (and related abstract-art movements) had swept the European art world. From modern art's stylistic, hard-edged geometric shapes came Art Deco's emphasis on angles and straight lines. In combining these two very disparate infl-uences, Art Deco became a design of contrasts: on the one hand, lissome and graceful in its curves and, on the other, geometric and rigid.

Added to these elements was the influence of a new industrial-age excitement, evidenced by symbols representing speed and ma-chinery itself. In addition, there were numerous exotic influences, ranging from the Aztec to the Egyptian. Nothing if not eclectic,

Art Deco conveyed a sense of excitement and possibility, as well as a tremendous appreciation for the virtues of design itself.

These elements affected architecture, as well as every other aspect of design, from interior decoration to fabric, glass, and furniture. Both sculpture and painting incorporated some of the same design ideas and found a place within the Deco interior that made them an integral part of the whole. Walls, grilles, windows, lighting fixtures, murals, tilework, and even floors became elements of pattern and design.

Thus, although this is not meant to be a book on architecture, a walk into the following buildings will introduce you to Art Deco, both as a fascinating building style and as an overall style of design and artistry. You'll enjoy identifying Deco design elements, both indoors and out, in the following buildings.

We will begin at Park Avenue and 32nd Street. At 2 Park Avenue you'll find a 1927 building designed by noted New York architects **Albert Buchman** and **Ely Jacques Kahn** ❶. Kahn was recognized as the city's best Art Deco designer. On the exterior, there is glazed terra-cotta cladding in primary colors (colors specially chosen to be seen at a distance). Of particular interest to us are the mosaics in the lobby. Mosaics were a newly discovered medium for Deco designers; mosaics had long ago been relegated to the ecclesiastical realm, but the Deco style made great use of their bright patterns. The design of these mosaics combines repetitive patterning with a faintly exotic design of zigzags, frequently seen in the Deco era.

Our second stop is two blocks north to 34th Street and one block west to Madison Avenue. Here at the southeast corner is the 1925 **Cheney Building** ❷, once the Cheney Brothers Store. The high points of this lobby are the original iron-work grilles and gates, particularly lovely examples of Deco imagery and craftsmanship. **Edgar Brandt**, the French ironworker whose Deco designs came to characterize the entire movement, designed these decorative elements. Note in particular the emphasis on growing flowers; images of burgeoning nature were typical of Deco design.

Walk six blocks north on Madison Avenue to 40th Street. At 275 Madison Avenue you'll find the old **Farmer's Trust Building** ❸, whose lobby and elevators are beautifully decorated. Note particularly the fluted columns, the floor design, and the elevator

doors. These highly stylized doors, with their linear pattern of iron (also suggesting nature's growth), were part of an integrated lobby design.

At 41st Street, two blocks east, you'll see one of the great masterpieces of Art Deco design in New York. The **Chanin Building** ④ occupies the entire block between 41st and 42nd streets on Lexington Avenue. Along with the Chrysler Building just up the street, the Chanin Building typifies the era, from its beautiful exterior to its interior ornamental brass fittings. Built between 1927 and 1930, it was designed by the architectural firm **Sloan & Robertson**; it was one of the city's tallest buildings in its day, and certainly one of its most elegant.

On the exterior is a band of terra-cotta ornamentation (again, stylized flower forms). Inside, you'll find a treasure-trove of both abstract and symbolic art. Note the small sculptured panels, by **René Chambellan**, representing allegorical figures (suggesting human and natural energy) in relief; the swirling, spiraling ornamentation on brass radiator grilles, with a fascinating freedom of design (though you'll recognize plant forms and stars here and there); the decorative columns with fan-shaped designs suggesting antiquity (once adorning the windows to the Longchamps Restaurant in the lobby); and a general ambience of Art Deco style.

Only a block north, on Lexington Avenue between 42nd and 43rd streets is arguably New York's most beloved landmark, the **Chrysler Building** ⑤. When it was completed in 1930 by **William Van Allen**, it was the tallest building in the world. No building so epitomized the Deco era, with its soaring height, machine symbolism, stylish interior, and original use of materials. We recommend getting a good view of its exterior from at least one block away; you will spot its distinctive reuse of automobile symbols (the building was, of course, constructed for Walter Chrysler). One of the first uses of stainless steel over a large exterior area of a building, the Chrysler Building gleams in the sun, while lower areas of the exterior have decorative masonry walls featuring winged radiator-cap gargoyles, basket-weave designs (another Deco favorite), and even a banded area of abstract car designs.

Above the entrance on the west side of the building you'll see a steel and glass design of zigzags and geometric shapes against

black glass. Inside, the lobby is equally stunning. It has a triangular shape and is lit with a series of cathode rays; imagine how startlingly machine-age they looked in 1930! On the ceiling of the lobby is a mural by **Edward Trumbull**; it too suggests speed and nature's forces in a light and airy design. Lighting fixtures, grilles, and the wood-veneered walls are all Deco in design. The doors and interiors of the elevators are some of the most beautiful in the nation; made of different wood veneers in geometric patterns, they are exceptionally elegant. There are four different patterns, each resembling a veneer collage. The Chrysler Building offers tours.

Your next stop is **Rockefeller Center** ❻ (where tours are also offered). We suggest that you walk west across town to Fifth Avenue then up to 50th Street. Here is a major tourist attraction, but also an interesting artistic one. Rockefeller Center consists of some fourteen different buildings and venues; for this outing, we will focus on elements of Art Deco only.

The most noticeable sight is, of course, the great Atlas statue, created by **Lee Lawrie** and **René Chambellan**. Note the stylized body (and exaggerated muscles) of Atlas. Inside the building, just behind the statue (636 Fifth Avenue) you'll find several artworks of interest, including polychrome limestone cartouches by **Attilio Piccirilli** and carved glass (cast by the Corning Company).

Nearby is 630 Fifth Avenue, whose lobby is the most stylish in the complex. There are copper-lined walls with steel infrastructure beams covered by green marble. At 25 West 50th Street (also part of the complex) you'll see a great sculptural relief, also by **Lee Lawrie** (such reliefs were typical of Deco interiors in public buildings). Made of polychrome limestone, the sculptured panels represent internationalism in a variety of ways. They are both symbolic and stylized.

At 30 Rockefeller Plaza (the old RCA Building) you'll find sculptures by **Lee Lawrie** just outside the front entrance. Note particularly the dramatic stone and glass decoration above the doorway; this is *Wisdom,* a well-known work suggesting Deco's enthusiastic embrace of the forms of nature (light and sound waves emanate). Light and sound waves are also represented in sculptural reliefs above doorways to the right and left. The famous sculpture by **Paul Manship** sits atop the fountain nearby. Representing Prometheus (who steals fire from the gods as a gift for mankind),

Manship's sculpture has the sleek lines and contrasting curves that became typical of 1930s sculpture in America.

Within 30 Rockefeller Plaza there is a distinctive series of murals by **José Maria Sert**. Representing American Progress, Time, and Man's Mastery of the Universe, they give a good idea of the nation's upbeat mood in the early 1930s. (They replaced the originals by **Diego Rivera**, whose "Communist imagery" was strongly opposed by Rockefeller himself.)

Perhaps the greatest Deco interiors in the city are to be found in the **Radio City Music Hall**. Unfortunately, you can only see these interiors (many designed by the Deco master **Donald Deskey**) on a tour. From wallpapers to furniture to the staircase itself, this building personifies the Deco aesthetic.

These are just a few highlights of the Rockefeller Center experience; though we don't usually recommend tours, in this case a tour might be just the thing.

From Radio City Music Hall, walk down to 45th Street and west to Ninth Avenue. Here, at 630 Ninth Avenue is a small but spectacular lobby, not to be missed. This is the **Film Center Building**, also designed by **Ely Jacques Kahn** ❼. Built between 1928 and 1929 to house all kinds of film activities, this setting is both original and evocative of other times and places. Featuring molded plaster and stone, as well as bright colors and brass radiator grilles, the lobby has Aztec and other exotic overtones, and it is said to have been inspired by fabric designs. Be sure to note the ceiling, too.

Other prime midtown Art Deco sites, perhaps for a longer walk, include the following:

- ☞ The **Daily News Building**, at 220 East 42nd Street, was designed by **Raymond Hood**. Note the entrance relief and the ceiling globe and design.
- ☞ The **Fuller Building**, at Madison Avenue and 57th Street, has an entrance with statues by **Elie Nadelman** (there are many galleries in this building, too).
- ☞ The **McGraw-Hill Building**, at 330 West 42nd Street, is a giant of a building with horizontal bands of blue-green terra cotta. Inside, note the lobby with its original detailing, elevators, and entrance.
- ☞ The elegant building at 60 Hudson Street, further downtown, will give you another taste of a lobby of the Deco era, from its

complex brickwork to its lighting fixtures to its grand proportions.

☞ At 745 Fifth Avenue, between 57th and 58th streets, is an unusual painted lobby ceiling from the Deco era. Painted by **Arthur Covey**, it is a brightly colored mosaic-style, semi-abstract picture of Manhattan Island.

9

Crisscrossing 42nd Street

Gardens, Architecture,
Art Deco, and Modern Art

HOW TO GET THERE
Subway: 4, 5, 6, or 7 train to Grand Central/42nd Street; or 42nd Street shuttle.

Most visitors who come to New York have heard of 42nd Street and include it among such must-see attractions as Fifth and Park avenues, Central Park, and Rockefeller Center. While most other sites are known for their elegance and charm, 42nd Street at Times Square used to be notorious for its sleazy movie houses, slick shops, and unsavory characters. But today, after major renovation and renewal, Times Square is a glittering and glamorous part of the city. If you walk with us from the eastern end of 42nd Street to Eighth Avenue, you will discover artistic and aesthetic pleasures you may not ordinarily associate with this street. For here you will find some of New York's grand landmarks, beautiful lobbies enhanced with murals or sculpture, indoor and outdoor garden oases, and odd and unexpected architectural gems—from a charming little church amid tall buildings to an unlikely Romanesque-style former bank to a brand-new eye-catching hotel. So, come along with us to discover the "other" 42nd Street.

Our first stop is the **Ford Foundation Building** ❶, halfway between First and Second avenues on the north side of 42nd Street. (The official address is 320 East 43rd Street, where you now must enter.) This tasteful, contemporary glass edifice is constructed around one of New York's most fabulous and spacious interior gardens, a 130-foot-high "greenhouse" that can be enjoyed by employees and visitors alike. (The garden is open to the public on weekdays during office hours.) All the interior windows in the building look out onto the spectacular greenery, rather than the

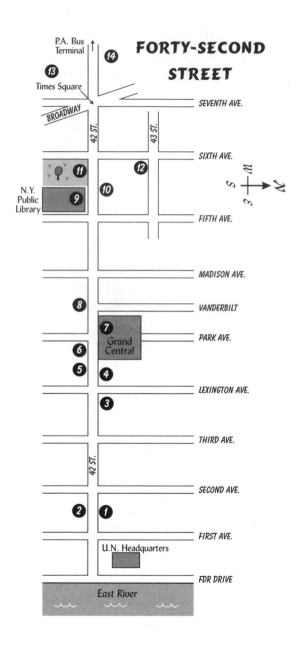

FORTY-SECOND STREET

P.A. Bus Terminal

14

13

Times Square

BROADWAY

SEVENTH AVE.

42 ST.

43 ST.

SIXTH AVE.

11

12

N.Y. Public Library

10

9

FIFTH AVE.

MADISON AVE.

8

VANDERBILT

7
Grand Central

PARK AVE.

6

5

4

LEXINGTON AVE.

3

THIRD AVE.

42 ST.

SECOND AVE.

2

1

FIRST AVE.

U.N. Headquarters

FDR DRIVE

East River

usual cityscape. The one-third-acre oasis is a lush combination of tall trees, terraced shrubbery, ground cover, and water plants gracing a tranquil pond. Although there are seasonal outbursts of brilliantly colored blossoms, the garden is mostly a subtle study of different intensities and shades of green. One can only wish that more urban corporate centers would create such luxuriant green spaces.

Directly opposite the Ford Foundation Building, on the other side of 42nd Street, is the **Church of the Covenant** ❷, at 310 East 42nd. This delightful little church is somewhat dwarfed by the surrounding tall buildings of Tudor City, a 1920s complex of apartments in the American Tudor style. But it can hold its own; built in 1871, it has great charm, with its gabled, peaked roof and nice proportions reminiscent of gentler times. To enter the church, you must climb some rather steep steps, which were added after the church found itself a full story above street level—when 42nd Street was lowered to construct the United Nations complex nearby. The inside is intimate but uncluttered; the unusually shaped sanctuary—more square than most—has pretty, circular stained-glass windows, delicately carved traceries, and wooden arches. You can visit Monday–Friday, 9–12, or attend a Sunday service at 11 a.m. ☎ 212-697-3185.

And now for one of the highlights on this walking tour. The **Chrysler Building** ❸, at 135 East 42nd (on the corner of Lexington), is one of Manhattan's most beloved and recognizable skyscrapers. It is also one of its most vivid icons, having appeared in many paintings, photographs, movies, and other pictorial representations since its completion in 1930. It was the dream of the automobile magnate Walter P. Chrysler, who wanted to create the world's tallest building. A secret contest ensued between his architect, **William Van Allen**, and **H. Craig Severance**, who was busy at work on the Bank of Manhattan on Wall Street. The latter assumed that he had won the competition when, at the very last moment, the dramatic stainless-steel spire of the Chrysler Building was assembled and installed, adding some 123 feet to its height. Walter Chrysler's dream come true was short-lived, however. Ironically, the Empire State Building was completed only a few short months later, dwarfing all the rest.

The Chrysler Building, now restored to its original splendor after some years of neglect, remains one of the city's most romantic

and dazzling images—particularly at night, when the diamond-shaped windows on its tapering tower are outlined in lights—a favorite site to native New Yorkers and visitors alike. The building reflects in many ways the automotive world it glorifies: from its largely stainless-steel façade (it probably has more stainless steel than any other building in the city) to its winged gargoyles (reminiscent of ornaments on car hoods) and radiator caps at the corners resembling capped wheels. The lobby, once an automobile showroom, is an artistic gem. This tasteful interior is rich in color and texture, from the warm tones of deep red and the buff African marble on the walls to the intricate inlaid wood patterns that form a subtle counterpoint. Note especially the magnificent elevator doors and walls decorated in four different patterns of wood veneer in fanciful floral designs. The large 1930 ceiling mural (97 feet by 100 feet), by **Edward Trumbull**, is representative of the Art Deco style in its theme as well as its style. (See chapter 8 for more on Art Deco design in New York City.) Appropriately, the mural depicts the glories of transportation and hard work, ideas popular during the 1930s, particularly with automobile magnates. (Apparently Trumbull used some of the workers in the building as models.)

And now we shift gears and go to the **Grand Hyatt Hotel** ❹, next to Grand Central Terminal (which we will visit later), for a complete contrast in style. For this building is pure glitter, from its mirrorlike glass façade—which reflects the surrounding buildings—to its razzle-dazzle interior. The four-story lobby atrium is complete with Italian-marble floors, giant bronze pillars, fountains cascading noisily, gilded ceiling rods in diagonal patterns, huge circular stairways, and mirrors galore. And there are plants and flowers everywhere. Music and the bustling sounds of activity fill whatever vacuum is left after the overabundance besieging the senses.

Cross 42nd Street back to the south side, where you'll find one of our favorite old buildings, at 122 East. An unusually well-kept and attractive example of Art Deco architecture and interior design, the **Chanin Building** ❺ is a delight to look at both inside and out. Before you enter you'll see on the front of the building some decorative carvings at the fourth-floor level and sea monsters just below. But the major interest for us was the narrow lobby with its elegant Istrian marble and intricate bronzework. Even the

little gateways that conceal firehoses are disguised with the most elegant designs, as are the elevator doors and mailboxes. This care for artistic details within a building puts many contemporary buildings to shame. Note the jeweled clocks and the Cubist bas-reliefs executed by the sculptor **René Chambellan**.

On the same block, at 110 East 42nd, is another New York landmark building ❻. Now a glamorous banquet facility run by Cipriani, it was formerly the **Bowery Savings Bank**, built in the style of a Romanesque basilica. Here you might imagine you are in an Italian church rather than a bank or a dining hall. This massive room is 160 feet long and 65 feet high, and its proportions and grace make it unusually striking. Note the fine details of its marvelous marble-patterned floor, colored marble columns, and arches (the marble came from France and Italy) intercut with polished bronze. The marble floors are so intricately designed with geometric patterns that they might serve as examples for the hard-edged abstractionists of post-Mondrian days. Note over the doorways the medieval-style carvings that depict squirrels and eagles—symbols appropriate to a bank's ideals of thrift and strength. Some bright tapestries decorate the wing to the east. Don't miss a visit to this site, which gives a taste of 1923 grandeur to old 42nd Street.

Cross back over 42nd Street to one of the city's best-loved, and much-used, buildings, **Grand Central Terminal** ❼. Designed in 1903–13, this building is one of the finest examples of Beaux-Arts architecture in Manhattan and has just been brilliantly renovated. You will enjoy walking through the doors to the main room—though you can hardly call such a massive space a room. It is a vast concourse with many fine windows, arches, happenings, people, and bustle, topped by a star-studded vaulted ceiling some 125 feet high.

There are a number of interesting sights in the terminal, as well as the passageways leading to the train tracks. (See chapter 33 for subterranean art.) In addition to the grand main hall with its amazing ceiling arranged in constellations, you won't want to miss the gallery near the 42nd Street entrance (also main floor), which features changing exhibits in a variety of media and subject matter. In the Grand Central Market just below the main floor is a chandelier-like sculpture of crystals by **Donald Lipski**, titled *Sirshasana*.

Go back to 42nd Street and cross once more. At 120 East 42nd you'll find an unusually nice spot: the branch of the **Whitney Museum of American Art at Altria** ❽. On the corner of Park and 42nd, a very inviting art space (free entrance) features changing exhibitions of contemporary art (some borrowed from galleries in the city), though several works are on permanent display. This pleasing area has some tables and chairs for a comfortable rest and presents the chance to take in very interesting pieces of art (the exhibitions change frequently) in an informal and spacious setting. (Snacks may be had here at an espresso bar.) There is also an adjacent gallery with exhibitions on a specific theme; among past subjects were Miniature Environments (box sculptures) and works by American realists Paul Cadmus and George Tooker. The museum offers film programs in connection with current exhibits (free, on a first-come, first-served basis), usually on Wednesdays at 6:30, in the auditorium. The museum is free of charge and tours are conducted by appointment. Hours: Monday–Friday, 11–6; Thursday, to 7:30. ☎ 917-663-2453.

Your next stop is another major city landmark, the **New York Public Library** ❾, the imposing building on the corner of Fifth Avenue and 42nd Street. You should visit the three floors of this library at your leisure, for it's filled with interesting sights, from the giant reading room to the special collection on the third floor. But on this outing, we suggest you walk up the broad stone steps between the famous lions (designed by **Edward C. Potter** in about 1901) and enter the lobby. Just behind it you'll find the library's small exhibition space, where a charming series of exhibits is featured. Combining writing, pictures, and a particular subject, these shows often include unusually fine works. A recent example was an exhibition of baseball writing and pictures, and among the wide-ranging paintings were works by Raoul Dufy, George Bellows, and Claes Oldenburg. In the periodical room on the first floor you'll find a newly completed set of thirteen murals, by **Richard Haas**, which depict New York's different architectural styles in trompe l'oeil.

If you take the elevator to the third floor, you'll find ongoing exhibitions of prints and rare manuscripts that line the halls or are displayed in the hushed elegance of the special-collection rooms. This library is one of New York's most important cultural treas-

ures. The collections are so vast and varied that you will invariably find something of interest on display. Also note the WPA murals by **Edward Laning**, dated to 1940, on the third floor. Called *The History of the Recorded Word,* they are among Laning's many vivid works. *Prometheus,* by the same artist, can be seen on the ceiling of the Reading Room.

The library conducts tours of current exhibitions and tours of the Central Research Library building, each lasting about one hour, Monday–Saturday, free of charge. For information, ☎ 212-930-0911 or ☎ 212-869-8089. For information on exhibits or general information, ☎ 212-930-0800.

After leaving the library, cross 42nd Street to 11 West 42nd, about halfway up the block going west. This is a well-kept and attractive building called **Salmon Towers** ⑩. It houses a number of different organizations. Note the attractive entranceway, with its carvings depicting the twelve months of the year and its sculptures of classical figures representing the professions. Inside is a highly polished interior. Take the elevator to the fourth floor, where you'll be surprised by a two-floor renovation for the **NYU Center for Continuing Education**. Their carefully decorated area makes a tasteful and elegant backdrop for the trompe-l'oeil paintings by **Richard Haas**. Depicting various scenes around 42nd Street in a muted palette of beiges and pale blues, these paintings present curious visual surprises at the end of each short corridor. Don't miss the little café, which pictures Central Park. Each corridor symbolizes another street with a view. We found this to be an ingenious setting for classrooms and a nice melding of contemporary art and architecture.

Continue your walk with a visit directly across 42nd Street to **Bryant Park** ⑪. The newly renovated Bryant Park, just behind the library, is now a delightful, European-style park, with well-kept grass, plantings, kiosks, balustrades, rows of trees, a working fountain, and small green chairs dotted across the lawn in the London style. There are five statues; on the terrace behind the library is perhaps the most intriguing: a Buddha-like bronze portrait by **Jo Davidson** of his friend Gertrude Stein.

Other statues include likenesses of Goethe by **Karl Fischer**; William Cullen Bryant by **Herbert Adams** and architect **Thomas Hastings**; William Earl Dodge by **John Quincy Adams Ward**; and

Brazilian statesman José Bonidacio de Andrada e Silva, a life-size statue by **José Otavia Correia Lima**. This nice center-city space is a cool, tree-lined place for a rest.

From Bryant Park, walk west one block to 1133 Avenue of the Americas (Sixth Avenue) and 43rd Street. Here you'll find the **International Center for Photography Museum** ⓬. This fascinating museum has a provocative exhibition schedule, ranging from retrospectives of famous photographers' works to contemporary, avant-garde photographic artworks. Recent exhibitions have included images of Afghan women, Ground Zero, and civil-rights photographs of the 1960s. The ICP is open Tuesday and Thursday, 10–5; Friday, 10–8; and Saturday and Sunday, 10–6. Voluntary contributions. ☎ 212-857-0000.

Directly across the avenue is the entrance to the last word in contemporary-style hotels. This is the **Westin New York at Times Square**. A fifty-four-story tower split in the center by a beam of light, it reflects Times Square's inviting glamour. After noting the jazzy, colorful exterior, enter the austere, stainless-steel lobbies on the ground floor and mezzanine, which form a startling contrast to the exterior.

Heading west, on the north side of 42nd Street, take note of the elegant façade of the **New Victory Theatre**, recently restored. Continuing west, you'll find **Madame Tussaud's Waxworks Museum**, at 234 West 42nd Street. If you're willing to pay a steep price and if such verisimilitude is up your alley, here you can see wax figures of such American icons as John Wayne, Woody Allen, and Marilyn Monroe, among many, many others. ☎ 1-800-246-8872.

Yet further west on 42nd, at Eighth Avenue, is the **Port Authority Terminal** ⓭, where you'll find a surprising collection of public art. On the ground floor, near the entrance from 42nd Street, are two major artworks not far from the door. Immediately inside the door is **George Rhoad**'s *42nd Street Ballroom* (1983), a delightful kinetic sculpture full of whimsical sights and sounds. (Kids will love this piece!) On the facing wall is a large, shiny stainless-steel and colored-acrylic work by **Yaacov Agam** called *Reflection and Depth*. Walk to the side for its full effect. Upstairs, at the top of the escalator on the second floor, center section, is **Hiroshe Murata**'s *Space Garden,* a large, jazzy maze of intersecting acrylic, enamel, and aluminum pieces in bright colors. Finally, you'll find, also on the second floor, **George Segal**'s well-known *Commuters* (1980), a

bright bronze sculpture with white patina, showing three realistic, tired-looking figures, who are almost lost among the sixty million passengers rushing by each year.

Just across 42nd Street from the Port Authority is a nice old church, the **Church of the Holy Cross** ⑭. Here, in a quiet atmosphere of stained glass and marble, you'll come across several works designed by **Louis Comfort Tiffany**, including the two mosaic panels that flank the center altar and, on the right of the entrance, a glass work depicting St. John the Baptist.

. . . And in Addition

☞ **Grand Central Plaza** (622 Third Avenue, between 40th and 41st streets) is an attractive vest-pocket park one level up from the street.

☞ *Neon for Forty-second Street,* by **Stephen Antonakos**, is a blue and red swirl of neon above a building at 440 West 42nd Street.

10

Midtown Oases

Atria and Outdoor Art: East Side

HOW TO GET THERE
Subway: N, R, or W train to Fifth Avenue and 59th Street; 4, 5, or 6 train to Lexington Avenue and 59th Street.

Even if you're a native New Yorker, you probably think of Manhattan as a vast collection of stone and steel buildings surrounded by streets and sidewalks. True, there's Central Park, but are there other urban oases with trees? And, better yet, with art in them? Well, surprisingly, even to us, we have found many right in the heart of midtown, and we've devised two walks (or one very long walk!) that will take you from one lovely spot to another, from oases with trees and potted flowers that change with the season to those with waterfalls and modern sculptures.

You'll see some exciting outdoor art and indoor atria. And there are benches aplenty to sit on.

We have divided this artwalk into two sections because there are so many places to visit in midtown. On one day you can explore the oases on the East Side, from Madison Avenue to Third Avenue, and on another day enjoy the sights of the West Side, from Fifth Avenue to Seventh Avenue. Or, if you are particularly energetic, you can do both walks in one day.

Begin your walk east of Park Avenue, at 110 East 59th Street. Here in the lobby of the **South Plaza Building** is a fascinating geometric Op Art piece by **Yaacov Agam** called *Night and Day* ❶. Don't miss this intriguing work; you'll be amazed how it changes as you move.

Exit on the 58th Street side to find a massive, bronze-toned, round work by **Tony Rosenthal** (1969) ❷ in front of the next-door public library.

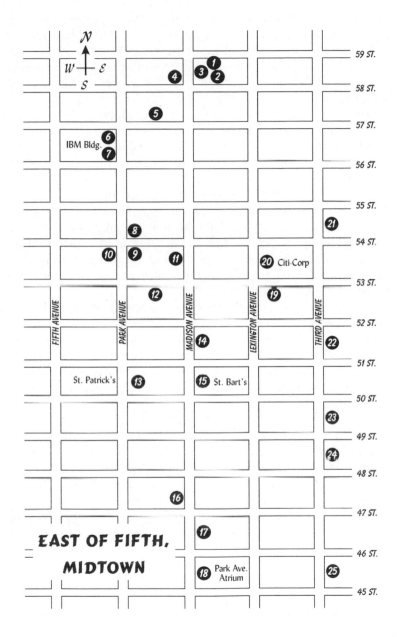

EAST OF FIFTH,
MIDTOWN

To make a quick detour, head north on Park Avenue to number 499, between 58th and 59th streets. In the modern, black marble lobby is a wall construction made by **Jean Dubuffet** in 1971 ❸. Unidentified, it is an unmistakable Dubuffet with characteristic amorphic shapes and bright red and blue stripes against a white background.

Immediately across Park Avenue at 500 Park (with the entrance on 59th Street) is a very large, bold, horizontal abstract painting by **Mimi Thompson** ❹. Called *One-Headed Landscape,* Thompson's work features fluorescent paint motifs on canvas in an expressionistic style.

Walk south on Park Avenue to 57th Street, then turn west toward Fifth Avenue to find the elegant **Four Seasons Hotel** ❺, at 57 East 57th Street. Designed by **I. M. Pei**, its lobby is well worth a visit, if only for its glowing lighting fixtures and sophisticated décor. If you search them out, you'll find about eight wonderful small **Le Corbusier** prints hanging above vintage Art Deco furnishings throughout the lobby.

Continue your walk to the west corner of 57th Street and Madison Avenue. The 57th Street entrance of the **IBM Building** ❻ (at the corner of Madison Avenue) features a giant, red, unmistakable **Alexander Calder** sculpture in front and several works by twentieth-century artists including **Andy Warhol**, whose wall hangings are joined by **Stephen McCallum**'s work called *Aberration of the Mad Guy.*

On the Madison Avenue side of the same building, you'll find the brand-new **Dahesh Museum** ❼ location at 580 Madison. This odd and fascinating museum, which moved here from Fifth Avenue in 2003, shows a variety of nineteenth-century European art of the academic and Romantic sort, with unexpectedly delightful effect.

Much of the art is owned by the museum but is supplemented by fine works borrowed from other collections, such as their recent exhibition of Prix de Rome recipients in the nineteenth century.

Walk toward 56th Street, and on the corner, just in front of the entrance to this same art-filled location, is a large segment of the Twin Towers, lying encased in a frame on the sidewalk like a giant, toppled sculpture.

The entrance just behind it will take you to one of New York's favorite public spaces.

When IBM opened its state-of-the-art public space, New Yorkers heaved a collective sigh of relief—at last a place to stop in midtown and rest, look at art, and even buy a snack. It is truly a delightful oasis. The tall, graceful bamboo trees of the indoor garden rise over tables and benches and always-changing displays of flowers and decorative plants. The atrium has an asymmetrical shape, and you'll wonder if you are actually indoors or out; the atrium is open all winter and it is always popular, like the favorite reading or hanging-out spot on a college campus.

Among the trees and marble tables looms a giant Pop Art sculpture by **Claes Oldenburg** and **Coosje van Bruggen**, dating to 1999. Its name (and obvious subject) is *Typewriter Eraser Scale X*.

Walk south on Madison Avenue, and cross over the avenue to 535 Madison (entrance on 54th Street). Here, in a small lobby (which also has a tiny plaza—replete with fountain and greenery and ivied walls), you'll find the bright woven forms of a **Leger** tapestry of acrobats ❽, as well as a wall-sized, many-sectioned abstract work by **Dubuffet**.

At 527 Madison (at 53rd Street) is an evocative sculpture by an English artist, **Raymond Mason**, called *The Crowd* ❾. Its many Rodin-like figures are huddled together against the outside world.

Back across Madison Avenue at 520 is one of the East Side's be best art-filled lobbies ❿. Works by a number of contemporary artists are always on display (when we were last there they were displaying art by Prieto, Magdalena Abrakanowicz, Tal R., and Gavin Turk). Most of the art is easily visible to the passer-by. And just outside the 53rd Street entrance are five cement slabs; these large, impressive, quite stunning segments were part of the Berlin Wall, filled with painted graffiti by two German artists.

Next we turn to Park Avenue, where at 54th Street you'll want to stop at **Lever House** ⓫. Here, both the well-tended garden and the spacious lobby feature art. As of our last viewing, they were exhibiting a large and wonderful collection of sculpture by **Isamu Noguchi**, set elegantly among the plantings outdoors and the well-lit spaces within.

A walk-through arcade between 52nd and 53rd streets will bring you to the dazzling **Park Avenue Plaza** ⓬. This somewhat stark,

green marble atrium is a good place for sitting. (There are tables and chairs at each end.) Its especially high ceiling gives it a feeling of great spaciousness, which is reduced to a more human scale by the various potted plants and flowers arranged diagonally. A waterfall—the inevitable ingredient in many modern interior gardens—adds interest to the high east wall, and ubiquitous ficus trees adorn each end. Next to the atrium, you can enjoy an arcade with several trendy shops and cafés. Park Avenue Plaza is open daily from 8 a.m. to 10 p.m.

The **Urban Center** ⓭ is at 457 Madison Avenue, between 50th and 51st streets. Occupying part of a wonderful courtyard, this center, run by the Municipal Art Society, has a nice two-room gallery open to the public. The subjects of their exhibitions range from art to architecture to public gardens, and they conduct a variety of excellent walking tours and other public events. ☎ 212-935-3960.

Walk back to Park Avenue to a sunken outdoor plaza in front of the **Rudin Management Building** ⓮ at 345 Park, between 51st and 52nd streets. This is a popular picnic spot for those who work in the neighborhood and the site of frequent lunch-hour concerts. (We once heard an excellent jazz group there.) The surroundings are pleasant and the people-watching first-rate on this busy street corner. Here, too, as in the case of so many new corporate building complexes, modern sculptures grace interior and exterior spaces. On one end of the plaza you'll find *Dinoceras,* a 12-foot-high bronze work by **Robert Cook**. This curious structure resembles the intertwining bones of a prehistoric animal (the *dinoceras* lived in North America during the Eocene period) and was modeled in beeswax, of all things! In the lobby of the building is an interesting rose marble work, by **Luis Sanguino**, depicting an amorous couple, not surprisingly called *Amor,* and a huge, jazzy wall tapestry woven in France, called *After Punch Card Flutter #3,* by **Stuart Davis**.

At Park Avenue and 50th Street you'll find **St. Bartholomew's Church** ⓯, affectionately known as "St. Bart's" in the community. This charming Romanesque-style church is virtually dwarfed by its towering neighbors and contrasts sharply with its surroundings. Note its graceful curved lines and ornate carved portico (sculpted by **Daniel Chester French** and **Philip Martiny** and modeled after a church in the south of France). Its delightful enclosed garden is reminiscent of those found in English country parson-

ages and provides a welcome respite in this urban setting. Within the garden is a bronze sculpture, *The Four Generations,* by the Mexican sculptor **Francisco Zuniga**, now depicting three barefoot Mexican peasant women (a fourth was stolen some years ago). There was a time when the future of St. Bartholomew's was in jeopardy, as some of New York's most aggressive real-estate developers had their eye on this prime site. Conservationists and the community rallied, and, with its future more secure, the church seems to hold its own in this unlikely spot.

On the northwest corner of Park Avenue and 47th Street (outside the **Morgan Chase Building**) note a bronze figure of a man hailing a cab at the front entrance ⑯. This amusingly realistic sculpture, called *Taxi!* (1983) and by **Seward Johnson Jr.**, blends in with the people rushing in and out of the building and might be passed unobserved.

And at Park Avenue between 46th and 47th streets, in front of 245 Park Avenue, you'll see a giant, contemporary, black fiberglass sculpture in the shape of interlocking serpentine forms (or doughnut-shaped parts, depending on your point of view). Entitled *Performance Machine, Big O's* ⑰, it was created by **Lowell Jones** in 1985 and very much embodies the twentieth century's fascination and love affair with machinery. This unusual kinetic sculpture, operated by solar energy, takes four hours to complete one rotation, which means that unless you have time and patience you won't notice its movement.

From here it's a short hop to our next stop, **Park Avenue Atrium** ⑱, which can be entered at 237 Lexington Avenue or at 45th or 46th Street (the building has three official addresses). This modern New York atrium is big, splashy, and jazzy, from its lighted see-through elevators that rush you up and down at top speed, to the tiers of greenery festooned over aluminum balconies on each floor. A huge suspended contemporary sculpture, *Winged Gamma* (1981) by **Richard Lippold**, extends over several stories, dominating the scene. Its long steel rays complement the stark, modern décor and add interest to the futuristic interior. Unfortunately, the seating area is not especially inviting, for you are offered only uncomfortable granite benches set among the usual ficus tress in large tubs. But the overall scene and the flurry of people coming and going are fascinating to watch. The Park Avenue Atrium is open from 8 a.m. to 6 p.m. Monday–Friday.

Walk north on Lexington Avenue to 53rd Street. At 599 Lexington Avenue, a large, typical **Frank Stella** work is the center of attraction. Entitled *Salta Nel Mio Sacco* ⑲, it consists of jagged cutout painted forms in brilliant colors.

Just north is another modern New York landmark, the Citicorp Building, with its contemporary church, **St. Peter's Lutheran Church** ⑳. This light-filled, glass space houses an impressive **Louise Nevelson** construction in its Erol Beker Chapel of the Good Shepherd.

From here walk east to Third Avenue and 55th Street, where you can visit a lobby at 900 Third Avenue. Here you'll find a large **Richard Lippold** sculpture ㉑.

Greenacre Park ㉒ on 51st Street, between Second and Third avenues, is an intimate Japanese-style urban garden, a tranquil respite from the city's noise and confusion. The gentle sounds you hear are those of a rushing brook, a fountain cascading over an abstract granite sculpture, and a graceful 25-foot waterfall. Even though this park is tiny—60 feet by 100 feet—it creates the impression of spaciousness. The plantings are well tended yet naturalistic and understated (in the Japanese manner) and, unless you arrive during lunchtime, you will not find this park crowded. Here you can sit amid the greenery and contemplate, read, or have a snack (as many do) before continuing your walk. There are tables and chairs on the main level, a raised platform in the shade, and discreet lights for night-time use.

From Greenacre Park walk back to Third Avenue and then south to 50th Street. The **Crystal Pavilion** ㉓, at 805 Third Avenue, is another world from the quiet oasis you've just left, for this is a bustling, glittering rendezvous spot with shops, galleries, cafés, and small restaurants, as well as places just to sit and rest. The setting is aggressively contemporary and glitzy, with its massive three-level shiny stainless-steel columns, neon lights, glass elevators, and granite. It's an impressive space, one that shows the fascination of many modern architects for volume and light. Its waterfall, sunny alcove, and plants (in large commercial pots) tend to soften its somewhat hard-boiled look and make the décor less forbidding. The Crystal Pavilion is open Monday–Saturday, 7:30 a.m. to 11 p.m.

Walk down to 777 Third Avenue, between 48th and 49th streets. Here, a graceful, swirling, 15-foot-high stainless-steel sculpture

adds interest to the otherwise anonymous contemporary building it adorns. Entitled *Contrappunto* ㉔, this light, airy work by **Beverly Pepper** consists of two separate parts: the upper portion, rotated by a motor, suspends from the actual building and reacts to the stationary lower portion, forming a sort of sculptural counterpoint.

Walk south on Third Avenue to 711 Third Avenue, between 45th and 46th streets. The lobby is decorated by a large wraparound 1956 **Hans Hoffmann** mosaic ㉕, in his customary, brilliant primary colors and geometric abstract shapes.

. . . And in Addition

☞ On 53rd Street and Park Avenue you'll find the **Seagram Building**, designed by **Philip Johnson** and **Mies van der Rohe** in the 1950s. Inside is the fabled **Four Seasons** restaurant (see p. 238). If you phone the manager in advance, you can arrange to see the art collection located within the restaurant. Included are two tapestries by **Miró** and—as of this writing—**Picasso**'s impressive *Le Tricorne,* a tapestry once used as a ballet stage set. ☎ 212-754-9469.

☞ **Pierpont Morgan Library**, 29 East 36th Street: The former library of J. P. Morgan houses a fabulous collection of rare books, manuscripts, drawings, and priceless illuminations. Periodic exhibitions of medieval and Renaissance works are open to the public. Don't miss the elegant café, a real oasis in its own right. ☎ 212-685-0008.

11

Midtown Oases

Atria and Outdoor Art: West Side

HOW TO GET THERE
Subway: E or V train to Fifth Avenue and 53rd Street.

You might begin the second half—the West Side section—of the midtown walk by strolling south on New York's favorite thoroughfare, Fifth Avenue, beginning at 53rd Street. Two distinguished churches are in this immediate area, as are a number of other art sites.

St. Thomas Church ❶, at the corner of Fifth Avenue and 53rd Street, has a lovely cathedral-like interior dominated by **Lee Lawrie**'s elaborate carved stone figures behind the altar, and it has brilliant stained-glass windows.

Just south of the church, at 666 Fifth Avenue in a passageway between 52nd and 53rd streets, you will want to see **Isamu Noguchi**'s *Ceiling and Waterfall* (1955–57) ❷. Here, in a dark walk-through is an aluminum and stainless steel merging of light, sound, and water (all familiar themes in Noguchi's mature work). This piece consists of a series of standing forms that resemble wave shapes, not unlike the raked Japanese gardens turned vertically. Ingenious lighting and the gently curved ceiling panels give the entire passage a faintly otherworldly quality, while the sounds of the trickling waterfall mask the honking horns outside.

Walk one block south to 51st Street and cross Fifth Avenue to another corporate headquarters: **Olympic Towers ❸**. This building includes an arcade between 51st and 52nd streets. (You'll find benches and chairs for resting here.) In the center of the arcade there is a high dome where skylights brighten a two-story waterfall that flows into a square pool below. You can eat here at a small café-bar and listen to piano music (competing with the rushing water for your attention). The arcade is open from 7 a.m.

WEST OF FIFTH,
MIDTOWN

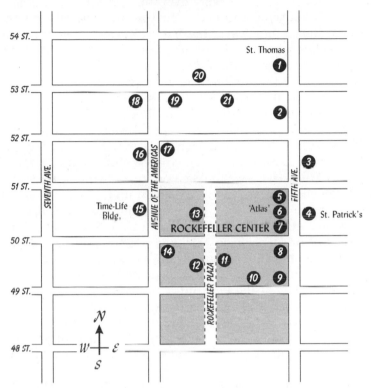

to midnight daily, but don't go on Sunday nights when the waterfall is shut down.

Don't miss the staircase, which leads to a brand-new addition to New York's cultural life: the **Onassis Center**, a small museum just below the lobby. Here, changing exhibits of ancient, Byzantine, modern, and contemporary Greek art are shown (and there are many cultural events dealing with Greek civilization). Exhibits change twice a year; recent shows included a preview of the new Acropolis Museum in Athens and Cycladic sculpture. Hours: Monday–Saturday, 10–6; admission is free. ☎ 212-486-4448.

Your next stop is **St. Patrick's Cathedral** ❹, one of New York's notable landmark buildings. Designed by **Joseph Renwick** and constructed between 1858 and 1910, it is the largest cathedral in the United States, seating twenty-five hundred people. It is in the French Gothic style, with a beautiful rose window, tall and thin interior columns, and twin spires that rise 330 feet. Note the seventy stained-glass windows, the bronze front doors, and the graceful white marble figure of the Virgin Mary.

Cross Fifth Avenue to find yourself in New York's most famous urban oasis of all: **Rockefeller Center**. Depending on how much time you have, you might prefer to devote more than just a few moments of a long walk to this special spot. Here you can ice-skate in season, eat, take a tour, walk though the underground passageways (filled with shops), visit the NBC studios, attend Radio City Music Hall—we could go on and on with the things to do at Rockefeller Center. If, however, you want to keep your eye only on the theme of this walk, note the major sculptures that ornament (and are indeed an integral part of the design of) this masterpiece of urban planning. Walking south on Fifth Avenue you'll come first to 636 Fifth Avenue, where a large glass bas-relief decorates the front of the entrance. Called *Youth Leading Industry* ❺, it was designed by **Attilio Piccirilli** in about 1936. The design, showing a young male guiding a charioteer that symbolizes commerce and industry, is in the idealistic and dramatic 1930s style that pervades much of Rockefeller Center's art. It is made of glass block (then a recent development), which can be illuminated from behind.

At the entrance to 630 Fifth Avenue, you'll find one of the city's most famous statues: **Lee Lawrie**'s 15-foot-high bronze statue of Atlas ❻. Made in 1937, the giant, muscular figure holding a globe symbolizes the spirit of enthusiasm and promise of the Rockefeller complex when it was built in the 1930s. The statue, which is the equivalent of four stories of the building behind it, fills the entrance court and harmonizes with the architecture around it.

Continuing south, at 626 Fifth, you'll find another bronze work. This one is a bas-relief made by the late **Giacomo Manzù**, which pictures *The Italian Immigrant and Italia* ❼. It was completed in about 1965 to decorate the entrance to Palazzo d'Italia. Manzù's sculpture depicts a sheaf of wheat and grapevines and, below, a barefoot mother and child, arrived at last in America.

Cross 50th Street to the next building of the Rockefeller Center complex, number 620. Here you'll see the gilded bronze relief called *Industries of the British Commonwealth* ⑧, an over-door panel decoration by **Paul Jennewein**. Its companion piece is an over-door panel on the corner of 49th Street, *The Friendship of France and the United States* ⑨ by **Alfred Janniot**; you'll find it over the entrance of **La Librairie Française** at 610 Fifth.

But in between these ornate decorations you'll enjoy visiting New York's favorite garden: the **Channel Gardens** of Rockefeller Center ⑩. Here, in an inviting walkway to the skating rink and other seasonal pleasures, are the ever-changing flower arrangements and topiary specialties that draw over fifty million visitors a year. In the center of the plantings are six statues; these fountain-head figures were made about 1935 by **René Paul Chambellan**, who made many other works for Rockefeller Center. Here the Nereids, riding the backs of dolphins, and the Tritons are part of a series of fountains and mirrored pools that are charming to look at; and they symbolize such admirable qualities as Thought, Imagination, Will, Energy, Alertness, and Leadership. Plantings around the statues are so carefully maintained that the Channel Gardens are often thought to be exceptional examples of the combination of art, nature, and urban planning.

Now, as you leave Fifth Avenue to walk west, take a look at the skating-rink restaurant from its high overlooking walls. Before you reach Rockefeller Plaza, a small interior street that divides the block between Fifth and Sixth (Avenue of the Americas), note another famous Rockefeller Center statue, *Prometheus* (1934) by **Paul Manship** ⑪. The golden bronze figure sits picturesquely in front of a splashing low fountain and a colorful collection of flags; its half-reclining form rests on a granite mountain like pedestal, symbolizing earth, and within a large ring decorated with zodiac signs, representing heaven. Prometheus holds aloft a flame as he flies; his suspension, the splashing fountain, and the flags waving in the wind seem to fill this urban spot with electrifying motion. Across Rockefeller Plaza is another **Lee Lawrie** artwork: over the doorway of 30 Rockefeller Plaza is a vast 1933 panel of molded glass, called *Wisdom with Light and Sound* ⑫. Made of some 240 glass blocks, it floods the lobby with light and decorates the street side with its ingenious design. The huge figure of Wisdom (above) traces—without the aid of a compass—the cycles of

Light and Sound (below). Don't miss this example of 1930s design and ethos.

Inside the building, on the west wall, you'll find **José Maria Sert**'s 1937 "American Progress" mural called *Triumph of Man's Accomplishment through Physical and Mental Labor.* Just to the north on Rockefeller Plaza is our last major sculpture of the Center. Here, over number 50, is an interesting example of **Isamu Noguchi**'s early work. There are examples of his work in its abstract form in several of our walks, but here you'll find a 1940 piece, one of his last figurative sculptures. Called *News* ⑬, this stainless-steel work adorns the **Associated Press Building** (hence its subject) and was the winner of a competition held by the builders. It represents newsmen at their work; careful examination will disclose notepads, wirephoto and teletype machines, and cameras, but its overall impression is of curving, massive bodies and planes. The abstraction of these forms was soon to appear in Noguchi's later work.

Continue west to Sixth Avenue, where more of Rockefeller Center's art decorates the buildings and plazas. At 49th and Sixth (1250 Sixth Avenue) you'll enjoy the mosaics on the outside of the entrance ⑭. Representing Poverty, the Arts, Fear, Thought, and Hygiene (a truly American collection!), these mosaics were made in 1933 by **Barry Faulkner**. Their bright colors are still gleaming.

Walk north to 50th Street and cross Sixth Avenue to the **Time-Life Building** ⑮, noted for its plain but spacious outdoor plaza. It features fountains and low walls for sunning, and has long been a favorite of lunchers and sun worshipers. In the plaza a large blue contemporary sculpture ornaments the space. *Curved Cube* (1972), by **William Crovello**, looks like a three-dimensional symbol, a letter or number from some obscure alphabet. It is said to have been inspired by classical Japanese calligraphy—in fact, the artist did study in Japan for some years. *Curved Cube* was one of six large sculptures placed around the city by the Association for a Better New York. Inside the lobby is a painting called *Broadway Rhythms,* by **Fritz Glarner**, in the abstract geometric style that grew out of Piet Mondrian's interest in angular spatial patterns. The painting is filled with pulsating small squares that suggest the dynamic motion of the city center.

From here it is a short hop to the impressive **UBS–Paine Webber Building** ⑯, at 1285 Sixth Avenue. This spacious, airy building

houses the **Paine Webber Gallery**, which offers changing exhibits of art—usually with a particular theme.

Across the street, at 1290 Sixth Avenue, is the **AXA Financial Center** ⑰, whose lobby features two of the famous **Thomas Hart Benton** murals called *America Today* (1930). The ten individually named panels are painted in tempera on linen. They represent, in a figurative idiom, the social and economic life of the nation as observed by Benton on his many travels cross-country during the 1920s. Here are lively and bold interpretations of urban life, workers, and industrial scenes. While most panels depict American life in optimistic and exuberant terms, one of its most effective, *Outreaching Hands,* is especially poignant in its portrayal of a poorhouse and breadlines during the Depression. Originally commissioned by the New School for Social Research in 1930, this early Works Progress Administration (WPA) piece was restored during the mid-1980s.

Cross Sixth Avenue and walk north. Between 52nd and 53rd streets you'll find one of the city's favorite additions to its outdoor art: a brand-new group of three works by **Jim Dine** called *Looking toward the Avenue* ⑱. These large figures are grouped (two together at 52nd and one at 53rd Street); they are all variations on the Venus de Milo theme. Dine, one of the first Pop artists, has here returned to a theme that interested him in the 1970s. The statues are a definite asset to the bland building behind them. Made of green bronze, they are 14, 18, and 23 feet high. (It may amuse you to know that the figures have caused a great many complaints by passers-by, who find the statues objectionable.) We think you will enjoy these modern versions of an antique theme.

Cross Sixth Avenue again at 52nd Street and walk a short way east on 52nd, toward Fifth Avenue. Your eye will soon be caught by a most unusual plaza on the north side of 52nd and opening through the block to 53rd. This is an interesting combination of art, architecture, and plantings forming the **E. F. Hutton Plaza** of the **Deutsche Bank Building** ⑲. Built in an unusual Aztec/Egyptian temple–postmodern style, the columns and arches are of a pinkish granite, surrounded with benches and a centerpiece sculpture, called *Lapstrake,* by native Texan **Jesus Bautista Moroles**. Made in 1987, this striking piece of art is also rather primitive in style; it is a vertical mass of alternating slabs of

granite, some rough, some smooth, suggesting primitive ruins in some distant place. It rises like an ancient column among the pathways and potted plantings of this very interesting public space. Inside the building you'll find the Lobby Gallery, an elegant exhibition space that presents a new show every six weeks.

Walk through the Deutsche Bank to 53rd Street, turn right, and you'll find the new location of the **American Folk Art Museum** ㉓, at 45 West 53rd Street. A visit here will delight anyone who enjoys the ingenious natural charm of folk art. This is a brand-new architectural jewel housing an inimitable collection of folk art on its four intimate floors. There are changing exhibitions ranging from Art Brut to Amish frakturs to duck decoys. The museum is open Tuesday–Sunday, 10–6; and Friday, 10–8. There is an admission fee. ☎ 212-265-1040.

Just across the street and a few steps away is the **Museum of Arts and Design**, formerly the American Craft Museum ㉑. This museum will challenge many a person's idea of the nature of "crafts." Its elegant, sophisticated, and quite new exhibition space displays traditional as well as contemporary crafts in an innovative fashion. You'll find works in a variety of styles, historic periods, and media—including clay, metal, glass, fiber, and wood; on a given day you might chance upon an exhibit of antique quilts or bold glassworks. A recent show featured the amazing basketlike sculptures of fiber artist **John McQueen**. The museum also has a permanent collection that focuses on post–World War II crafts. A full agenda of educational programs, lectures, and special events is available to the public. The Museum of Arts and Design is open Tuesday, 10–8; and Wednesday–Sunday, 10–5. There is an entrance fee. ☎ 212-956-3535.

And, of course, the major museum on this block is the **Museum of Modern Art**. As we go to press, it is scheduled to reopen in its glamorously renovated Manhattan location in the fall of 2004. There will be two main entrances—on 53rd and 54th Streets.

The redesigned museum will nearly double its size, with a spectacular outdoor sculpture garden twenty times larger than its predecessor. Interior features will include the original Bauhaus staircase designed in 1939 by **Philip L. Goodwin** and **Edward Durrell Stone**, and a 110-foot-tall atrium with dramatic views of the city. And, of particular interest to art lovers, numerous works that

had been languishing in storage will finally be on view. Don't miss visiting this most extraordinary art site in Manhattan. ☎ 212-307-6420.

. . . And in Addition

☞ On the northeast corner of 46th Street and Seventh Avenue is the **I. Miller Building**, where **Alexander Stirling Calder** figures grace the outside of the building. Among them are images of Mary Pickford as Little Lord Fauntleroy, Rosa Ponseille as Norma, and Ethel Barrymore as Ophelia.

☞ **International Center for Photography** (ICP), 1133 Avenue of the Americas: changing photographic exhibits. ☎ 212-857-0000.

☞ At the **Plaza Hotel**, 59th Street entrance, off Fifth Avenue, ask to see the **Paul Gauguin** flower painting in an office to the right of the door.

☞ The **Edison Hotel**, at 225 West 47th Street, has bright faux–Art Deco murals of New York by **Kenneth Gore**.

☞ **Bendels**, at 714 Fifth Avenue and 56th Street, has four incised white-on-white **Lalique** windows on the second floor. They date to 1912.

☞ **Steinway Hall**, 109 West 57th Street: Here in opulent, old-world splendor, amid dozens of shiny grand pianos, is the Steinway art collection, featuring massive rhetorical paintings of an era long past. All with musical subjects, they include works, by illustrators **Rockwell Kent** and **N. C. Wyeth** and numerous other artists, bearing titles such as *Beethoven in Nature*, *Das Rheingold*, *Tristan und Isolde*, and an unforgettable Schubertian *Erl King*. ☎ 212-246-1100.

☞ At 745 Fifth Avenue between 57th and 58th streets visit a 1930s building midblock. Here you'll find an unusual painted lobby ceiling from the Art Deco era. It is the work of **Arthur Covey**, who made a brightly colored, mosaic-style, semi-abstract picture of Manhattan Island filled with bridges, street scenes, skyscrapers, and rushing trains.

☞ **Trump Plaza**, between 56th and 57th streets on Fifth Avenue: Some people consider this fairly new addition to the New York scene to be an example of unbridled glitz—tacky, overdone, and symptomatic of conspicuous consumption. On the other

hand, you won't want to miss this controversial site, a curious blend of beauty and excess. Here the glamorous salmon-pink marble walls are so warm in tone and spectacular in texture that they almost overwhelm you. The centerpieces of this lobby are its fancy escalators and multistoried waterfall (80 feet high). Its rushing noise, the frequent musical entertainment (live pop), and the hundreds of gawking tourists make this a very noisy place indeed.

☞ The **Gallery at Takashimaya**, at 693 Fifth Avenue between 54th and 55th streets, designed by **Kevin Roche**, shows the finest in contemporary Japanese crafts.

☞ A familiar image called *LOVE* by **Robert Indiana** is on the corner of 55th Street and Avenue of the Americas.

☞ 1211 Sixth Avenue at 48th Street has a lobby with a mural by **Bob Natkin**.

12

Art in the Lincoln Center Area

Music for the Eyes

HOW TO GET THERE
Subway: 1 or 9 train to 66th Street and Broadway.

No art tour of New York can claim to be complete without a visit to the famed Lincoln Center, on the Upper West Side of Manhattan. This magnificent cultural center celebrates not only the performing arts—music, theater, and dance—but the visual arts, too. For within the few blocks of modern buildings and connecting expansive plazas that make up the Lincoln Center complex, you will find—both inside and out—a surprising number of art treasures, from the splendid Chagall murals that can be admired through the arched glass façade of the Metropolitan Opera House (as well as from up close) to dramatic sculptures, constructions, and mobiles in plazas and interior lobbies. Although most of the works are contemporary in style—in keeping with the modern architecture of such masters as **Philip Johnson** and **Eero Saarinen**—some are more traditional, such as the statue of Dante Alighieri located in the small park in front of Lincoln Center.

And this profusion of art doesn't stop at Lincoln Center. Literally next door, at Fordham University's Columbus Avenue campus, you'll find a variety of outdoor sculptures that can be enjoyed by any passer-by. Finally, to end your walk, we'll take you one block south to the Church of St. Paul the Apostle for a change of pace, where you can admire the lovely LaFarge stained-glass windows, and to the gallery at the American Bible Society.

While you can see the outdoor sculpture in this artwalk at any time, you'll have to do a bit more planning to see the interior art. Your options are to take a guided tour (Lincoln Center sponsors them daily, 10–5; ☎ 212-870-5350 for information) or to attend a performance of the ballet, opera, or philharmonic, where you will

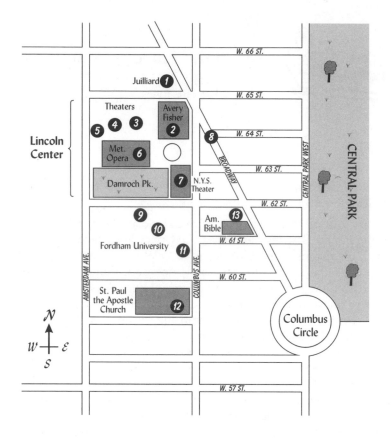

have the time during intermission (or before and after the performance) to go from one art piece to the next. You'll be walking only about five blocks—from 65th Street and Broadway to 60th—but in those concentrated blocks there is a great deal to see, so allow plenty of time.

Begin your walk at the **Juilliard School** ❶, at Broadway and 65th Street. Outside the building and facing Broadway stands *Three Times Three Interplay* (1971), a 32-foot-high stainless-steel sculpture by **Yaacov Agam**. The three tall zigzag columns of this kinetic work are movable, "a constant becoming," rather than a set statement—perhaps appropriate in front of a school.

Cross 65th Street and walk one block south on Columbus until you come to the dramatic main plaza of **Lincoln Center**, domi-

nated by the three largest halls of the complex: the Metropolitan Opera House in front of you, Avery Fisher Hall on your right, and the New York State Theater on your left. In the center of the vast space is a fountain by **Philip Johnson**, where, on a warm day or evening, you might well see crowds of New Yorkers sitting casually on the edge of the fountain wall and enjoying the passing scene.

Avery Fisher Hall ②, built in 1962, contains a number of impressive sculptures. Looking in through the huge windows from the outside, you can already catch a glimpse of **Richard Lippold**'s giant hanging mobile, *Orpheus and Apollo,* which stretches across the entire main foyer. This decorative work is made of 190 strips of shiny metal suspended from the ceiling by steel wires. Apparently (according to a knowledgeable security guard), the sculpture will move slightly in air currents, which adds to its shimmering presence. As you enter the building, you'll find two main works in the entrance foyer, both large bronze sculptures. Tucked away on the left is an abstract piece that **Dimitri Hadzi** called *K.458—The Hunt,* inspired by a Mozart string quartet; on the right, behind a small café is **Seymour Lipton**'s *Archangel* (1964), also an interesting abstract composition. On the grand Promenade level are **Antoine Bourdelle**'s *Tragic Mask of Beethoven* (also in bronze) and **Auguste Rodin**'s head of Gustav Mahler (1901).

Walk toward the **Vivian Beaumont Theater**, just behind Avery Fisher Hall, where you'll see the stunning *Lincoln Center Reclining Figure* ❸, by **Henry Moore**. This massive bronze piece sits in splendor in a large reflecting pool, which is, unfortunately, kept empty most of the time because of a leak. Henry Moore hoped this work would create a welcome contrast to the stark geometric architecture in the background. The rough texture and strong lines are reminiscent of primitive pre-Columbian figures, like many other reclining figures by Moore. You can sit here and enjoy the work in a tranquil atmosphere. Inside the front lobby of the Beaumont, by the way, is **David Smith**'s *Zig IV* (1961), an abstract bronze work that can also be seen from the outside through the large windows, if you cannot enter the lobby.

Near the entrance to the New York Public Library at Lincoln Center and adjacent to the Beaumont is a wonderful **Alexander Calder** work made in 1965. Called *Le Guichet* ❹, this 14-foot-high painted black steel stabile is like a giant tentacled creature branching out across the plaza. (Calder thought it was too large for this

space and had not intended for it to be placed here.) Its name means "ticket window" in French, appropriate enough in an area of performing arts. Enter the **Library for the Performing Arts** ❺ and take the elevator to the lowest floor. Here you'll find a series of exhibits relating to music, musicians, productions, and artistic subjects.

Return to the street-level plaza and walk to the **Metropolitan Opera House** ❻, the centerpiece of Lincoln Center. This impressive building of travertine arches and columns is the best known part of Lincoln Center. It is particularly dramatic when lit up at night, and the two striking **Marc Chagall** murals impose themselves even more boldly on the façade of the building. (Note that on sunny mornings the murals are covered with curtains to protect them from excessive light, and thus you will not be able to see them.) If you choose to attend a performance or take a tour, you will have the opportunity to enter the building for a better view of the Chagall works. You can walk up the sweeping staircase to the mezzanine level. On the south wall is *Le Triomphe de la Musique,* a predominantly red mural depicting thirteen different themes in typical Chagall fashion: many figures (singers, ballerinas, musicians) are seen moving, flying overhead, and celebrating the joys of music amid scenes from opera, jazz, and folk music. Chagall himself and his wife appear, as does former Metropolitan Opera manager Rudolph Bing, playfully (and somewhat incongruously) dressed in gypsy garb. The other mural, on the north wall, *Les Sources de la Musique,* is predominantly in yellow tones. Here—if you know your composers—you'll recognize Beethoven, Bach, Wagner, and Verdi, as well as such personages as Orpheus and King David. Several operas are depicted, and the tree of life is seen floating down the river. These masterpieces are mesmerizing and always fresh; and even if you've seen them many times, you can discover new things in them at each viewing. Among other works to note within the grand opera house are three by the great French sculptor **Aristide Maillol**: two figures, *Summer* (1910) and *Venus without Arms* (1920), on the Grand Tier; and one on the level above, *Kneeling Woman: Monument to Debussy* (1931). And you should not miss the amusing gallery on the ground floor (below the main foyer), where you'll see paintings of opera composers and the most famous opera stars who have sung at the Met. If you're an opera buff, you'll recognize such famous singers as Enrico Caruso,

Chaliapin, Maria Callas, and Lily Pons, all in costumes and in appropriate dramatic poses.

There are many interesting artworks to see in the last of the three main Lincoln Center buildings, the **New York State Theater** ❼. You can view the following by attending a performance or by taking a tour. One of the first works to see (on the right as you walk in) is **Lee Bontecou**'s *Untitled Relief* (1964), a canvaslike wall construction reminiscent of Native American designs. On the left side is a gray painting by **Jasper Johns**, appropriately called *Numbers* (1964), as a series of digits appear in various configurations. On both the left and right staircases are companion pieces by **Kobashi**—*Dance* on the left and *Ancient Song* on the right. These abstract wall pieces are made of gold leaf on fiberglass. **Reuben Nakian**'s *Leda and the Swan*, **Jacques Lipchitz**'s *Birth of the Muses* (1949), and **Francesco Somaini**'s *Grande Sartirion Sanquinante*—all bronze abstractions— are scattered about on the orchestra level. One floor up, on the promenade level, are a pair of massive sculptures dominating either end of the hall. Both by **Elie Nadelman**, *Two Nudes* (1930) and *Two Circus Women* (1931) are made of chalk-like white Carrara marble and have become well-known landmarks of New York's sculpture scene.

Now you've seen the major works in the Lincoln Center complex. But our artwalk is definitely not finished. If you walk to the small triangular park at the intersection of Broadway and Columbus (at 63rd Street), you'll find **Dante Park** ❽ and, not surprisingly, Dante Alighieri himself on a tall granite pedestal overlooking—perhaps disdainfully—the modern world. Created by **Ettore Ximenes** in 1921, this work was a commemoration of the six hundredth anniversary of the poet's death, although it's not clear why it was placed in this particular spot. Dante is depicted with a laurel wreath, a stern and strong expression, and a copy of the *Divine Comedy* in hand. In the same triangle is a more modern limestone work by **Mark Rabinowitz** called *Pygmalion's Dilemma*.

From here it's a very short walk to the Lincoln Center campus of **Fordham University**, which occupies the two blocks between 62nd and 63rd streets and Columbus and Amsterdam avenues. Two large buildings form this complex, with a newly landscaped plaza between them. To the west of the **Leon Lowenstein Center** ❾, at 62nd Street, is a gangly 28-foot-high bronze statue of St. Peter, called *Peter, the Fisherman* (1965), by **Frederick Shrady** ❿.

This emaciated, almost Giacometti-like figure dramatically casts a 14-foot net over a fountain pool. The sculptor felt that this symbolism could also represent the function of the university as an agent of influence in the community, "casting its lines of influence, knowledge, and concern over the metropolis."

Walk up the steps to the refurbished plaza between Lowenstein and Fordham Law School and gardens ⓫. This 2.2-acre space has lately become an inviting location for sculpture. Actually a roof-garden over the library and computer center, it includes contemporary artworks, a mini-amphitheater, and wisteria arbors. Fordham has another area of well-kept gardens and sculpture. Walk back down the steps out onto Columbus Avenue and then south. On this busy block—where pedestrians rush by, perhaps unaware of the artworks they are passing—you'll walk past a surprising number of contemporary sculptures, all set within the enclosed Fordham Garden amid well-maintained lawns and shrubs—quite a contrast to the plaza above. The sculptures are all well marked and can be easily identified and seen from the sidewalk. *Circle World #2* (1969) by **Masami Kodama** is reminiscent of work by Noguchi in its simplicity of line and use of material. Made of pink and black granite, the geometric sculpture consists of two halves of a circle that, significantly, do not meet. *City Spirit* (1978) by **Lila Katzen** is a large stainless-steel work that, with its fluid curls and loops, represents the "interlocking of all the elements of the city"—a noble theme in front of an institution of learning. Other sculptures include *Peace* (1985) by **Leonardo Nieman**, which reminded us of a huge bronze flame; *Moses* by **Larry Mohr**, another geometric bronze abstraction; and *Simple Justice* by **Vivienne Thaul Wechter**, a mainly stainless-steel and brass tripodlike form with a circle on top. The only figurative work is *Mother Playing* (1961) by **Chaim Gross**. This bronze statue depicts a reclining mother with her small daughter precariously perched on her knees in a sort of balancing act. Gross was intrigued by figures in action, such as acrobats and dancers, as well as the mother-daughter theme.

At the end of the block, on Columbus and 60th, is the imposing **Church of St. Paul the Apostle** ⓬. The massive basilica, Late Gothic in style, was built in 1885 by the architect **James O'Rourke** and has recently undergone a wonderful restoration. The talents and energies of some of the eminent artists and architects of the

day were used, such as **John LaFarge**, **Augustus Saint-Gaudens**, and **Stanford White**. Their legacies are still in evidence today, and the church is full of wonderful surprises. As you walk in, notice the unusual mosaic-like pattern on the floor at the entrance. Made of different types and colors of marble, it represents the buildings of the Acropolis, which the Apostle Paul saw before him from the Hill of Mars. The ceiling, a deep blue, is an artistic interpretation of the constellation on the very day the church was dedicated. (It was re-searched methodically and precisely by the Paulist Father George M. Searle, who was also a competent astronomer.) As you walk around the church you'll see several murals—some unfortunately very dark—including the one that is high on the south wall of the sanctuary. Called *The Angel of the Moon,* it is by **John LaFarge**, who also designed the columns and the narthex. The altar at the far end of the south side is by **Philip Martiny**. But the stained-glass win-dows are especially worthy of your attention. The blue windows on the end behind the altar, by LaFarge, are remarkable in their brightness and luminosity. And one of our favorites is another La-Farge creation, the great East Window over the main entrance. We recommend you pick up the small free pamphlet guide inside the bookshop at the entrance, which will point out every art piece in the church, since nothing is marked on site.

At 1865 Broadway and 61st Street (one block north and one block east) is the **American Bible Society Gallery** ❸. This upstairs gallery hosts very interesting exhibits. A recent show on the mak-ing of contemporary stained glass was particularly outstanding. Admission is free and the setting is bright and inviting. Hours: Monday, Wednesday, Friday, 10–4; Thursday, 10–7; Saturday, 10–5. Tours are also available. ☎ 212 408 1500.

. . . And in Addition

☞ The *Eleanor Roosevelt Monument* on the corner of Riverside Drive and 72nd Street, by **Penelope Jencks**, is one of the few statues of notable women in the city.

☞ Just beyond Lincoln Center at 66th Street and Amsterdam Av-enue you'll find the *Sculpture Memorial to Martin Luther King Jr.* (1973), by **William Tarr**. This massive cube resembling a giant printer's block bears numbers and letters relating to King's life.

13

Americana

Historic Houses, Gardens, and Collections around the City

New York is such a changing and up-to-date city that it is easy to forget that some corners here and there have been preserved from earlier times. Recent aggressive landmarking of buildings and entire neighborhoods is helping in the effort to protect some of the city's architectural past. And there are many worthwhile collections, historic houses, and even reconstructed old-fashioned gardens that will give you a taste of the old days in the city. Although you can't walk quickly from one of these spots to the next, each is well worth visiting for a composite portrait of pre-twentieth-century New York. If you're a history buff and enjoy Colonial and Federal period art and artifacts or the creations of America's folk artists, be sure to visit the sites specializing in Americana and New York's history that are listed in the pages that follow. (There are many other historic houses in the five boroughs, but we have chosen these as among the most interesting to garden and fine-art enthusiasts.)

Museum of the City of New York

HOW TO GET THERE

Subway: 6 train to 103rd Street and Lexington Avenue; walk three blocks west.

For an overview of the city's history (through art, costumes, and numerous other objects of interest), you may first want to visit the wonderful **Museum of the City of New York** on Fifth Avenue at 103rd Street. Here you'll take a quick time-trip through the early days of Old Amsterdam, the Colonial period, the Federal era of the city's growing importance, midcentury's mores, and the gay nineties. Portraits, costumed figures, landscapes, and numerous

examples of art and artifacts make this a wonderfully appealing and attractive collection. (Children will love this museum, with its outstanding examples of toys, fire engines, and dollhouses.) In addition to its permanent collection, the museum features a variety of shows relating to the city's early life. The museum is open Tuesday–Saturday, 10–5; and Sunday, 1–5. Admission is free. ☎ 212-534-1672 for current exhibitions.

Morris-Jumel Mansion

HOW TO GET THERE
Subway: C train to 163rd Street and Amsterdam Avenue; walk two blocks south on Amsterdam and turn left.

Your next detour—and not one to be missed by the Americana enthusiast and history buff—is the **Morris-Jumel Mansion**, at 160th Street and Edgecombe Avenue, in Upper Manhattan. The borough's oldest private dwelling (1765), it is its only surviving pre-Revolutionary house and an important New York landmark and museum. Once a grand mansion within 130 acres stretching from one river to the other, its territory has inevitably been reduced to a small park, surrounded by apartment houses, as well as a charming street of well-preserved historic townhouses. The lovely Colonial house (now in need of some exterior restoration) has undergone many incarnations through the years, the evidence of which can be seen inside. Originally the summer house of a British colonel (Roger Morris) and his American wife, in 1776 it became the temporary headquarters of George Washington, and then a popular tavern. In 1810 a wealthy French merchant named Stephen Jumel bought the house and, with the help of his ambitious and scandal-plagued wife Eliza, refurbished it. After Stephen's death, the eccentric Mme. Jumel married (very briefly) Aaron Burr. She remained in the house until her death (at age ninety-one). After more ups and downs (including a short time when the house became an exhibition space for the newly invented motion-picture process), the Morris-Jumel Mansion was transformed into a museum dedicated to America's past.

You'll enjoy wandering through the lovely old house, whose interior has been restored with care, including George Washington's headquarters. The rooms, halls, and Colonial kitchen include many original Jumel pieces—furniture and artifacts—wallpapers

(note especially the hand-painted Chinese wallpaper in the octago-
nal drawing room), paintings by **Alcide Ercole** of Eliza Jumel and
her grandchildren, as well as handsome portraits, in a bedroom, of
Washington and, in the dining room, of the hero of the Battle of
Bunker Hill, Colonel John Chester, shown with his wife. You can
take a group tour or go from room to room on your own.

The Morris-Jumel Mansion is open Wednesday–Sunday, 10–4.
Note that even during those times you may find the door locked
for security reasons; don't hesitate to knock to be admitted! There
is a small entrance fee. ☎ 212-923-8008.

Mount Vernon Hotel Museum and Garden
(formerly the Abigal Adams Smith House)

HOW TO GET THERE
Subway: F train to Lexington Avenue and 63rd Street.

Further downtown, also on the East Side, at 42 East 61st Street, is
the **Mount Vernon Hotel and Garden**. Here, in the somewhat
formal atmosphere of the "historic house" type of museum, you
can see one of the few surviving eighteenth-century buildings in
Manhattan. Abigail Adams Smith was a daughter of John Adams,
the second president. This house—which has had a typically
checkered career similar to the Jumel Mansion—was purchased by
the Colonial Dames of America in 1924 and resurrected as a his-
toric museum, after many years as a hotel, a gas company head-
quarters, and an antique shop.

Of particular interest, besides the handsome stone building and
its period furnishings, is the eighteenth-century garden (which sur-
rounds the house and can be walked through without entering the
front door). Planted in the characteristic eighteenth-century way,
this quaint garden is a charming example of America's most deco-
rative style. Influenced by the Dutch idea of patterned gardens
and surrounded by Colonial board fences, the flowering area is de-
lightful. We recommend a visit in springtime, when tulips, crocus,
and hyacinth, interspersed with patterns of brickwork and English
ivy, make this a bright and charming place to visit. (It is particu-
larly astonishing because it is in the middle of a nondescript block
of East Side Manhattan and invisible from the street.) A brick ter-
race with old-fashioned benches sits above the flower area. On this
level is an herb garden. There are trees and shrubs—many of the

flowering varieties, whose best blossoms can be seen in May—including orange, viburnum, and flowering quince. Under the trees you'll find a profusion of violets and other bright flowers. But all is orderly in the garden, as favored by early American (and European) gardeners. This place is a well-kept secret, even among natives of the city; despite the harsh environment of the city, it's also a well-kept garden. A garden map is available at the desk. There is a small admission charge to see the house; none for the garden. Hours: Tuesday–Sunday, 11–4 (Tuesday to 9 p.m. in summer). ☎ 212-838-6878.

Although folk arts and crafts were long neglected in the world of fine art, they are nowadays often described as the most truly indigenous of America's early art. In fact, early primitive art in the United States has become somewhat of a fashion in the collecting world. Art historians no longer regard these types of Americana as mere oddities, but as fine examples of a national art unhampered by European influences and academic styles. You'll find a museum devoted to this subject at 45 West 53rd Street. The **American Folk Art Museum** is one of the country's leading centers of research and exhibition of folk art. (See chapter 11 for more on this museum.) Included in the collection are examples dating from mid-eighteenth century to the present, encompassing everything from quilts to weather vanes, paintings to furniture, carved wooden sculpture to pottery and tinwork. Needless to say, you won't be able to view the museum's entire collection in one visit, but you should enjoy examples of its permanent collection and its exhibitions. Recent shows included Art Brut and Fraktur Treasures. Hours: 9–9 daily. ☎ 212-265-1040.

The museum's branch at 2 Lincoln Center on Columbus Avenue (between 65th and 66th streets) has shown painted saws by Jacob Kass and double-wedding-ring quilts. ☎ 212-595-9533.

New-York Historical Society

HOW TO GET THERE

Subway: B or C train to 81st Street/Museum of Natural History.

Your last stop of this New York/Americana odyssey is the **New-York Historical Society** at 170 Central Park West (between 76th and 77th streets). You will be fascinated by this very rich and comprehensive collection (more than two million works of art),

ranging from first-rate American paintings, furniture, and period rooms to antique silver, craftwares, early American toys, prints, and photographs. Here, in its newly renovated building, you will find 435 of **James Audubon**'s famous original illustrations for *Birds of America* (two are missing), as well as important American paintings by such masters as **Rembrandt Peale**, **Thomas Cole**, **John Durand**, **Gilbert Stuart**, and **Thomas Eakins**. There are four floors of exhibition space, which may be more than you can take in on one visit (especially after having already seen many things). But the museum is rarely crowded, and you can take your time as you wander from one gallery to the next. One of the most impressive exhibits is a veritable who's-who gallery of famous Americans, such as George Washington (painted by **Gilbert Stuart** and **Rembrandt Peale**), Thomas Jefferson (**Peale**), James Madison, James Monroe, John Quincy Adams, Andrew Jackson (**Asher Brown Durand**) as well as wonderful portraits by **John Singleton Copley**, **Ezra Ames**, and **Abraham Tuthill**. A landscape gallery features paintings by the Hudson River artists—many of these works have recently been restored—including pictures by **Durand**, **Samuel F. B. Morse**, and **Albert Bierstadt**. The New-York Historical Society organizes interesting changing exhibitions that, usually, deal with some aspect of New York history, although recently they have gone further afield, with such exhibitions as Paris 1889: American Artists at the Universal Exposition. The recent efforts to refurbish the museum have included arranging displays to focus more on New York's cultural and ethnic diversity: paintings depicting Africans Americans and Native Americans and a first translation of the Bible into a Native American dialect. Hours: Tuesday–Friday, 11–5; Saturday, 10–5; Sunday, 1–5. Suggested voluntary contribution. ☎ 212-873-3400.

. . . And in Addition

If these listings of Americana have intrigued you, perhaps the following suggestions will also be of interest:

☞ The **Bartow-Pell Mansion** in Pelham Bay Park in the Bronx has extensive formal gardens and a number of paintings worth seeing. The mansion, dating to 1842, is a stately midcentury house with a grand spiral staircase and period furnishings, a

fountain, and a carriage house and stable. The gardens have been carefully maintained by the International Garden Club since 1914. ☎ 718-885-1461.

☞ The **Van Cortland Mansion**, also in the Bronx (at Broadway and 242nd Street), is a stone house of Georgian design constructed in about 1748. It has a flower garden and an herb garden, as well as some paintings and period furnishings. Hours: Wednesday–Saturday, 10–4:30; Sunday, noon–4:30. ☎ 718-543-3344.

☞ **Gracie Mansion**, the mayor's residence, is also open in part to the public. The house, at 89th Street and East End Avenue, overlooking Hell's Gate—a stretch of water where the Harlem and East rivers meet—is a grand building dating to 1799, with a later addition. Of particular interest in the formally furnished historic home are the art and antiques, almost all of which were created by New York's own artists and craftspersons. Hours: By appointment, Monday–Thursday. ☎ 212-570-4751.

☞ The **Alice Austen House Museum and Park** on Staten Island is described in chapter 30. Hours: Thursday–Sunday, noon–5 (May–November). ☎ 718-816-4501.

☞ **Historic Richmond Town**, see chapter 30. ☎ 718-351-1611.

☞ The **Conference House**, also on Staten Island, at 7455 Hylan Boulevard, is wonderfully situated overlooking the harbor. A seventeenth-century stone manor house, it has some formal gardens (as well as a great rolling hillside down to the water) and a number of historic paintings. Hours: Wednesday–Sunday, 1–4. Closed January and February. ☎ 718-984 6046.

☞ The **Conservatory Garden** in Central Park is in nineteenth century style (see chapter 17).

☞ **Fraunces Tavern Museum**, 54 Pearl Street in Lower Manhattan: This continuously active tavern/restaurant and upstairs museum has been operating in the same building since the eighteenth century (see chapter 1). ☎ 212-968-1776.

☞ The **South Street Seaport Museum**, at 207 Front Street, presents a series of exhibitions devoted to New York's maritime history (see chapter 1). ☎ 212-748-8786.

14

New York's Magnificent Museum Mile and Museums Just Beyond

HOW TO GET THERE
Subway: 4, 5, or 6 train to 86th Street and Lexington Avenue; walk west to Fifth Avenue and south to 84th Street.
Bus: Fifth or Madison Avenue M1, 2, 3, or 4.

Needless to say, any New York art lover—or visitor to the city—won't want to miss the Museum Mile. Here on upper Fifth Avenue are some of the world's greatest museums, all within walking distance of one another. And though we doubt anyone would want to include so much art on one walk, the following is a listing of the offerings. (Don't forget that each of these museums has changing exhibitions in addition to its permanent collection.) Our suggestions on how best to enjoy this embarrassment of riches is to plan a single day or two at the Metropolitan (if you see all of it, you'll be covering a good mile indoors). Depending on your particular interests, you might want to spend longer at various collections listed here, but if you are a marathon museumgoer, you could conceivably take all of them in. You will have the pleasure of Central Park available to you all along your artwalk, both for tired feet and as a respite from looking at everything from medieval icons to modern photography.

Begin your artwalk at 81st Street and Fifth Avenue, where you'll find one of the world's most illustrious museums of art: the **Metropolitan** ❶. But before you enter, note an outdoor artistic addition to the museum at Fifth Avenue and 80th Street. **Isamu Noguchi**'s creative presence can be seen throughout the city; here you'll see his 1979 *Unidentified Object,* an abstract basalt form set on a pedestal among the trees.

The giant and comprehensive museum includes one of the great collections of European paintings (some two thousand),

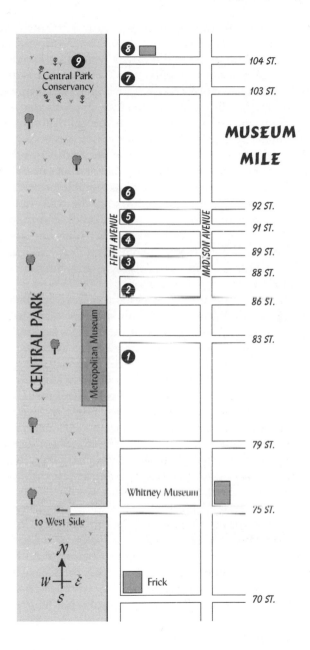

8 104 ST.

9 Central Park Conservancy

7 103 ST.

MUSEUM MILE

6

5 92 ST.

91 ST.

4 89 ST.

3 88 ST.

FIFTH AVENUE

MADISON AVENUE

2 86 ST.

83 ST.

1

CENTRAL PARK

Metropolitan Museum

79 ST.

Whitney Museum

75 ST.

to West Side

Frick

70 ST.

N
W — E
S

contemporary art, furniture, musical instruments, medieval man-
uscripts and statuary, costumes, Asian art, African sculpture,
Egyptian art including the well-known Temple of Dendur, draw-
ings, American paintings, Roman and Greek statuary and vases,
medieval and Renaissance armor, and much, much more. There
are always several shows, either visiting from abroad or drawn
from the thousands of items that even the colossal museum can-
not show regularly. Don't miss the lovely roof garden with its large
outdoor sculptures (by **Rodin**, **David Smith**, and **Gaston
Lachaise**, among others) and its magnificent views of the city. The
Charles Englehard Court also contains notable sculpture. You'll
find many different types of guidebooks to the collections, as well
as docents, available, or, if you prefer, guided tours with ear-
phones. The museum has lectures and a wide variety of educa-
tional events, including many for children. The Met asks for a
contribution. Hours: Tuesday–Thursday and Sunday, 9:30–5:30;
Friday and Saturday, 9:30–9. ☎ 212-535-7710.

Across Fifth Avenue at 86th Street is the recently opened **Neue
Gallerie ❷**, at 1048 Fifth Avenue. This smallish, distinguished fine
and decorative arts collection features early-twentieth-century
works from Germany and Austria, housed in a stunning mansion.
Egon Schiele, **Gustav Klimt**, and **Oscar Kokoschka** are a few of
the noted painters whose works are on display. There are also ter-
rific examples of design by **Weiner Werkstatte**, **Josef Hoffman**,
Dagobert Peche, and **Adolf Loos**, among others. Don't miss the
mercurial **Schiele** drawings or the spectacular Viennese clocks.
There are changing exhibitions on the third floor every few
months. The Café Sabarsky will make you feel you're back in the
Old World. Hours: Friday, Saturday, Monday, 11–7; Sunday, 1–6.
There is an admission fee. ☎ 212-628-6200.

Our next stop is at 88th Street and Fifth Avenue, **Frank Lloyd
Wright**'s extraordinary circular building housing the **Solomon R.
Guggenheim Museum ❸**. Guggenheim, a great industrialist and
philanthropist, began collecting paintings before World War I. In
addition to buying old masters, he had a fine eye for early modern
art. He commissioned Wright to build a museum to display his
collection; the fascinating Wright museum building opened in
1959. Its cylindrical form is in six stories, and you'll walk up (or
down, if you prefer to take the elevator to the top) a gentle ramp
round and round the interior. The circular exhibition space is

now—since the museum's recent renovation—used for changing shows of contemporary art, while the new gallery space, adjacent to the ramp on each floor, houses some of the museum's amazing collection of **Kandinskys** (there are about 180 in the collection), **Mondrians**, **Mirós**, **Braques**, and many of the other giants of modern art. The Guggenheim's exhibitions are almost always top quality, and the experience of walking through Wright's building is not to be missed. (Even the curving lunch counter is a Wright design.) Hours: Sunday–Wednesday, 9–6; Friday and Saturday, 9–8; closed Thursday. There is an admission fee. ☎ 212-423-3500.

The **National Academy of Design Museum** ❹ is just north of the Guggenheim, at 1083 Fifth Avenue at 89th Street. While not strictly speaking a museum, it does have a series of exhibitions. Founded in 1825 for the purpose of showing American art, the Academy has both juried shows and a permanent collection. Although the Academy's taste in painting may be considered conservative, we have particularly enjoyed its watercolor shows. The emphasis is on figure drawing here, as well as on architecture and representational painting. Art classes are offered as well. Hours: Friday–Sunday, 11–6; closed Monday and Tuesday. ☎ 212-369-4880.

From here walk north to 91st Street, where you'll find the entrance to the **Cooper-Hewitt Museum** ❺ just around the corner at 2 East 91st Street. This is the National Museum of Design of the Smithsonian Institution. It exhibits an eclectic collection of items. It's great fun to wander through the rooms of the former Andrew Carnegie mansion and examine such things as advertising art of the nineteenth century, glass and ceramic figurines, textiles, salad bowls, architectural drawings—or whatever objects the curatorial staff has decided would make a historically and artistically interesting exhibition. Recent shows have included nineteenth-century jewelry and watercolors from the Vatican collection. One of our favorites was a show of Victorian wallpapers. The Cooper-Hewitt also has a full agenda of lectures and other programs. You'll find the museum open Tuesday, 10–9; Wednesday–Saturday, 10–5; and Sunday, noon–5. There is a fee except on Tuesday after 5. ☎ 212-849-8400.

Only a few blocks north is the newly and magnificently renovated **Jewish Museum** ❻, at 1109 Fifth Avenue, between 92nd and 93rd streets on Fifth Avenue. This museum, which is devoted to Jewish art and history from ancient to modern times, also presents

some of the city's best and most timely changing exhibitions. The permanent collection features hundreds of ceremonial items, decorative arts, photographs, paintings, prints, and manuscript illuminations from medieval Jewish communities. Major exhibitions of contemporary artists, as well as historical shows—an especially interesting one was devoted to the Dreyfus case—make this a must-see museum. The admission fee entitles you to attend films, lectures, and classes. Hours: Monday–Wednesday, 11–5:45; Thursday, 11–8; Friday, 11–3; Sunday, 10–5:45; closed on Saturday. ☎ 212-423-3200.

A brisk walk north to 103rd Street will bring you to the **Museum of the City of New York** ❼. In front of it you'll find a statue of Alexander Hamilton by **Adolph Weinman**. This collection is a must for children, who will find all kinds of things to love, from antique fire engines to dollhouses that can only be described as sensational. There are also many fine paintings, including portraits of important New Yorkers, dioramas of the early days of the city, wonderful costumes of "olde New Yorke," memorabilia of all kinds, toys, theater programs, prints, and—in general—a retrospective look at the city as it was long ago. There are ongoing events, such as puppet shows and lectures. The museum has the kind of collection that makes you go back time and time again, with or without children. Suggested contribution. Hours: Wednesday–Saturday, 10–5; Sunday, noon–5. ☎ 212-534-1672.

Our final museum stop is the inviting building at 1230 Fifth Avenue at 107th Street: **El Museo del Barrio** ❽. The fine brick building houses a collection devoted to Hispanic culture. Here you'll find an extensive collection of prints, paintings, and artifacts of Puerto Rico and Latin America. There are exciting things to see, including works by contemporary Latin American painters and sculptors. At the southern end of the building you'll find the **Taller Galeria Boricua**, or Puerto Rican Workshop. This is the neighborhood's artists' workshop, an exhibition space for the community's creative artists. Since 1970 the Taller space has provided studios and an exhibitions gallery for a number of artists; the Hispanic community is well represented in the shows held here. The Museo also holds a series of lectures and other cultural events relating to Hispanic art and music that are of interest to the general

public. Hours: Wednesday–Sunday, 11–5. There is an admission fee.
☎ 212-831-7272.

Your last stop is not a museum in the traditional sense, but it, too, will provide you with color and form. Cross the street and enter the **Central Park Conservancy** ❾ between 104th and 105th streets, where you will find yourself in a garden of great elegance and beauty; it was a gift from the Vanderbilt family a century ago. Classically styled with columns, walkways, areas of lawn, flowerbeds, two fountains, and stairways, this perfectly maintained garden is a delight. You can stroll through its elegant paths, rest among the vine-covered trellises, and admire the changing flower garden. Truly an oasis in the bustle and cement of the city, the Conservancy is a rare, beautifully kept spot to end your Museum Mile walk.

One of the city's favorite fountains, the Untermyer Fountain with its three dancing maidens, is a centerpiece of the Conservatory Garden to the north. Made some time before 1910, the fountain has three whimsical bronze figures dancing around its single jet of water. It was made by **Walter Schott**, a German sculptor and portraitist. Its light, airy design is a charming addition to the harmonious spaces and bright colors of the garden. Also in the Conservatory Garden to the south is a memorial to the author of *The Secret Garden* and *Little Lord Fauntleroy*, the Frances Hodges Burnett Memorial Fountain. The sculpture surrounding the fountain consists of a small boy playing the flute while a young girl holding a seashell listens. A birdbath at her feet spills into a small pool. The fountain was created by **Bessie Potter Vonnoh** between 1926 and 1937, when it was given to the Garden. Hours: daily before dusk. Admission is free. Central Park is not recommended after dusk, but don't miss this garden during the day.

. . . And in Addition

Below are other museums, galleries, and art sites of interest in the neighborhood.

☞ The **Frick Museum**, 1 East 70th Street and Fifth Avenue: Once the grand home of Henry Clay Frick, today it houses in exquisite surroundings a fabulous collection of European art from

the fourteenth through the nineteenth centuries. Hours: Tuesday–Thursday and Saturday, 10–6; Friday, 10–9; Sunday, 1–6. There is an admission fee. ☎ 212-288-0700.

☞ The **Whitney Museum of American Art**, 945 Madison Avenue and 75th Street: This is New York's other major modern art museum, this one featuring American art of the twentieth and twenty-first centuries. Recent shows have been devoted to such subjects as Ellsworth Kelly, political art, and the museum's well-known Biennial with avant-garde and emerging artists. Hours: Tuesday–Sunday, 11–6; Friday, 1–8. There is an admission fee. ☎ 212-570-3676.

☞ The **Museum for African** Art will eventually be located at Fifth Avenue and 110th Street. (See chapter 26 for its present, temporary, location in Long Island City, Queens.)

☞ The **National Museum of Catholic Art and History**, 443 East 115th Street, near First Avenue: This museum, which has just opened its doors as we write, will feature many different facets of Catholic art, from medieval wood carvings to Renaissance paintings to folk art to **Salvador Dali** to occasional solo shows of international contemporary artists. (A recent show exhibited fabric sculptor Muriel Castanis's *Angels in the Wind.*) The museum also plans shows devoted to an eclectic mix of history and sociology, as they relate to famous Catholics, as well as an extensive collection of dolls dressed in the habits of every order of nuns in the world. ☎ 212-828-5209.

☞ Three new **Alexander Calder** additions to the East Side: In front of the **James Graham Gallery** at 1014 Madison Avenue (between 78th and 79th streets) is an eye-catching design of alternating black and white rectangles. Next-door, in front of the **Perle Gallery** at 1016 Madison, is a series of black crescents in a white field. At 1018 Madison are Calder's black and white sunbursts. These are the only known examples of Calder as a sidewalk artist.

☞ **Arsenal Gallery**, 830 Fifth Avenue at 64th Street: The giant Arsenal building houses a variety of exhibitions, including community arts, antique shows, and other events. The New York City Department of Parks administers the gallery. ☎ 212-360-8111.

☞ And if you are in the neighborhood, **Louise Nevelson**'s *Night Presence IV,* made in 1972, is one of the artist's earliest outdoor

metal works. You'll find its complex collection of knobs, bird shapes, ribbon forms, and other abstract designs in the center median of Park Avenue at 92nd Street.

☞ **Alice Aycock**'s grand construction *East River Roundabout* is at 60th Street off FDR Drive. An amusement park-like aluminum work in looping spirals, it faces the East River.

15

An Auction Outing

Previewing Art for Sale

HOW TO GET THERE
Sotheby's by Subway: 4, 5, or 6 train to 68th Street (Hunter College);
walk east to York Avenue.
Christie's by Subway: V or F train to Rockefeller Center.
William Doyle Galleries by Subway: 4, 5, or 6 train to 86th Street.

On this artwalk we propose to take you to two of New York's finest auction houses—or three, if you wish to make the optional loop.

If you've never experienced a fine-art auction, you have a real treat in store. For, in addition to providing you with the rare opportunity to view works that may not be seen elsewhere, auctions are a form of theater. At center stage of these live performances are the artworks or objects being considered by the audience—international art collectors, museum curators, dealers, art lovers, or simply observers—while the auctioneer in stentorian tones announces the bids. The battles for items are not loud or raucous—indeed, bidders hold up their paddles in silence, while others phone them in—but the atmosphere can be charged with electricity, especially when prices escalate at a dizzying rate, leaving everyone reeling in suspense. The pace is quick, as the bidding surges from one lot to the next with hardly a moment's hesitation (sometimes as many as a hundred lots are sold per hour).

In our view, attending an auction is an entertaining and informative way to spend a morning or afternoon, whether you are buying, looking, or just soaking up the atmosphere, and you can learn a great deal about today's art market. Contrary to popular belief, not everything sold at auction is wildly expensive. Indeed, part of the fun and challenge is that you can still find great bargains, especially in the decorative arts (granted, less frequently in the fine-arts arena). And, while most museums charge an entrance fee, gallery

viewing at auction houses, as well as most New York auctions themselves, is free—unless you buy a catalog or get carried away in your bidding!

New York has its fair share of first-rate auction houses—from famous institutions that sponsor some of the most dazzling sales in the international art market to more modest but still important houses, where you can find a wide variety of items in terms of both quality and price.

You may wonder where the auction houses get their fine art. Much of it comes from private collectors who have decided to sell off major works. Some art comes from museums that want to exchange gifts that have been gathering dust in their cellars (because they already own a similar work). You'll see many famous names, from marquises to museums to oil tycoons, in the small print of the catalog. Similarly, the buyers are often the same museums, trading up or plugging a hole in their collections, or wealthy investors and dealers bidding on behalf of anonymous international collectors.

On this auction outing you will sample two of Manhattan's most distinguished auction houses. One, the famed Sotheby's (with auction houses on four continents), is known worldwide for its elegant and high-quality auctions of European and American paintings, sculpture, and drawings, from old masters and Impressionists to modern and contemporary works and all sorts of decorative arts (as well as being known for international intrigue). The other auction house is the internationally acclaimed Christie's. Here, paintings, prints, photographs, sculpture, and furniture are sold at more accessible prices (many of the items are sold for under $5,000). We chose these two houses because we felt they were representative of the types of auction houses found in our area—and also because the walk from one to the other is pleasant and not too long.

You can plan your outing in one of two ways: if you're interested in attending a particular type of auction, you should call Sotheby's or Christie's ahead of time to find out what kind of art is being auctioned and when, so you can plan accordingly. Or, if you suddenly find you have a free day, you can go on the spur of the moment, taking your chances as to what you'll find. Keep in mind that before each auction the items to be sold are put on display for several days, where they can be examined carefully, up close. At

the presale, catalogs are available free of charge for consultation; at the sale, there's a charge for them. In order to bid, you are given a paddle, which you get when you register at the entrance (free of charge). And, if you plan to buy, check ahead as to what method of payment will be accepted. Although we cannot promise that world records will be broken at the auction block on the day you go, we can assure you that you'll enjoy your adventure.

From the moment you step into **Sotheby's** chic East Side building at York and 72nd Street, you're aware you're in the world of art as high finance. The plush carpets, uniformed guards, and elegantly dressed customers all denote the rarefied world of the collector—not just any collector, but the likely purchasers of Picassos or old masters or Jasper Johns. The bustle of commerce mixes with the fabulous collections of art, and everyone seems to talk in whispers. The constantly changing shows and subsequent auctions require a lot of moving of pictures and objets d'art, and the galleries are filled with future buyers, honest-to-goodness art lovers, and dealers, dealers, dealers.

Down on the lowest level from the lobby is a giant exhibition space. Here you'll find the art items that will soon be put on the auction block. These may include an impressive collection of paintings by the masters, which you can walk around and examine for free, in a museumlike but uncrowded, relaxed atmosphere. You can also consult the catalogs hanging on each wall and find out how much the management expects each item to bring at auction (a bonus not available at museums). Stylish young women answer your questions with alacrity.

On the second level, up a flight of plushly carpeted stairs, you'll find a long desk, another exhibition hall, and the famous auction room. Here the world of high finance meets the world of art. You are given a large paddle with a number on it, you can buy a catalog, and then you take a seat (free admission). Up in front you'll see an auctioneer who speaks in a polite and noncommittal tone, selling art in increments of $100 or $10,000. A bank of telephone-bid receivers faces the audience and occasionally bids on behalf of an unseen collector on the phone. With studied lack of emotion, the auctioneer bangs down his gavel every few moments and quietly says something like, "Sold for $45,000, to bidder number such and such" (although it should be added that many works go for far less). You shouldn't miss this taste of the art scene. As far removed

as it can be from the little studios and workshops of the artists themselves, it nevertheless represents the rarefied heights of success that some artists dream about (and few attain in their own lifetimes). It does seem rather hard to make the connection, though, between this scene and the artist's act of creation. Nonetheless, the international firm of Sotheby's (with auction houses in cities from London to Tokyo, Madrid to Beverly Hills, and Milan to St. Moritz) is still supposed to be flourishing, after riding the crest of the wave of "art as investment."

Among recent exhibitions and auctions held here were Southeast Asian art, contemporary paintings, and a world of decorative art from rare jewelry to antique furniture and Persian rugs. You will find information for planning your visit to coincide with the kind of art of most interest to you in the Sunday *New York Times* (Arts and Leisure section) or by calling Sotheby's: ☎ 212-606-7000. The hours for exhibitions of art to be sold are Tuesday–Saturday, 10–5; and occasional Sundays. Exhibitions close at 3 p.m. on the day preceding the auction. The auctions themselves are held at 10:15 a.m. and 3 p.m. (You can wander in during the auction and wander out again at will.)

In addition to the scene described, Sotheby's is also running a slightly less-exalted set of auctions called **Sotheby's Arcade** in the same building. Here you'll find lower prices and items that might not interest the most serious investors or biggest museums. Nevertheless, if you actually plan to buy something at a reasonable price at one of these auctions, you would be advised to go to the Arcade. Viewing hours are the same; auctions are at 2 p.m.

From Sotheby's find your way to **Christie's** at 20 Rockefeller Plaza. Christie's is filled to the brim with artworks, "objets," and furniture. Don't miss the giant, brilliantly colored **Sol Lewitt** mural (not for sale!) in the lobby. At these auction houses, estates are often sold, which can result in an eclectic mix of artworks or "objets"—from fine paintings and prints to coins, stamps, furniture, antique jewelry, rugs, or unusual collectibles such as toys and dolls. You might well fall in love with a unique object and decide to bid on it, for there is great choice and the prices are not astronomical. On one of our last visits, we attended an auction featuring American paintings, watercolors, drawings, and sculpture, many of which were going for relatively modest sums (under $1,000). The hall was filled to capacity, and the gallant auctioneer had to speak

over a constant hum of conversation, as people were comparing notes on the various lots. Other recent auctions at Christie's have featured, among many other sales, twentieth-century Indian art, old master paintings, and animation art.

Viewing at Christie's occurs several days before an auction. ☎ 212-636-2000 or ☎ 212-636-2010.

And now, depending on your energy and time, you can visit the **William Doyle Galleries**, at 175 East 87th Street, for a slightly different atmosphere. Here is a more cluttered and pleasantly inviting auction house that might remind you of nineteenth-century London (or how you imagine it). There is a mix of grand pianos, giant Victorian art on the walls, and bustle that makes the place appealing. People at the auction are definitely there to buy; it does not attract the same clientele as Sotheby's and Christie's—here they are more likely interior decorators or others looking for a piece of the past that they can afford. Recent auctions included mostly furniture, decorations, and silver, but some had paintings and sculpture as well. Among the most interesting were an auction of Art Nouveau and Art Deco works, a French Empire auction, and a sale of Belle Époque decorative arts.

Exhibition hours are Saturday, 10–5; Sunday, 12–5; Monday, 9–7:30; and Tuesday, 9–2. Auctions take place several times per month, usually on Wednesdays and Thursdays and occasional evenings. ☎ 212-427-2730.

Perhaps you will return home from this artwalk with an original work of art in hand!

. . . And in Addition

- ☞ **Sotheby's** has a series of lectures and seminars that are of very high quality. Recent examples included a series on Georgia O'Keeffe and Alfred Stieglitz, a fine-arts conservation seminar, and a travel seminar to Italy on Futurism. For information, ☎ 212-894-1111.

- ☞ **Christie's** has special events and seminars on a variety of art-related topics; they are open to the public and free of charge on a first-come, first-served basis. ☎ 212-636-2687.

- ☞ Other auction houses to visit in Manhattan: **Swann Galleries**, 104 East 25th Street, ☎ 212-254-4710. **Tepper Galleries**, 110 East 25th Street, ☎ 212-677-5300.

16

Around the World in Thirty Blocks (and Further Afield)

International Art Centers

HOW TO GET THERE
Subway: N, R, W, 4, 5, or 6 train to Lexington Avenue and 59th Street.

New York, the "capital" of the art world, is also one of the world's most international cities. In about twenty blocks you can enjoy a round-the-world artwalk that combines the polyrhythmic nature of the city with some very fine art. No, you will not have to wander from foreign neighborhood to foreign neighborhood; instead we recommend a stretch of East Side Manhattan that will transport you (artistically speaking) quite easily around the world. In fact, a visit to the embassies, regional centers, and galleries of this area will acquaint you with some of the newest art being done abroad, as well as with antiquities and native art that you might usually only see in museums. And, because these exhibitions change periodically, you can do this walk every few months for a new artistic adventure!

Begin at the corner of Park Avenue and 57th Street (460 Park), where you'll find the **Korean Cultural Service Gallery**. In this modern building you must take the elevator up to the sixth floor to the elegantly appointed gallery to see a stunning series of Korean exhibitions. Korean art is not as well known as Chinese or Japanese art in this country, but judging by the exhibitions (5,000 Years of Korean Art at the Met recently and the contemporary Korean drawings at the Brooklyn Museum), there is much to appreciate. Hours: Monday–Friday, 9–6. ☎ 212-759-9550.

Head to Fifth Avenue and walk to 59th Street. At 781 Fifth Avenue you'll find the stylish shop/gallery/museum called **A la Vieille Russie**. This is a New York landmark of sorts, featuring pre-Soviet Russian antiquities, jewels, and, of special interest,

wonderful icons. Upstairs on the mezzanine is a truly extraordinary collection of these icons from medieval to nineteenth-century Russia. Some have been lent for exhibitions; others are for sale. When seen together they are a vivid representation of Russia's past. A la Vieille Russie is open Monday–Friday, 10–5; and Saturday, 11–4:30. ☎ 212-752-1727.

Around the corner, at 22 East 60th Street (between Fifth and Madison), you'll enjoy the **French Institute**, or Alliance Française. This branch of the French cultural offices has a nice exhibition space that houses amusing and sometimes very fine exhibitions in addition to every sort of French cultural event, film, and concert. We saw a show featuring art and cookies that was sponsored by a baking company, which commissioned artists to create works inspired by the cookies! You can phone the Alliance at ☎ 212-355-6100 for general information or ☎ 212-355-6160 for box office information. Hours: Monday–Thursday, 10–8; Friday, 10–6.

If you are energetic, take a detour from here to 125 East 65th Street, where you will find another stop on your hopscotch around the world: **China Institute**. The gallery here sponsors a series of exhibitions, symposia, videotape programs, and gallery talks. It specializes in introducing Chinese art to Westerners, and its recent shows have included modern Chinese painters, Chinese antiquities, and Ming landscapes—in fact, a wonderful array of Eastern art can be seen here. The discussions that accompany these exhibitions go on for days at a time, bringing scholars of Chinese art to speak and offering to the public unusually interesting commentary. The gallery itself is open Monday–Saturday, 10–5; and Sunday, 1–5. ☎ 212-744-8181.

Walk west on 65th, to 1 East 65th, between Madison and Fifth. Here the **Herbert and Eileen Bernard Museum** (which is part of the Congregation of Temple Emanu-El) displays an unusually significant collection of religious and cultural objects and memorabilia: nineteenth-century silver, jewels, and enamel; Polish cast brasses; and a fourteenth-century Hanukkah lamp are among the treasures featured. (The adjacent temple, the largest in the world, is also well worth a visit for its remarkable stained-glass windows and colorful mosaics, in the Viennese Secessionist style.) Museum hours: Sunday–Thursday, 10–4:30; Friday, 10–4; Saturday, 1–4:30. No fee. ☎ 212-744-1400, extension 259.

Return to Park Avenue and head north, to 68th Street, where you will find several stops bunched together. First, at the **Americas Society** at 680 Park is a fine gallery devoted to art from Latin America, the Caribbean, and Canada. This is a must-see stop, with three or four changing exhibitions per year. The 1912 landmark townhouse is a gracious home for the most varied and interesting of art shows. A recent exhibit, for example, contained altar decorations and wood carvings from South American Guarani Indians who had adopted a "Baroque" Christian style. Other recent exhibitions in the large ground-floor rooms have included Venezuelan landscapes, Realism in Ecuadorian art, and the paintings of Fernando Botero and Diego Rivera. Other activities at Americas Society include concerts, stage readings, workshops, publications, and an active outreach program for schools and the Hispanic community. The society is open daily from noon to 6 p.m. ☎ 212-249-8950.

Having jumped from Asia to the Americas in only a few blocks, you'll find yourself "in Europe" next-door at the **Spanish Institute** at 684 Park. Like its neighbor, the Spanish Institute is housed in an imposing building, with galleries on the ground floor. Often combining literature and art, the exhibitions here include a variety of unusual subjects: a recent show was called Po(e)(li)tical Object: Visual Poetry from Spain. They have also exhibited Spanish paintings, manuscripts, and sculpture; occasionally you will have the opportunity to see new Spanish art, just as if you were wandering among the galleries of Madrid and Barcelona. An array of Spanish cultural events and courses in art history is also available. The Spanish Institute is open Monday–Sunday, 11–6. ☎ 212-628-0420.

Walk next-door to 686 Park, where you will see the imposing entrance of the **Italian Cultural Institute** (part of the Consulate). Here you will find a small display board listing exhibitions and events, and most likely you will find a show of Italian art in its upstairs gallery. The elegant surroundings, the polished wood, and the architectural details of the Consulate building are well worth a visit in any case, but, if you're lucky, there will also be a show to see. The **Italian Cultural Institute**, or the Istituto Italiano di Cultura, is open Monday–Friday, 9–12:30 and 1:30–4:30. ☎ 212-879-4242.

Think of yourself as leaving Europe for the moment, to return again to the Far East; for, only two blocks north, at 725 Park (70th Street), you'll come to the well-known **Asia Society and Museum**.

Here is a stellar collection of arts from many different countries of Asia, housed in a recently and most elegantly renovated building originally designed by **Edward Larrabee Barnes**. For more on this especially rewarding site, see chapter 7. Hours: Tuesday–Sunday, 11–6; Friday, 11–9. ☎ 212-288-6400.

Next, walk up to 2 East 79th Street, the entrance of the **Ukrainian Institute of America**. This imposing building with iron gates was designed to resemble a French château, but inside you will be transported to a world of Ukrainian folk art, paintings, and posters. Among the works are permanent displays of art by notable Ukrainians, including **Alexander Archipenko** and **Alexis Gritchenko**. There is an exhibition hall on the ground floor, and paintings literally cover the walls as you climb the great staircase to the upper stories. Upstairs you'll find traditional decorated Easter eggs, costumes, textiles, and folk decorations. When we were there recently we found political posters and an exhibition celebrating a millennium of Christianity in the region. There is a general air of another time and place here and a definite political overtone to much of the art shown. The Ukrainian Institute is open Tuesday–Sunday, 12–6. ☎ 212-288-8660.

Back on Fifth Avenue, walk north for several blocks to one of our favorite spots, the busy **Goethe House**, at 1014 Fifth Avenue (at 83rd Street). In a newly renovated Beaux-Arts townhouse opposite the Metropolitan Museum, Goethe House is devoted to German art and cultural activities. There are exhibitions (in addition to every sort of artistic event) as well as some permanent paintings on view. Goethe House is nothing if not eclectic; a recent show featured the history of German rock-and-roll, and others have included works by German painters and art from German museums. Goethe House is open Saturday, noon–5; Wednesday and Friday, 9–5; and Tuesday and Thursday, 9–7. ☎ 212-439-8700.

Walk to 1109 Madison and 83rd Street for a visit to the **Czech Center**, where the ground-floor gallery displays a variety of cultural exhibits, including a recent one devoted to Kafka and the city of Prague. ☎ 212-288-0830.

We should note that you are in the vicinity of New York's most famous Museum Mile (see chapter 14). Included in this neighborhood are the **Met**, of course, the **Jewish Museum**, and several other notable collections—among them, the **Neue Gallery** with its fine German and Austrian art from the early twentieth century

and the **Frick**. (Although you might wish to combine this artwalk with visits to these famous collections while you are in the neighborhood, we think they deserve separate trips at another time, and therefore we are purposefully turning east to the galleries on Madison Avenue.) Here, between 86th Street and 68th Street, you will find an astonishing array of international art. This section of Madison is one of the three major art gallery areas in Manhattan (visit Chelsea and the 57th Street area for the others). As you walk down the avenue enjoying the generally posh and artistic stores, you will find (both upstairs and at street level) perhaps two dozen interesting art galleries. Among them are several devoted to Asian antiquities, one showing Soviet art, a charming shop/gallery featuring primitive objects carved in Oceania, South America, and elsewhere, several showing American primitives, two devoted to African carvings, and, of course, many exhibiting contemporary European painters and sculptors. We recommend that you pick up a Gallery Guide in any one of these galleries for particular information on current shows in the neighborhood, or, if you prefer, duck in and out of whichever galleries you find of interest. (Remember that New York dealers welcome browsers; you don't have to pretend you are a prospective purchaser.)

Several of the most interesting international galleries can be seen by appointment only. We enjoyed **Jeffrey Myers Primitive and Fine Art Gallery** (12 East 86th Street), which specializes in prehistoric to nineteenth-century Eskimo art and Northwest-coast Indian art. ☎ 212-369-4880. Chinese antiquities, from the Neolithic period through the Song Dynasty, can be seen at the **Randel Gallery** (49 East 78th), also by appointment. ☎ 212-861-6650. The **Scholten Japanese Art Gallery**, off Madison on 66th Street, is the largest gallery devoted to Japanese screens, prints, and ceramics in New York. For an appointment, call ☎ 212-585-0474.

... And in Addition

It should be added that this tour of New York's ethnic collections is not all-inclusive. We hope you will also visit—if not on this outing, then on another day—the following collections: The **National Museum of the American Indian** (downtown, at 1 Bowling Green and Broadway); the **Hispanic Society** (Broadway and 155th Street); the **Chinatown History Museum** (70 Mulberry Street); the

Caribbean Cultural Center (408 West 58th Street); **El Museo del Barrio** (Fifth Avenue and 106th Street); the **Swiss Institute** (495 Broadway at Broome Street); the **Galeria Venezuela** (7 East 51st Street); and **Scandinavia House** (58 Park Avenue at 38th Street).

Also of note are the **Asian American Arts Center** (26 Bowery between Bayard and Pell streets), where you can see changing exhibits related to Asian and Asian American arts and culture (☎ 212-925-2035); the **Ukrainian Museum** (222 East 6th Street), which features painted Easter eggs, photos, folk arts, jewelry, paintings, and sculpture (including works by **Archipenko**); the **Latin Collector Art Center** (153 Hudson Street), which shows contemporary Latin American artists (☎ 212-334-7814); and the **Japan Society** (333 East 47th Street), which displays Japanese prints, sculptures, and paintings of centuries (☎ 212-832-1155).

In Brooklyn you can visit the **Kurdish Library** (114 Underhill Avenue at Park Place) to see North America's only cultural center devoted to the history and arts of the Kurdish people. ☎ 718-783-7930.

On Staten Island you'll find the **Jacques Marchais Center for Tibetan Art** (338 Lighthouse Avenue, Richmond). ☎ 718-987-3478.

Almost every one of these institutions has extensive series of lectures, concerts, symposia, films, language classes, art discussion, and so on. Pick up flyers and listings when you visit or phone ahead to see what is being offered and when.

17

Exploring Central Park and Its Surroundings

A Treasure Hunt for Children and Other Art Sites for Kids

HOW TO GET THERE
Subway: N, R, or W train to Fifth Avenue and 59th Street

Central Park, in the heart of Manhattan, is the crowning achievement of landscape architect Frederick Law Olmstead. It is a cherished recreational resource for New Yorkers. Here you can engage in many an activity, from biking, boating, and carriage and horseback rides to roller- and ice-skating, running, ball playing, and birding. You can attend cultural events during summer months—outdoor concerts, Shakespeare in the Park, or even the opera. But in addition, Central Park is also a wonderful outdoor sculpture park with a collection of interesting, unusual, and sometimes charming statues that coexist with the usual equestrian and heroic pieces found in public places. These works are all nestled within the leafy 843 acres of rolling terrain that make up the park. Many of these statues are particularly appealing to children, who delight in seeing favorite storybook characters or easily recognizable animals rendered in stone or bronze. This free outdoor exhibition is a wonderful place to introduce young children to sculpture; for, unlike more inhibiting and confining museum settings, here they can walk right up to each sculpture, touch it, and even climb on it. (*Alice in Wonderland*, stop 10, is a particularly popular spot for children to do just that.)

This artwalk—designed primarily for younger children (although all readers will enjoy it)—covers the area in and around the Central Park Zoo at 64th Street and Fifth Avenue, north to 76th Street, and the West Side portion between 80th and 81st streets. Later, after you leave the park, you can continue your treasure

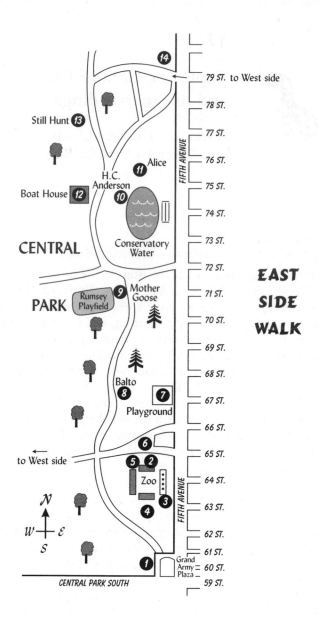

EAST
SIDE
WALK

79 ST. to West side
78 ST.
77 ST.
76 ST.
75 ST.
74 ST.
73 ST.
72 ST.
71 ST.
70 ST.
69 ST.
68 ST.
67 ST.
66 ST.
65 ST.
64 ST.
63 ST.
62 ST.
61 ST.
60 ST.
59 ST.

FIFTH AVENUE

Still Hunt ⑬
H.C. Anderson
Boat House ⑫
Alice ⑪
⑩
Conservatory Water
CENTRAL
PARK
Rumsey Playfield ⑨ Mother Goose
Balto ⑧ ⑦ Playground
⑥
to West side
⑤ ②
Zoo
④ ③
①
Grand Army Plaza
CENTRAL PARK SOUTH
⑭

N
W—E
S

114

hunt in the West Side neighborhood as far north as 91st Street, for the treat of an animal-sculpture playground. For practical reasons, we have divided this artwalk into two sections: East Side and West Side. (The full walk may be too long for small children.) Note that most of the animal sculptures in the park are inside or near the zoo; others are also easily reached on foot. To make the walk more amusing for youngsters, you might have them "find" the sculptures listed here. Using our descriptions (and, perhaps, armed with a map of Central Park, available at the information center near the entrance to the zoo), you might ask them to look for a sculpture that fits a certain description and location, rather than simply pointing it out. Most children love treasure hunts, and these are all treasures worth hunting for.

You will be searching for the following:

East Side

1. Giant feet
2. A clock with a group of animal musicians (monkeys, bear, elephant, goat, kangaroo, penguins, hippopotamus)
3. A dancing goat surrounded by frogs
4. A great tigress with cubs
5. A dancing bear with five small frogs
6. An animal gate
7. An arched bridge
8. A heroic Siberian husky dog
9. Mother Goose with some of her friends (Humpty Dumpty, Mother Hubbard, Little Bo-Peep, and Old King Cole)
10. Hans Christian Andersen with his ugly duckling
11. Alice in Wonderland and her friends
12. Rowboat sculpture
13. Fierce stalking panther
14. Three bears

West Side (and the neighborhood nearby)

1. A fifteenth-century Polish King on horseback
2. Four characters from Shakespeare
3. Herbs and flowers descended from Shakespeare's own garden

4. Six wild creatures and Teddy Roosevelt with his guides, all decorating a museum
5. A small stone squirrel eating an acorn
6. A hands-on museum just for children
7. A stone family group on a park bench
8. A flock of sheep

Please keep in mind that this is in no way a comprehensive guide to all of Central Park's statues; these might appeal most to the smallest and youngest of artwalkers.

East Side

Begin your walk at the **Grand Army Plaza** (near the Plaza Hotel) with a visit to a giant pair of melded feet by sculptor **Tom Otterness ❶**. Children will long to climb on these feet.

From here we suggest walking up Fifth Avenue to the entrance to the **Central Park Zoo** at 64th Street. At the southern entrance, above the arched brick gate, you will see the delightful *Delacorte Clock* (1964–65) by **Andrea Spadini ❷**. Commissioned by the philanthropist George T. Delacorte—who was fascinated by the animated clocks he had seen in Europe—it features a motley collection of eight animals. At the top, two bronze monkeys strike a bell, while a group of six "musicians" play instruments and dance in circles below them. A bear plays a tambourine, an elephant the accordion, a goat the pipes, a kangaroo with baby the horn, a penguin the drum. But our favorite is the hippopotamus who, amazingly, plays the violin—and with great gusto! A complete performance can be heard on the hour, when you'll be treated to the tunes of nursery rhymes; a shorter version plays on the half-hour. Children love to watch the figures dancing above, and the gate is often bustling with eager anticipation just before the performances.

From here you can enter the zoo, where, in addition to the many live animals, you and the children will also find two bronze animal groupings: *Dancing Goat* (c. 1935), located in a niche near the Zoo Café, and *Tigress and Cubs* (1866), next to the real monkey display.

Dancing Goat ❸ is part of a pair of fountain statues by **Frederick George Roth**. (You'll see its counterpart, *Honey Bear*, as you leave the zoo.) The fanciful 6-foot goat balances on its hind legs in

a humanlike position, as water sprays from the mouths of surrounding frogs at its feet. Whereas the goat is depicted in a whimsical fairy-tale-like way, *Tigress and Cubs* ➍ is a bold, gripping work. The artist, **Auguste Cain**, who worked in Paris, created what is certainly a fine heroic statue—animal or not. The larger-than-life-size tigress proudly holds in her mouth a dead peacock, its long tail hanging down to the ground, while her two cubs leap about at her feet. Cain was able to capture an expression of pure triumph on the face of his heroine.

As you leave the zoo, look for *Honey Bear* (c. 1935) ➎ on your left, just past the Delacorte clock. Like the goat, this charming bear also stands on his hind legs with his head thrown back, while the five frogs at his feet recycle the fountain's water. Unlike *Tigress and Cubs*, this happy work is one of fantasy and humor rather than realism.

Next you'll walk under the overpass (to the 65th Street Transverse) where, immediately to the right, you'll find the **Lehman Children's Zoo** ➏. Its gates (1960–61), by the sculptor **Paul Manship**, celebrate the joyous effects of music on all creatures, humans and animals alike. On either side of the gate two boys are shown playing the pipes of Pan, while a central male figure is dancing with abandon, surrounded by two goats and assorted birds. These birds, all different, are perched merrily atop the decorative bronze swirling arches that form the gate.

As you leave the zoo heading north you'll soon find yourself at a small and unusually charming children's playground ➐. By artistic use of wood, stone pavilions, and an arched bridge reminiscent of a Japanese garden, the designers of this playground (adjacent to Fifth Avenue at 67th Street) have created the feel of environmental sculpture. The natural boulders that adjoin the playground and the unusually pretty plantings help make this an especially appealing spot.

And now you'll come to one of the park's most beloved statues. From the playground, walk along the path bearing to your left at the fork. You'll find *Balto* (1925) ➑, New York's most famous commemoration of man's best friend. And what a heroic tale is Balto's! The Siberian husky led a team of dogs on a long trek through Arctic blizzards, carrying diphtheria serum to desperate, epidemic-ridden Nome, Alaska, in 1925. Because of this brave dog who "never faltered once" on the arduous journey, the mission

was successful—all except for poor Balto, who died shortly after from overexertion. To celebrate his incredible courage and loyalty, a committee commissioned **Frederick G. R. Roth** to create a commemorative statue. This realistic piece is a dramatic vision of heroic determination. The larger-than-life-size bronze dog is shown panting, eyes fixed upon the trail ahead of him, legs apart, ready to continue the journey. His harness is attached to his back. He sits atop a rough boulder in a naturalistic setting, and there is an impressive plaque below him describing his deeds. Generations of young admirers have climbed on him, stroked him, and hugged him. As a result, the patina has worn in places, adding to the impression of the roughness of his voyage.

On leaving Balto, walk alongside the main roadway heading north. To the left of the road, near the Rumsey Playfield, is a 1938 carved granite statue of Mother Goose ❾ looking much the way we might imagine her (also by the sculptor **Frederick G. R. Roth**). This Mother Goose is an energetic figure, cape flying, witchlike hat on her head, and a giant basket clutched in her hand. On the sides of the statue are some old favorites of every child who has been read to or has looked at some of the most familiar pictures in children's literature. Among the characters are Humpty Dumpty, Mother Hubbard, Little Bo-Peep, and Old King Cole. Mother Goose is a bit scary—and children will love her.

To get to the Conservatory Water—a lovely pond next on the agenda—you must cross the 72nd Street Drive. Here, near 72nd Street and Fifth, is a particularly pleasant part of the park for small children to visit. They will find children sailing model boats across the water and an atmosphere of calm and orderliness reminiscent of a French park. Here also are two of the city's favorite sculptures.

On the west bank of the pond is the legendary statue of Hans Christian Andersen ❿ made in bronze by **George Lober** and installed in 1956. Ever since, this 8-foot-tall portrait of the great Danish writer (with one of his familiar characters) has attracted children by the thousands, who like to sit on the open book in his lap, climb on his head, and otherwise show their affection. Among the Andersen tales than inspired the work is the story of the ugly duckling, and in fact, a sculpted duckling sits at the statue's feet. From May to September, on Saturdays, one or another of Andersen's (and other writers') stories are told for children at this site.

The statue is surrounded by steps and a feeling of space. As it over-looks the Conservatory Water, it makes a fine place to stop for a story yourself.

On the north side of the same pond is another city landmark for children (and adults) of all ages. The group of Alice in Wonder-land and her friends **⓫**, by **José de Creeft**, can be found in an al-cove near Fifth Avenue and 75th Street. Seated atop a great toadstool, Alice is seen surrounded by the Mad Hatter, the March Hare, the Dormouse, and the Cheshire Cat. The scale of this bronze tableau is such that children climb all over it and explore. *Alice* fanciers will notice that she and her friends vaguely resemble the characters in the John Tenniel original 1865 *Alice* edition, which inspired the sculptor.

Bear west to the Boathouse at 72nd Street, where you will see a Rowboat sculpture by **Irwin Glusker** **⓬**. Walk back toward Fifth Avenue, heading north.

Walk to 76th Street and the East Drive, where you'll find a vivid, bold, bronze panther stalking its prey. Crouching on a rocky out-cropping amid the foliage, he looks as though he is about to spring on you. Called *Still Hunt* **⓭**, this is the gripping 1881–83 work of the American sculptor **Edward Kemeys**, who was best known for his animal sculptures, especially those of wild animals. Unlike some of the other animal sculptors of his day, he had no interest in representing the animals literally. *Still Hunt* is intentionally rough in the way it is finished, and it's not completely accurate anatomi-cally. But you'll find that it dramatically conveys the idea of a pan-ther about to pounce on its next victim.

A little farther north is one of the newest additions to Central Park's sculpture collection, a trio of bears **⓮**. Like their counter-parts at the Children's Zoo, these three are friendly-looking, climb-on type bronzes. The work of **Paul Manship**, they are the centerpiece of the refurbished playground at Fifth Avenue and 79th Street, called the **Pat Hoffman Friedman Playground**. And note also a set of animal gates at the 85th Street playground, just north of the Metropolitan Museum on Fifth Avenue.

Charming murals by **Ludwig Bemelmans**, author of *Madeleine,* will also delight children in this neighborhood. You will find these decorating the walls of Bemelmans Bar, located in the **Carlyle Hotel** at Madison Avenue and 76th Street. (Of course, children can only visit this site during non-bar hours.)

This ends our children's East Side treasure hunt. If you're game to discover additional pleasures, continue on to the West Side.

West Side

From *Still Hunt,* head northwest toward Belvedere Lake to find *King Jagiello* (1939) ❶, a gripping heroic equestrian statue. This over-life-size work was the creation of the Polish sculptor **Stanislaw Ostrowski**. It represents a famous fifteenth-century Polish warrior who united Lithuanian and Polish territories. Here he is dramatically portrayed, standing straight in his stirrups, with two swords in hand, symbolizing his military successes. The statue was first seen at the Polish Pavilion at the 1939 World's Fair in New York, an appropriately timely work of defiance and patriotism during the early war years in Europe.

Follow the main path, bearing left, to "Shakespeare territory" in the Park. You'll find the celebrated Delacorte Theater, home of Shakespeare in the Park, a venerable New York tradition, the romantic-looking storybook Belvedere Castle in the background, and just beyond, the delightful Shakespeare Garden. At the entrance to the theater are two groups of bronze statues ❷. You should immediately recognize one as *Romeo and Juliet* (1977), with the couple in romantic embrace, and if you're up on your Shakespeare, you may perhaps identify the other as *The Tempest* (1966). Though both are by the sculptor **Milton Hebald**, they express very different moods. While *Romeo and Juliet* is lyrical in spirit, *The Tempest* is turbulent, animated, and wild. The smooth surfaces of the former contrast sharply with the rough texture of the group in *The Tempest* depicting Prospero and Miranda.

The Shakespeare Garden ❸, on a hill below Belvedere Castle, contains hawthorn and mulberry trees descended from the very plantings Shakespeare once tended. There are over 120 plants, all mentioned in his plays: delphiniums, primroses, and columbines, as well as sundry herbs. The plantings are tended but natural looking, and the setting is perfect for a spring picnic.

Exit Central Park at 77th Street, where you'll find yourself directly in front of the imposing **American Museum of Natural History** ❹, one of New York's most important cultural institutions. If you look beyond the grand architecture, you'll find all sorts of interesting details that may pique children's fancy,

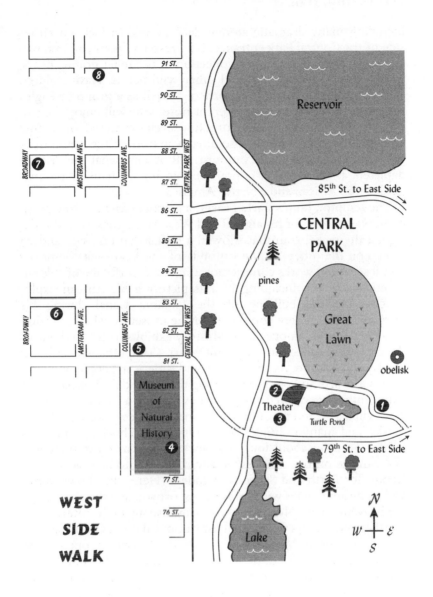

including many dramatic animal decorations. In fact, on either side of the Central Park entrance, is a "bestiary" your children will enjoy discovering. Look for a collection of bas-relief granite bears, bison, moose, rams, lions, and other wild beasts. Have children spot the large eagle over the portico, as well as a group of eagles on the turret above. On a different note, you will enjoy the impressive memorial to Theodore Roosevelt, centered on a fine equestrian statue (c. 1940)—also directly in front of the museum. A great naturalist and conservationist, T.R. is somewhat rhetorically depicted as an explorer-hunter on his horse, flanked by two guides—an African and a Native American.

The sculptor, **James Earle Fraser**, a personal friend of the president, was known for his animal and Western themes. (He also designed the nickel coin that showed a buffalo on one side and an Indian on the other.) In the Rotunda of the Roosevelt Memorial you'll see more works commemorating the colorful life of this energetic president, including murals picturing his African explorations and the building of the Panama Canal during his presidency. From here you can enter the museum, where, in addition to its world-famous natural-history exhibits, you'll find one of the city's best collections of primitive art. Comprehensive cultural displays on Eskimo, Asian, African, and American people with costumes and arts and crafts are among the fine exhibitions. You can enjoy entirely re-created village scenes (such as a wedding in an Indian village), models of a traditional Japanese home, African masks, and many examples of primitive art. This large museum (which occupies about four city blocks) contains more than anyone can see on one visit, especially if the not-to-be-missed Rose Center for Earth and Space is included. (Here, sky shows, films, and panoramic slides will almost transport you and the children to the heavens above. Shows are held daily, usually in the afternoons, but there are always permanent astronomical displays on view.)

The American Museum of Natural History is open daily, 10–4:45; Wednesdays until 8; and Sundays and holidays, 10–5. There is a discretionary entrance fee. ☎ 212-769-5100. For information on the Rose Center for Earth and Space, ☎ 212-769-5920. There is an entrance fee.

Upon leaving the museum, turn left onto 81st Street, and walk to number 25, between Central Park West and Columbus Avenue.

Have your children spot a small stone squirrel ❺ in medallion bas-relief on the third floor between two windows. (He's busily eating an acorn.) This is the kind of decorative detail that adds charm to many otherwise nondescript buildings in New York.

From here it's a fairly short walk to the **Children's Museum of Manhattan** ❻, at 212 West 83rd Street, between Broadway and Amsterdam Avenue. A relatively new place (founded in 1973), it is filled with innovative exhibits and events where children are encouraged to participate, as well as to observe, learn, and have fun. There is a main exhibition hall, including the "Brainarium," with films. And there are magical patterns, games, and a so-called activity station; an up-to-the-minute media station complete with the latest of equipment, studios, and videos to inspire today's youngest communications generation; an early-childhood center with activities for the tiniest tots; a well-lit, airy art studio for everything from painting, sculpting, and etching to weaving, calligraphy, and bookmaking; a nature and pet center (a miniversion of some of the exhibits at the Museum of Natural History); and a photography studio, collection rooms, greenhouses, outdoor gardens, and a roof garden. Here, children of all ages can explore art, science, and nature throughout the four floors of exhibits, studios, and activity centers. It's a very busy, bustling place, so come prepared. Hours: Tuesday–Sunday, 10–5; Friday, 2–5; closed on holidays. There is a small admission fee. ☎ 212-721-1223.

If energy level is not a problem for you or the child, end your outing at a special children's playground at West 91st Street. But we have something else for you to see en route: a whimsical and very lifelike statue in the courtyard of the **Montana Building**, at 247 West 87th Street (on Broadway, between 87th and 88th streets). Called *Park Bench* ❼, this bronze work by **Bruno Lucchesi** realistically depicts a family group—grandparents, mother, and small child—sitting on a park bench. Here at the Montana their bench is located on a sort of dais well above ground level, so that you can look up to the sculpture.

It's a short distance from here to the last stop on this walk. Don't fail to take your small fry to **Constantino Nivola**'s **Children's Playground** ❽ at 91st Street between Columbus and Amsterdam avenues. Here, on an ordinary city block, is a charming collection of stone sheep, just the size for small children to enjoy. Nivola, a

native of Sardinia, specializes in children's sculpture, and the sheep on 91st Street are a delightful addition to the city. Of several different colors, these rough-textured, woolly-looking creatures are fanciful, sturdy, and obviously popular with small kids. Nivola is a leading exponent of this kind of environmental sculpture for playgrounds.

. . . And in Addition

Another wonderful spot for children is the **Battery Park Playground**. These 8.2 greenacres include a playing meadow and children's playground, complete with carousel, child-size bridges, climbing nets, slides, games, swings, and animal sculptures. But of particular interest is *The Real World,* an enclosed paved terrace featuring some fifty whimsical bronze sculptures by **Tom Otterness**. Conceived as a playground to stimulate the curiosity of children, it is an unusual collection of odd objects and creatures—animal, human, imaginary, real, giant, and Lilliputian—in the most imaginative and unlikely combinations. Children and adults alike will delight in these sometimes surreal, always clever vignettes: a cat dressed in a bowler hat plays chess at a picnic table; Humpty Dumpty fiddles away, while a creature looking like a vacuum cleaner/dinosaur is about to attack; a dog carefully observes a cat stalking a bird about to catch a worm; a frog atop a lamppost looks down on the proceedings, while a fierce-looking dog is tightly chained to a water fountain. Footprints and penny motifs (in apparent acknowledgment of nearby Wall Street) can be found throughout, in the most unexpected spots. Overscale bronze pennies and child-size footprints are interspersed in a winding stone path, and an island made entirely of pennies is surrounded by a moat. Children will enjoy discovering and identifying these and the other items that are sometimes cleverly disguised by Otterness's intricate designs.

Other sites of interest for children around the city include the following:

☞ The **Doll and Toy Museum of New York City**, 610 Henry Street, in Brooklyn (by appointment or tour). ☎ 718-243-0820.
☞ The **Children's Museum of the Arts**, 182 Lafayette Street. ☎ 212-274-0986.

☞ **Staten Island Children's Museum**, 1000 Richmond Terrace. ☎ 718-273-2060.

☞ **Brooklyn Children's Museum**, 145 Brooklyn Avenue. ☎ 718-735-4400.

☞ The herd of sculpted hippos by **Bob Cassily** is the centerpiece of the children's playground in **Riverside Park** at 91st Street.

18

University and Cathedral Walk

Art on the Columbia Campus and
Nearby St. John the Divine

HOW TO GET THERE
Subway: 1 or 9 train to 116th Street/Columbia University.

In the heart of uptown Manhattan you'll find the campus of **Columbia University** hospitably housing a number of interesting sculptures. Set amid the walkways and hedges of the lovely college campus is a great variety of artworks—each separately placed to enhance the building behind it or the courtyard around it. We suggest that you arrive at the 116th Street entrance to the campus and walk directly through the large gates into the center of the campus. From there you can follow this brief walking tour to see the highlights of the sculpture collection. While you are on your art-walk you might step into several of the buildings that house museum collections or student art shows. But our main focus in this walk is on the outdoor art, which is almost always accessible and is particularly enjoyable to see on a nice spring day, when the campus is filled with students lolling about the grounds (and sometimes sitting on the sculptures).

Begin your walk at the main entrance at Broadway and 116th Street; here you will find the first of Columbia's outdoor artworks. Forming the pylons to the main gate are two tall, imposing statues. One represents Letters and the other, Science ❶. They date to about 1915 and 1925, respectively, and were made by the sculptor **Charles Keck**. Their granite forms are properly dignified for the entrance to a great university. *Letters* (on the south side) is a classically draped female figure holding an open book across her chest, while *Science* is a male figure holding a compass and a globe. Both are in the classical style of early-nineteenth-century institutional sculpture that personified the arts and sciences as idealized ancient Greeks serenely standing atop pedestals.

ART ON THE COLUMBIA UNIVERSITY CAMPUS

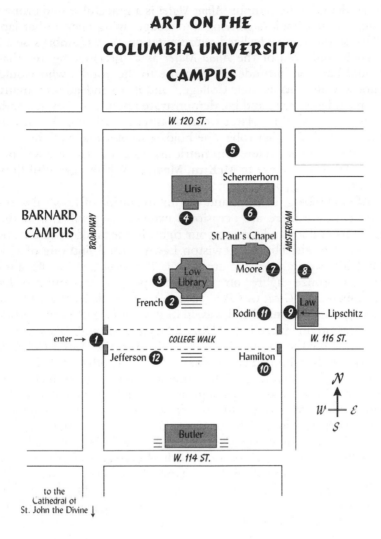

Walk in through the gate to the wide central space of Columbia's main campus. On your left is **Low Library**, now home to a variety of short-term exhibitions and events. (The library itself has moved across the campus.) On the wide steps of Low Library is perhaps Columbia's best-known sculpture, *Alma Mater*, by **Daniel Chester French** ❷. Representing the university and welcoming

its students to the campus, *Alma Mater* is a graceful seated bronze figure with a book (signifying knowledge) lying open in her lap. (The statue is an idealized representation of Columbia's seal.) French conceived of the *Alma Mater* as a "gracious figure" that would have "an attitude of welcome to the youths who would choose Columbia as their College," and it has indeed seen many such students come and go, demonstrate upon it, and even bomb it in the 1960s. Alma Mater wears a laurel wreath and also has an owl in the fold of her robe. She holds a scepter made of shafts of wheat in one hand. Here symmetrically upraised arms are well designed to lead the eye to **McKim, Mead & White**'s graceful **Low Library** building behind her.

After climbing the steps and visiting the inside of Low's fine rotunda, where there are occasional exhibits, you will exit at the same front door and turn to your right. In the landscaped area to the west of the library (Lewiston Lawn), you'll find one of Columbia's favorite works of art. This is *The Great God Pan* ❸, a reclining bronze figure on a granite pedestal surrounded by shrubbery. *The Great God Pan* (1894–99) was made by the sculptor **George Gray Barnard** and was, in its day, the largest bronze work ever cast in one piece in the United States. Although *Pan* was not designed for the campus (it was a gift from the Alfred Corning Clark family, who had commissioned it for another site), it is an unmistakable landmark on the campus. Pan (half goat, half man) is seen lying on a rock, playing his pipe, and gazing shyly at the world. His body is powerful, his face, with its goat ears and mass of curls, rather sardonic. This pagan nature god is certainly not your run-of-the-mill university sculpture and should not be missed.

Walk around Low Library until it is behind you. You'll next come upon a distinctly different type of sculpture, a 1968 work called *Curl,* by the sculptor **Clement Meadmore** ❹. Made of giant twists of black-painted steel, it is 12 feet high and is a hollow squared tube twisted into a series of curved forms. Meadmore, a native of Australia, views public sculpture as a "bridge between human scale and architectural scale," and here his *Curl* sits directly in front of Columbia Business School's vertical modern building. Curiously, it is also a kind of reclining piece and makes a nice contrast with *The Great God Pan,* who stretches out on one elbow nearby.

From this point walk north, alongside Uris Hall, toward the School of Engineering (Mudd Hall). In the cemented plaza area there you'll find *Le Marteleur* ❺, a bronze work made in 1886 by a Belgian artist named **Constantin-Emile Meunier**. Though from a distance the strong figure (larger than life-size) seems quite abstract in form, up close you'll find it's a fairly realistic, socially conscious work celebrating the modern laborer. *Le Marteleur* (which means "a metal worker" or "hammerer") is one of Meunier's works that calls attention to the world's workers as noble, handsome, proud men. The figure here carries pincers for pouring molten metal; he wears a leather apron and a worker's cap. Slightly out of place on this patrician campus, he makes a strong statement not only as a work of art, but also in his positioning between the School of Business and the School of Engineering.

Here you will turn back (south) toward the center of the campus again and come to Schermerhorn Hall on your left. In this building on the eighth floor (take the elevator) you'll find a small museum housing visiting collections. Called the **Miriam and Ira D. Wallach Art Gallery** ❻, the museum holds exhibitions of interest to the public, as well as to the students and the faculty. Exhibitions change regularly and include contemporary—as well as traditional—work in painting, architecture, drawing, murals, and photography. ☎ 212-854-7288.

On leaving this building, continue south. On your left there is an overpass crossing Amsterdam Avenue at 117th Street, and here you'll see **Henry Moore**'s (1967) work called *Three Way Piece* ❼. This large bronze sculpture is 7 feet high and is a collection of abstract forms, quite distinct from the more-traditional (and earlier) Moore works—such as the reclining figures at Lincoln Center. The shapes, however, are recognizably Moore-like, as is the smooth bronze finish.

Nearby, across the overpass, is a very different work, *Tightrope Walker* (1973–79) by the sculptor **Kees Verkade** ❽. While Moore's sculpture is purely abstract in form, Verkade's is a more realistic, allegorical work. It is imaginative and fun to look at. Two acrobats are balancing one on top of the other, their arms outstretched as though they were walking a tightrope. Though the work is made of bronze, it was modeled with bits of clay and has the rough texture of long, knobby limbs we might associate with the tinier

Giacometti sculptures. It is a tribute to "Wild Bill" Donovan, the war-hero Columbia alumnus, who was known for his daring. *Tightrope Walker* can be seen from below, by the way, if you wish to go down to the lower level.

Our next artwork is *Bellerophon Taming Pegasus,* by **Jacques Lipchitz** ❾. This giant work (over 40 feet tall), which towers over the entrance to the Law School, might be enjoyed better from a distance. You might wish to back up over the bridge to get a better view. Created between 1964 and 1967, it is a quintessential Lipchitz design with its twisted shapes, wings, outstretched limbs, and grouping of forms. You can see the winged horse Pegasus, with Bellerophon trying to tame him by pulling him downward from his ascent toward heaven. Particularly typical of this sculptor's style is the horse's face, with its bulging eyes and contorted shape. A similar Lipchitz work, by the way, can be seen on the wall of the New York State Theater at Lincoln Center (see chapter 12).

Back on College Walk (the main artery through the campus to 116th Street), you'll spot a more traditional work on you left as you head toward Broadway. In front of Hamilton Hall you find, appropriately, a statue of Alexander Hamilton ❿, made in 1908 by **William Ordway Partridge**. The bronze statue shows Hamilton making a speech, his hand on his heart, his eyes intense. Hamilton, one of the most illustrious students at the college, has a companion piece, also by Partridge, in a statue of Thomas Jefferson (see below). Partridge was an American sculptor whose work was characterized by a somewhat impressionistic style, rather than the classical toga-draped or naturalistic style of so many other late-nineteenth-century / early-twentieth-century American sculptors.

In front of the philosophy building on the right of College Walk is a familiar statue: **Auguste Rodin**'s *The Thinker* ⓫. Rodin originally sculpted this famous work in 1880, but as is well known, it has been cast and recast numerous times. This casting of *The Thinker* was made in 1930. Certainly it would be hard to find a more suitable site for it, even though Rodin originally made it for the Pantheon in Paris. *The Thinker* has been interpreted in various ways, even by its own creator, who originally modeled a "poet-artist" brooding over man's condition. Later Rodin said it was "a social symbol," representing the "fertile thought" of humble people. In

any case, you'll enjoy seeing it in New York's own university environment.

As we mentioned, a statue of Thomas Jefferson ⑫ is the last stop on the Columbia campus. You'll see a work by **William Ordway Partridge** representing Jefferson in front of the Graduate School of Journalism, which is on the south side of College Walk. Made in 1914, it too celebrates the thinker, for Jefferson is shown as an intellectual with wrinkled brow and serious expression. Like the Hamilton statue, this one is also somewhat impressionistic, but it has the familiar details of likeness and dress. The statue was given as a gift to the university by the Joseph Pulitzer family.

This completes the outdoor tour, but visits to various departments and to **Barnard College** across Broadway will allow you to see additional exhibits. For example, you'll find architectural displays at the Architecture School, film exhibitions at the Fine Arts Department, and Middle Eastern art or student works in the appropriate buildings. To find out what's showing where, you can go to the visitors' office in Dodge Hall, just on your left as you enter the campus gates.

And now for a visit to America's largest Gothic cathedral and one of New York's major attractions. From the Columbia University campus it's a short walk to the **Cathedral Church of St. John the Divine**, at Amsterdam Avenue and 112th Street.

Begun in 1892, this extraordinary structure is still not completed. (Its predecessors in the Middle Ages took at least as long, if not longer, to be built, some never to be finished at all.) A bustling community unto itself, the St. John the Divine compound is populated with artists, artisans, construction workers, church people, and visitors moving about its vast expanses, busily engaged in various activities. As an art lover you'll enjoy wandering around and seeing the many individual chapels, the stained-glass windows, the lovely rose window, the stone carvings, the great bronze doors, tapestries, arches, columns, and other architectural details.

The seven chapels—each honoring a distinct ethnic group—are filled with art objects of interest. Two have impressive works by the noted sculptor **Gutzon Borglum**. In St. Columba's Chapel (dedicated to people of Celtic descent) are Borglum's figures representing influential personages in the English Church. St. Savior's Chapel (dedicated to Eastern Orthodoxy) includes over fifty of

Borglum's carvings. (You'll find additional work by this artist in other parts of the church.) Here, too, you will see many ancient icons of great beauty. St. Ambrose's Chapel contains fine Renaissance paintings by **Giovanni di Paolo**, **Simone Martini**, and the School of **Paolo Veronese**.

The cathedral's stained-glass windows are particularly appealing for their deep, intense color. Their style varies from faux-medieval to more modern. They represent many different areas of human endeavor, some surprising in a church setting. One of the bays is dedicated to sports, and you can identify a wide variety of activities, from bowling to auto racing and swimming. There are bay windows that depict the arts, education, the law, motherhood, medicine, and the press, as well as vignettes from history and the Bible. You shouldn't miss the magnificent rose window at the end, composed in a more traditional vein.

Rare tapestries are among the church's greatest treasures. There are two sets, both dating from the seventeenth century and depicting scenes from the New Testament. Those hanging in the nave, based on designs painted by Raphael in 1513, were made in England. The other group, called the Barberini tapestries, was woven in Rome on the papal looms founded by Cardinal Barberini. As you walk about, you will be struck by the remarkable wood and stone carvings and statues that adorn portals, niches, altars, pulpits, and columns. There are also constantly changing exhibitions of contemporary art. Among the unfinished portions of the church are the still-empty niches that await future works of art.

If you are interested in learning about the church's many treasures in greater detail, you might want to take a guided tour or pick up one of the guidebooks available in the gift shop outside the church.

Also outside the church is a tiny (but charming) Biblical garden, with plants mentioned in the Bible, and a courtyard with a fountain decorated in giraffe and crab motifs. If you have children in tow (and even if you don't), you won't want to miss the Children's Sculpture Garden. The garden's Peace Fountain was designed by sculptor **Greg Wyatt** in 1985 (see below). This is one sculpture garden where children are encouraged to touch the artworks and even to splash around the fountain. Surrounding the dramatic Biblical figures that form the center of the fountain are some 120 small bronze sculptures designed by children for a series of contests over

the years. There is also a nice seating area where one can relax and take in the scene.

One of our favorite parts of this visit is the crypt of the Cathedral, where Greg Wyatt has been sculptor-in-residence for years. After your descent into the depths of the Cathedral, Mr. Wyatt's studio-workshop will surprise and delight you. Here, in a brightly lighted, two-story space, giant sculptures take form, proceeding through the many and various stages that come before their casting in bronze.

You will find Mr. Wyatt a most informative and helpful guide to the work going on here. He uses the space for both Cathedral projects and his own commissions—among them many major monuments for public and corporate buildings. (You will see his large statue in the Cathedral's garden, the Peace Fountain, in various casted stages and parts on the shelves in the studio.) Mr. Wyatt's graceful, complex, figurative works begin as small plaster sculptures; they are transformed in this studio into the giant forms that in a later stage will be covered by a wax cast preparatory to being taken to the foundry to become the monumental bronze statuary we see in public spaces.

Of particular interest here, too, is the apprenticeship program that the sculptor encourages. Students from various city high schools and art programs are at work here under the most inviting conditions (except for the plaster-dust-filled air; we do not recommend sculpture studios to visitors with respiratory problems). This environment brings students together with the artist and the process in a way that is most unusual today, though it is a time-honored tradition since medieval days. And for those of us who know little about the process, this is an ideal place to begin.

To visit Mr. Wyatt's studio you must call for an appointment. ☎ 212-662-4479. The guard in the kiosk at the south-side driveway of the Cathedral will give you directions to the crypt.

Having visited the inside of the Cathedral, you should be sure to see the stone-carving workshop on the north side of the building. Here, for many years the stone carvings of the figures, pediments, cornices, and other parts of the Cathedral have been cut from limestone and other giant blocks of stone.

Although today the additions to the façade have come to a halt until further donations are received, the stonework continues on other commissions for buildings across the country. The vast

workshop areas include gargantuan cutting wheels for marble, storage of huge blocks of limestone, wheels and saws and other tools of the trade, and in the smaller areas, people at work at the more delicate task of hand carving and polishing. (Again, we do not recommend this very dusty environment to those with respiratory problems.)

This visit is more or less inspiring, depending on what is being worked on at the time you arrive. The recent slow-down in building and the interruption in the work on the façade of the Cathedral itself have left the stone workshop rather forlorn, but probably not for long. We know of few such workshops in New York, and a visit to see the stonecutters, sculptors, and the process itself is always interesting.

Many concerts and other special events are held at St. John the Divine. Tours are offered regularly at 11 and 2 on weekdays and 12:30 on Sundays, but you are welcome to walk around at will (except during services). The church is open daily, 7–5. ☎ 212-316-7400.

. . . And in Addition

☞ **Riverside Church**, at 490 Riverside Drive, has some wonderful stone carvings, stained-glass windows, paintings, and a cloister, as well as a 392-foot bell tower. Don't miss **Jacob Epstein**'s *Christ in Majesty* in the nave on the second-floor gallery and his *Madonna and Child* in the court next to the cloister. ☎ 212-222-5900.

☞ The **Interchurch Center**, nearby at 475 Riverside Drive, is quite active in the area's arts scene. In addition to sponsoring events such as concerts (on Wednesdays at noon), film screenings, and special art demonstrations, the Center also houses inviting exhibition spaces on the main floor: the Treasure Room Gallery, with changing displays of paintings, sculpture, drawings, photographs, and textiles; and some twenty display windows along the surrounding corridors for additional fine-arts viewing. Main office: ☎ 212-870-2200.

☞ **Nicholas Roerich Museum**, at 319 West 107th Street (at Riverside Drive), is a one-of-a-kind small museum in an elegant townhouse devoted to the works of **Nicholas Roerich**, an eclectic Russian artist, anthropologist, philosopher, traveler to the Far East, and nominee for the Nobel Peace Prize. Among

his unusual collections are paintings evoking Russia's ancient past and others celebrating nature's mystical powers. Particularly striking are the costume and stage-set designs he created for opera and ballet. (His collaboration with Igor Stravinsky on *The Rite of Spring* is legendary.) ☎ 212-864-7752.

☞ **Grant's Tomb**, Riverside Drive at West 122nd Street: This imposing memorial, now shiningly refurbished, is a dignified tribute to a beloved American hero. (It also happens to be the largest mausoleum in the country.) Reminiscent of the grand tombs of the emperors Hadrian and Napoleon, its marble interior includes a massive dome, allegorical bas-reliefs and sculptures, and matching polished-wood sarcophagi of Grant and his wife, Julia. There are also interesting displays concerning Grant's life. Outside, surrounding the building, is an unusual artistic feature: a series of benches, adorned with bright mosaic-tile designs, surround the monument and depict myriad images of city life. They were made by residents of the community and are filled with cheerful energy and good humor. Just across the street (on 122nd Street, between Riverside Drive and Claremont Avenue) is a little gem of a park called **Sakura Park**. Designed by **Frederick Law Olmsted**'s architectural firm, it is a lovely oasis.

19

Exploring Harlem's Artistic Heritage

HOW TO GET THERE
Subway: A, B, C, D, 2, or 3 train to 125th Street.

Art made by contemporary African American artists, as well as art of Africa and the Caribbean, is enjoying a cultural boom. New York has major exhibition spaces that focus on a variety of aspects of these arts—from African tribal masks and three-dimensional sculptures to the exquisite craftsmanship of folk arts. The following is a hop-skip-jump type of outing that will introduce you to the black diaspora—the extraordinarily widespread branching out of black culture.

Eventually (after 2006, we hope), you will be able to begin your artwalk in Harlem, exploring African art in its purest form, at the **Museum for African Art**. Now housed at its temporary location in Long Island City (see chapter 26), the museum is planning a new site at 110th Street and Fifth Avenue. You might wish to begin your tour of this artistic heritage at the museum's present location. Here are magnificent masks, figure sculptures, and other arts of various tribal origins. You will find many visual references to these shapes and styles as you journey into contemporary black art. The museum has changing exhibitions as well as a permanent collection. Recent shows included Face of the Gods: Art and Altars of Africa and the African Americas, and Fusion: West African Artists at the Venice Biennale; and a show concerning architectural sculpture by contemporary African artists.

The major exhibition space in New York for art of African heritage is surely the **Studio Museum of Harlem**. This facility, at 144 West 125th Street, is a lively place with frequently changing exhibitions. Some shows are coordinated with other museums—for example, the recent exhibition called The Decade Show was mounted in conjunction with the Museum of Contemporary His-

panic Art and the New Museum of Contemporary Art. Other exhibitions at the Studio Museum include works from its permanent collection—mostly by living artists. Occasionally the museum has major retrospective exhibits by noted artists such as **Romare Bearden**. Other recent exhibits have included works by contemporary black photographers and works by the museum's own artists in residence, one of the most interesting aspects of the Studio Museum. In the same building as the exhibition space are studios where artists can work and then have their output exhibited. This supportive setup encourages a number of black visual artists to work within their community. Among the many other activities of the museum are seminars and classes, both in art itself and in collecting, art history, and other aspects of the field. The museum sponsors tours and workshops. Hours: Wednesday–Sunday, noon–6. There is a small entrance fee. ☎ 212-864-4500.

Our next stop is the **Schomberg Center for Research in Black Culture**, at 515 Lenox Avenue and 135th Street. The Center has every sort of material relating to black life and culture, including many kinds of art. Among its major assets are a research library, Swahili recordings, and an important collection of books on African and black history. Special exhibits by black artists are ongoing. And there is also a permanent collection of African metalwork and carvings. To receive a listing of the changing exhibitions schedule, call ☎ 212-491-2200.

Also on 135th Street, at the **Harlem YMCA** (180 West 135th Street), you'll find a WPA mural by the well-known Harlem Renaissance artist **Aaron Douglas**. This lively scene of outdoor dancers can be found in the lobby. (Other murals in the building from the same period have been painted over; restoration is a goal for the future.)

Nearby, on 137th Street between Fifth and Lenox avenues in a foyer of **Harlem Hospital** are two murals by **Charles Alston**, an artist well known for his use of African symbols in his paintings of the black experience. The subject of these newly restored murals is medicine—both ritualistic and modern.

At 144th Street you'll find the famous **Harlem School of the Arts**, at 645 St. Nicholas Avenue. This institution is not only known for teaching the performing and visual arts, but also for sponsoring a number of art exhibits a year—both by its students and by outside professional artists. This is a good place to discover

up-and-coming young artists in an atmosphere of great enthusiasm. Before you go, call ☎ 212-926-4100.

. . . And in Addition

☞ The **Lenox Lounge**, at 288 Lenox Avenue, smack in the middle of Harlem, in its bar features renovated, warm-toned murals from Harlem's jazz heyday.

☞ **Triple Candie**, 461 West 126th Street: changing exhibits by contemporary artists. ☎ 212-865-0783.

☞ **Caribbean Cultural Center**, 408 West 58th Street (at Ninth Avenue): You can enjoy art, films, and other cultural events here. ☎ 212-307-7420.

20

The Unexpected Art Treasures of Audubon Terrace

Hispanic Society of America, the Numismatic Society, and More

HOW TO GET THERE

Subway: 1 train (local, marked 242nd Street heading north) to 157th Street; walk two blocks south.

Nestled in a partially enclosed block on Broadway, between 155th and 156th streets, the **Audubon Terrace Historic District** is a welcome and unexpected pleasure: a rich collection of art and historic treasures at the Hispanic Society of America's imposing building.

In this vast courtyard you'll find not only the Hispanic Society's museum, but also the Numismatic Society and the American Academy of Arts and Letters. At the center of the courtyard is a collection of dramatic sculptures, by **Anna Hyatt Huntington**, representing El Cid and a variety of animals. The **Hispanic Society of America** is now the centerpiece of the courtyard. This surprisingly rich collection was created through the efforts of Archer M. Huntington (Anna's husband), who, from an early age, was fascinated by Iberian culture. He traveled throughout Spain and Portugal, collecting manuscripts, paintings, and decorative artifacts from prehistoric times through the Moorish period to the modern day. The results can be enjoyed both in this impressive structure and in the facing building, which houses an extensive reference library (over a hundred thousand volumes and manuscripts having to do with Spanish and Portuguese history, literature, and art). In 1904 Huntington founded the Hispanic Society of America to promote Spanish culture and arts; the museum was opened in 1908, and the library in 1930.

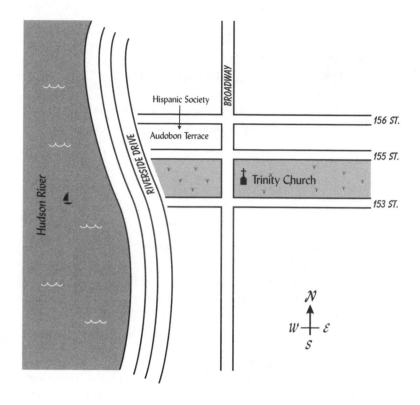

From the moment you enter the building you feel as though you are in an authentic Renaissance-style Spanish mansion. A gracious central two-story atrium (the main exhibition room), with sky-lights above, is surrounded by smaller, more-intimate galleries and niches. Carved woodwork on the walls and staircase, deep-red terra-cotta archways, rustic tile floors, and decorative, brightly colored wall tiles make the interior especially lovely. The rooms are filled with art treasures—a surprising number of fine paintings, drawings, sculptures, as well as decorative arts (rugs, furniture, ceramics, textiles, etc.). The paintings—from the earliest, intensely religious fourteenth-century works of the Catalan, Aragonese, Valencian, and Castilian schools to modern works—include an exceptionally rich collection of masterworks by **El Greco**, **Zurbaran**, **Velasquez**, **Ribera**, **Morales**, and **Goya**. El Greco's

early Toledan period is presented in his *Pietà* and *Holy Family*, both deeply spiritual works, as well as in his mystical *St. Jerome*, which shows the mesmerized figure with a long, white beard, gazing intently upon Jesus on the Cross. The two fine paintings by José de Riberas, *Ecstasy of St. Mary Magdalen* and *St. Paul*, embody the Baroque ideals of volume and light. Velasquez, the great master of portrait painting in the court of Philip IV, is represented in several fine works at the Society; in particular, his *Little Girl* is certainly one of his best portraits. The Society has several splendid Goyas (five paintings and ten drawings). In the central gallery you'll find the very large painting *Duchess of Alba* (1797), an enigmatic work that has left art historians wondering about her relationship with the painter. Her expression is defiant, and she is flaunting two rings on her fingers, one inscribed with "Goya" and the other with "Alba."

A more recent Spanish artist, **Joaquin Sorolla y Bastida**, a great friend of Huntington's, is especially well represented. His magnificent series of murals called *The Provinces of Spain* (1911)—fourteen canvases colorfully illustrating Spanish life and culture—takes up a full room. In addition, the Society owns at least another one hundred works of his (not on view, however). Hours: Tuesday–Saturday, 10–4:30; Sunday, 1–4. ☎ 212 926 2234.

Next-door you'll find the **American Numismatic Society**, which contains one of the world's largest coin collections, as well as the premier numismatic library (over seventy thousand items). Even though coins are not technically "fine art," they are artifacts of interest to anyone concerned with visual arts and history. The eight hundred thousand or so pieces that form this extensive collection include everything from Greek, Roman, Byzantine, and Renaissance coins to those of the modern era. Here you can also see metals and decorations from the Middle Ages to the present, as well as an interesting display of money in early America. Admission is free, but you must ring the bell for admittance. Hours: Tuesday–Saturday, 9–4:30; Sunday, 1–4. ☎ 212-234-3130.

As you walk from one museum to the next, you can't fail to see the dramatic grouping of sculptures in the central courtyard. These impressive works are by **Anna Hyatt Huntington**, especially known for her equestrian statues and animal pieces. In the middle, in heroic stance, is *El Cid Campeador* (1927), a vivid representation of the eleventh-century Spanish knight who valiantly

(and successfully) fought the Moors. He is shown on his equally heroic horse, proudly holding a pennant, a strong and victorious expression on his face. (It may amuse our readers to know that according to common lore, the position of horses' hooves in equestrian statues reflects the way in which the rider died. If all four hooves are on the ground, the rider died a natural death. If one hoof is raised, the rider died of his wounds. If two hooves are in the air, the rider was killed in battle.) The four warriors surrounding him in a symmetrical design at the base of the statue's pedestal symbolize Spain's Order of Chivalry. Alongside this group are two very interesting high reliefs in the limestone wall, both depicting characters of major importance in Spanish culture: *Don Quixote* (1942) and *Boabdil* (1943), the last Moorish king of Granada. Don't miss the wondrous collection of marble and bronze animals in the courtyard as well; they are all animals that are found in Spain: a bronze stag (1942), a doe and fawn (1934), and on a fiercer note, vultures, wild boars, jaguars, and bears (1936). Anna Huntington was clearly drawn to Spanish culture, as was her husband, and she claimed that his interest in all things Spanish "gave me the wish to supplement his work by my sculpture." The concept is grand and the result is stunning.

Also at Audubon Terrace you'll find the **American Academy of Arts and Letters**. It contains a wonderful library that includes first editions, musical scores, and memorabilia of its famous past and present members. There is also a permanent collection of paintings by the American Impressionist **Childe Hassam**. There is an annual art exhibition, as well. The Academy is open only by appointment. ☎ 212-368-5900.

After visiting the museums, cross Broadway to the southeast corner, where you'll see **Trinity Cemetery**, set behind the **Church of the Intercession**. Enter the gates on 155th Street.

Trinity Cemetery (a.k.a. the Graveyard of American Revolutionary Heroes), at West 153rd to 155th streets between Amsterdam Avenue and Riverside Drive, is open 9–4:30 daily. This landmark cemetery, the largest in Manhattan, dates from 1846 and is the burial site of such prominent people as John James Audubon, John Jacob Astor, Madame Jumel (of Jumel Mansion fame), members of the family of Charles Dickens, and Clement Clark Moore, author of "'Twas the Night before Christmas." A quiet, shady, and hilly

spot, surrounded by an ornamental iron gate, it is reminiscent of old New York, with its rural ambience and unleveled topography.

Just beyond the gate is the grave and marker of John James Audubon. One of the greatest American naturalists and nature artists, Audubon owned a farm at this very site. With a few carved relief drawings, his grave marker suggests more than many words; here are the delights of nature—birds and animals that he so beautifully recorded—and images of a rifle and of a palette and brushes, all on a simple Celtic cross.

The Church of the Intercession is a neo-Gothic complex including bell tower, parish house, cloister, and vicarage. Inside the church you'll find a fine wooden ceiling, wood carvings, and an altar decorated with many stones collected from early Christian shrines.

There is also a memorial to the architect of the church, **Bertram Goodhue**, by the notable sculptor **Lee Lawrie**.

. . . And in Addition

☞ The **Morris-Jumel Mansion** is not far away, at 160th Street and Edgecombe Avenue. (For more on this pre-Revolutionary house see chapter 13.)

21

Walking down Medieval Garden Paths

The Cloisters

HOW TO GET THERE
Subway: A train to 190th Street and Overlook Terrace; exit by elevator and walk through the park.
Bus: M4 Madison Avenue (Fort Tyron Park—The Cloisters).
Car: West Side Drive (Henry Hudson Parkway) north to first exit after George Washington Bridge, follow signs; parking on premises.

Among the particularly magical parts of the **Cloisters** (the Metropolitan's medieval-style museum in northern Manhattan) are the gardens. While the pleasures of visiting the museum's medieval architecture and seeing its exquisite collection of fine art from the Middle Ages may be well known to New York's museumgoers, its gardens are in themselves well worth a special trip. The arcades of five cloisters have been reconstructed with the original stones and integrated into the museum's architecture; four cloisters surround their own unusual gardens. These spots are extraordinarily evocative; in fact, it is hard to believe you have to exit into the twenty-first century when you leave. Though they are small, as gardens go, they are so filled with architectural, sculptural, and botanical interest that you might spend many hours walking round and round, or dreamily sitting on a bench imagining you are in thirteenth-century France, perhaps, or a member of a twelfth-century Cistercian order. Dimly heard medieval music sounds as you walk, and of course, the art treasures of this distant past await you in the stone-walled rooms of the museum.

Two of the cloisters (square-columned walkways that once were parts of monasteries) are enjoyable to visit even out of garden season, for they are in covered areas and are kept flowering throughout the winter. All four of the cloister gardens are at their

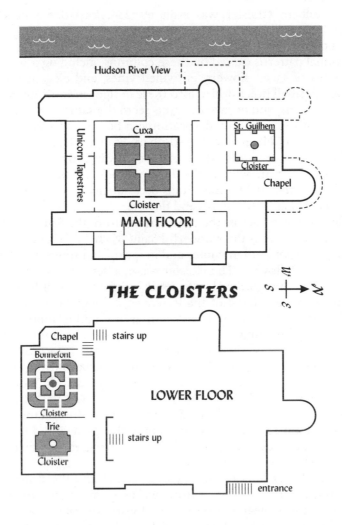

best in late spring and early summer, of course, when the flowers are blooming, the herbs bright and green, the espaliers leafy on their trellises. The following thumbnail descriptions should give you an idea of what to expect from each of these (chronologically listed) garden walks.

The earliest cloister is Saint-Guilhem le Desert. Formerly part of a French abbey that dates back to a Benedictine order in 804 AD,

Saint-Guilhem Cloister was built in 1206. Its stone pillars are topped by capitals (the decorative carved tops) whose designs are based on the spiny leaf of the acanthus plant. But there are many additional patterns carved on these columns, including a wonderful series of faces, flowers, entwined vines, and elegant foliage. There are small holes drilled into these designs in intricate honeycomb patterns, and no two columns seem the same.

Some of the sculptural decoration can be traced to ancient Roman design (still in evidence in southern France). This cloister surrounds an indoor garden that is planted fully in early spring. When we saw it last in winter, the flowers were potted and neatly arranged. The architectural details occasionally seemed to imitate the very shapes of the leaves and flowers.

Almost directly across the central room from the Saint-Guilhem le Desert Cloister is the wonderful Saint Michel de Cuxa Cloister, a beautiful spot both in winter and in spring and summer, when it is ablaze with flowers. This cloister was in a Benedictine abbey first built in 878, though the cloister itself is from the twelfth century. From an area northeast of the Pyrenees, it forms the central part of the framework of the Cloisters museum and is appropriately gracious and inviting. Its original function as a communal place for monks to walk, meditate, read, or take part in processionals can be readily imagined. The lovely stone walks surrounded by archways and columns open onto a sunlit garden of individual bedded flowers and plants. Each column is carved with typically medieval gargoyles, two-headed animals, or two-bodied monsters. You will want to spend time examining this garden and its cloisters, and perhaps sitting on a bench enjoying the ambience of quiet and beauty.

On the lower level of the museum you'll find the **Bonnefont Cloister**, a purely outdoor garden walkway. Its origins are in the south of France, near Toulouse. The cloister, with it slender graceful columns in rows of two, comes from the late thirteenth–early fourteenth century. Cistercian monks once walked through these cloisters, and the very simple design of the architecture and limited amount of sculptural pattern represent their asceticism. (Decoration was meant not to draw attention away from devotion to duty and God.) Of particular garden interest here is the herb garden, a favorite among New Yorkers. More than 250 species of plants that were grown in the Middle Ages are cultivated in this

outdoor space. In the center is a charming little well. The herbs are grown in raised planting beds with fences around them. Among our particular favorites here are the trained espaliers, growing against lattices in the sunlight. Anyone with an interest in gardening will find this cloister irresistible.

Finally, the fourth cloister, also on the lower level, is the Trie Cloister, from a Carmelite building in the Bigorre region of southern France. Reassembled with parts of several other cloisters, this small outdoor garden arcade is of particular interest if you look at the unicorn tapestries in the museum. The garden contains samples of the very plants woven into the design of the tapestries some five centuries ago. (Information at the Cloisters will identify them for you.) Part of the charm of this garden is the sight of the red tile roof surrounding it and the fruit trees set among the flowers. This garden, of course, is also only cultivated during growing months.

Though obviously you will get more pleasure out of this medieval garden walk in the growing season, even in wintertime it is nice to wander about the unkempt cloisters outdoors, to see the view of the Hudson, and to contemplate the beauty of the architecture and sculptural designs in the indoor gardens.

Among the many treasures you will want to enjoy while you are in the museum are the unicorn tapestries, the stained glass in the Boppard Room, the wonderful altarpiece by the fifteenth-century painter **Robert Campin**, and our particular favorites, the medieval wood sculptures. Children, by the way, will enjoy this walk; there are numerous crenellated walls, dark staircases, and impressive and picturesque statues that they'll love, and there are even medieval playing cards on display.

A visit to the Cloisters is perhaps the closest you can get to being in France while in Manhattan. We found the combination of art, history, and flowering plants an irresistible delight.

. . . And in Addition

Many events of interest are held at the Cloisters; among them are gallery talks on such subjects as medieval imagery, tapestries, gardens of the Middle Ages, and colors in use in medieval France. There are many concerts of medieval music played on early instruments. You will also find demonstrations of how medieval art

was made, including such techniques as enameling and miniature painting. There is a guide to the gardens in which each plant is labeled and described. For more information on all these events, including guided tours, call ☎ 212-923-3700. If you feel the need for additional exercise, you might wish to leave the Cloisters by way of Fort Tyron Park and walk south through this very pleasant park, with its terrific views of the Hudson and New Jersey's palisades.

The Bronx

The Bronx

22

Botanical Delights, Indoors and Out

New York (Bronx) Botanical Garden Walk

HOW TO GET THERE

Subway: B, D, or 4 train to Bedford Park Boulevard Station. Then take 26 bus eastbound or walk eight blocks east.

Bus: Regular bus service from Manhattan, Westchester, and the Bronx. Call for information: ☎ 718 817 8700.

Car: Get on Bronx River Parkway north, either from the Cross Bronx Expressway (Route 95) or from the Triborough Bridge and the Bruckner Expressway (Route 278). Follow signs for Botanical Garden (after the Bronx Zoo). Parking on premises (small fee).

It's a cold, bleak, and gray February morning, and you're wondering if spring will ever come. Perhaps it's a muggy, noisy New York summer day, and you're feeling hot and bothered. A visit to the **New York Botanical Garden** in the Bronx, where you are transported to a special world, will lift your spirits at any time of the year. For here, in this wonderful and vast oasis of natural beauty, all sorts of plants and flowers grow, bloom, and proliferate during much of the year—whether inside the grand Conservatory (where spring becomes a reality, starting in early February) or throughout the bucolic 250 acres of meadows, woodlands, ponds, brooks, hills, and gardens. In this environment you will not only feel a sense of peace and relaxation—away from the cares of the surrounding city—but also of joy in the discovery of the wonderful gardens.

The New York Botanical Garden—one of the largest and most important in the country—was the creation of Dr. Nathaniel Lord Britton, a young American botanist. While on his honeymoon in England in 1889, he and his bride visited the Royal Botanic Gardens at Kew, outside London. They were so inspired and enthused

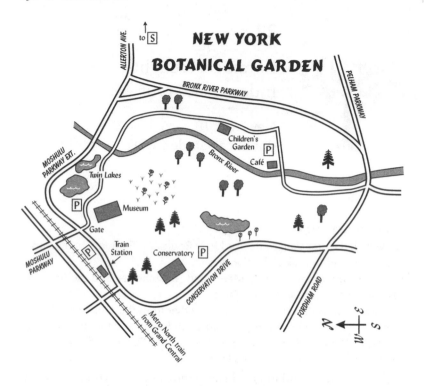

by what they saw that they were able to convince the Torrey Botanical Club in New York to create within the newly formed Bronx Park a similar public institution for botany and horticulture.

The resulting complex is very grand indeed (and becoming grander in a massive restoration project), encompassing the famous **Enid A. Haupt Conservatory**, as well as a wide variety of outdoor gardens and several imposing buildings housing a library, a charming botanical shop, classrooms, and administrative offices. One of the main attractions throughout the year is the Conservatory, an elegant Victorian greenhouse ambitiously patterned after the Palmer House at Kew Gardens (1884) and the Crystal Palace at Hyde Park in London (1851). Its eleven galleries, which surround a courtyard with two reflecting pools, are a delight to wander through; here you will experience a variety of habitats, climates, and collections of plants—from historic to thematic to old-fashioned English spring gardens. At the entrance of the Conservatory

is the splendid Victorian-style Palm Court, a 90-foot-high central-domed pavilion that contains over three thousand species of palms of different sizes and shapes. Some galleries are devoted to changing displays of flowers and plants, including exuberant spring flowers in the most brilliant colors, patterns, and combinations, which cheered us up on one particularly grim wintry day. Other galleries concentrate on very special permanent exhibits; among our favorites are two galleries devoted to new- and old-world desert plants, where you can see the endlessly fascinating masses of cacti (some of which are very old) with their fantastic shapes and textures, as well as the subtly shaded sagebrushes and exotic bushes from the American desert. Another favorite is a mysterious primeval fern forest with cascading waterfall, orchids, and mosses. You can view this display from a skywalk above, but walking through it makes you feel as if you're in an exotic jungle. As you wander from one room to the next, you will experience the different environmental habitats and climates—from the dry heat of the desert to the sultry tropics.

Surrounding the Conservatory are several inspiring gardens that should be visited during the appropriate seasons. The formal Bechtel Memorial Rose Garden is a particular pleasure with its geometric designs formed by crisscrossing paths amid rose beds containing over two hundred varieties of rose bushes. The Jane Watson Irwin Garden with its collection of flowering perennials, ornamental grasses, and bulbs is systematically arranged to produce a colorfully pleasing effect. The Armand G. Erpf is a compass garden, where the points of the compass are made of granite cobblestones surrounded by Victorian plantings. There is a small, elegant herb garden containing over eighty varieties of herbs. A sensational rock garden where you will find masses of plants from rocky and mountainous regions of the world is interspersed with giant boulders to create an alpine habitat. The native-plant garden features wildflowers and other indigenous plants of our region growing abundantly, along with forest trees, a limestone outcropping, a marshy meadow, and a sandy strip of New Jersey Pine Barrens. And throughout these varied gardens are avenues of bulb displays, hills of daffodils, circular beds of crocuses, and masses of azaleas and rhododendrons—truly a feast for the eye! If you're not feeling too tired, you might walk through parts of the hemlock forest, 40 acres of virgin forest that cuts through the middle of the

garden. This unique woodland is supposedly the only section remaining of the original forest that once covered all of New York City.

After you have taken in all this natural beauty, you might want to browse in the Shop in the Garden, an original little store located in the Visitor Center (open Tuesday–Sunday, 10–5).

The New York Botanical Garden is open Tuesday–Sunday, 10–4 (summer hours are 10–6); there is an admission charge (except Wednesday all day and Saturday, 10–12) for grounds only, and there is a charge for parking. There are guided tours on weekends from 10:30 to 3:30. To get information or make arrangements, call ☎ 718-817-8747. The general information number for the garden is ☎ 718-817-8700.

... And in Addition

☞ For occasional lectures, classes, and symposia on botany, horticulture, ecology, and landscape design at the New York Botanical Garden, call ☎ 718-817-8700. For guided tours on weekends, call ☎ 212-220-8747.

☞ **Lehman College**, Bedford Park Boulevard West: changing art and photographic exhibits. ☎ 718-960-8211.

☞ **Bronx Museum of the Arts**, 851 Grand Concourse at 161st Street: Changing exhibitions of modern painting, photography, and sculpture, as well as community art shows can be seen here and at satellite galleries throughout the Bronx. ☎ 718-681-6000.

☞ A **Tom Otterness** bronze sculpture called *Double Foot* is a new addition to **Roberto Clemente State Park**, near Yankee Stadium. These giant, melded-together feet are adorned by tiny sculpted figures.

☞ **Bronx Central Post Office**, Grand Concourse and 149th Street: On the walls inside are a series of murals celebrating Americans at work, by **Ben Shahn** and his wife, **Bernarda Bryson**. Among the colorful scenes are farmers planting their fields and engineers surveying sites. One vignette depicts Walt Whitman speaking before a group of workers and their families, apparently discussing his poetry.

☞ In the elevated IRT station for the 6 train at East Tremont Avenue and Williamsbridge Road there is a stained-glass triptych

by the noted artist **Romare Bearden**. The recently installed 9-by-6-foot work, *City of Glass,* depicts a luminous city. (For more subway art see chapter 33.)

☞ **Bronx River Art Center Gallery**, 1087 East Tremont Avenue (at 177th Street): exhibits of professional artists, children's classes, workshops. ☎ 718-589-5819.

23

Woodlawn Cemetery

Artists' Graves and Artistic Monuments

HOW TO GET THERE
Subway: 4 train or Metro North Harlem Line (from Grand Central) to Woodlawn.
Car: Cross Bronx Expressway to Jerome Avenue; entrance is on your right, opposite Van Cortlandt Park. Or Major Deegan Expressway, Exit 13, at East 233rd Street, to Jerome Avenue.

NOTE
Open 8:30–5 daily. Maps available at entrance (see security). Visitors are welcome to walk and drive around the grounds; shuttle buses provide frequent service. Guided tours offered. ☎ 718-920-0500.

Woodlawn Cemetery comes as a wonderful surprise to the first-time visitor. A peaceful oasis surrounded by a bustling urban environment, it contains a remarkable collection of artistic and historic monuments and mausoleums in an unusually lovely setting. Here, in an idyllic landscape of magnificent trees, shrubs, flowers, and ponds are buried some three hundred thousand souls—among them many noted figures in politics, sports, science, industry, and the arts. Their graves range from simple stone markings to grandiose monuments with sculptures, Gothic arches, stained-glass windows, and myriad decorations. To stroll on winding shaded pathways through these vast grounds—about 400 acres of gently rolling terrain—is a rare treat for anyone, especially those who love history, art, architecture, gardens, or even birds (nearly 120 species have been spotted here).

Woodlawn was founded in 1863, as a "rural cemetery," in the tradition of Green-Wood in Brooklyn (see chapter 29). Like other garden cemeteries, Woodlawn was an inviting spot for leisurely

WOODLAWN CEMETERY WALK

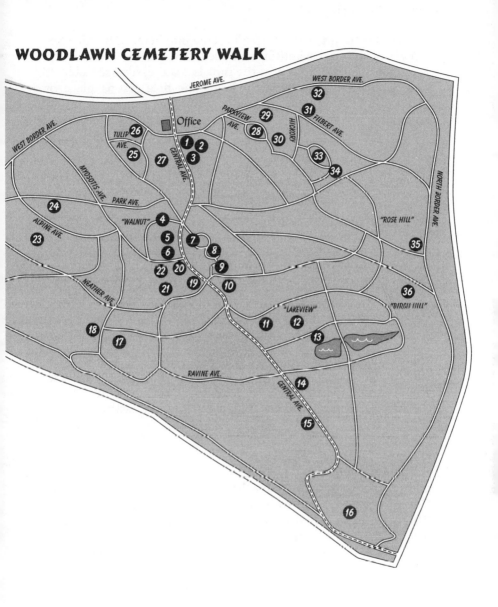

JEROME AVE.

WEST BORDER AVE.

32

PARKVIEW AVE.

31

FILBERT AVE.

29

Office

28

HICKORY

WEST BORDER AVE.

30

TULIP AVE.

26

25

27

CENTRAL AVE.

1 2

3

33

34

NORTH BORDER AVE.

MYOSOTIS AVE.

PARK AVE.

"ROSE HILL"

24

ALPINE AVE.

"WALNUT"

4

23

5

7

8

35

6

9

HEATHER AVE.

22 20

21

19

10

"LAKEVIEW"

36

"BIRCH HILL"

11

12

18

13

17

RAVINE AVE.

14

CENTRAL AVE.

15

16

walkers, before urban public parks came into being. The site cho-
sen was within the beautifully wooded Bronx River Valley, which
was not yet part of the city at the time but was easily accessible. It
soon gained the reputation for being the final resting place of
many prominent people, not only from America, but from all
around the world.

Since the cemetery now has a greater number of interesting
graves than one can possibly see at any given time, we have limited
our suggested itinerary to some sites of artistic or architectural
importance, as well as to those where noted artists are buried. Our
list is by no means comprehensive, and we hope you will make
your own discoveries as you zigzag through this labyrinth, search-
ing for the sites.

Before starting off, we recommend that you pick up a map from
security, just inside the entrance gates, to help you locate streets.
(Note, however, that the numbers on the itinerary below corre-
spond to our map, and not to that of the cemetery.) You'll find the
staff unusually helpful. So don't hesitate to ask for directions, if
you get lost.

Begin by walking to the cemetery's Central Avenue, the wide
street directly in front of you. Our first stop is the **Gates Mau-
soleum** ❶, a classical Greek temple on the left corner. Here you
will note an impressive bronze door with grieving figure. This is
the work of **Robert Aitken**, a leading American sculptor in the
representational style, known for his busts of famous Americans
(Thomas Jefferson, Edgar Allan Poe, and Henry Clay, among oth-
ers).

The **Ehret Mausoleum** ❷ is next, an impressive French-style
mausoleum guarded by stone lions. These creatures protecting
George Ehret (a prosperous beer magnate) are by **John Massey
Rhind**, an architectural sculptor who also made commemorative
portraits of notable Americans.

Nearby is the Egyptian Revival–style **Woolworth Mausoleum**
❸, a stark white structure featuring two sphinxes. This tomb
(where F. W. Woolworth and his granddaughter Barbara Hutton
are buried) was designed by **John Russell Pope**, the architect of
the Jefferson Memorial in Washington, D.C.; the statues are by the
sculptor **J. C. Loester**.

Continue on Central Avenue, past Park Avenue, to the "Walnut"
plots. On your right you'll see the **H. A. C. Taylor Mausoleum**

❹, designed in 1902 by **McKim, Mead & White**, This is one of eight tombs at Woodlawn by this historically important architectural firm.

Next to it are the **Leeds Mausoleum** ❺, designed by **John Russell Pope** in 1910; and the **Bliss Memorial** ❻, created by **Robert Aitken** in 1917, with figures carved by the **Piccirilli Brothers** (one of whom, Attilio Piccirilli, was a sculptor of monuments in his own right).

Cross Central Avenue to Oak Hill. Here you'll find the **St. John Memorial** of 1916 ❼, whose single figure is by noted sculptor **William Ordway Partridge**. An important creator of commemorative statuary and monuments, Partridge is known for his images of Thomas Jefferson, Alexander Hamilton, Horace Greeley, General Grant (on his horse), Beethoven, and Tennyson, among others.

Just down the road is the **Goelet Mausoleum** ❽, again by **McKim, Mead & White**; it once was more elaborate, with a gilded front by **Edward Sanford**. Nearby is the **Clark Memorial** ❾, a grand neoclassical temple decorated with Ionic columns and bas-reliefs by **Paul W. Bartlett**. This imposing tomb is the final resting place of William A. Clark, a spectacularly wealthy U.S. senator from Montana who, among his many real-estate holdings, owned a lavish 130-room mansion on Manhattan's Fifth Avenue.

Cross Prospect Avenue to the "Hawthorn" plots. Here is the **Kinsley Memorial** ❿, by the legendary sculptor **Daniel Chester French**, one of the most influential artists of his time. French, especially noted for his seated Abraham Lincoln at the Lincoln Memorial in Washington, is well represented across the country, with his many noted war memorials and images of national leaders and allegorical figures. (In New York you can see several of his works, including the famous *Alma Mater* in front of Low Library at Columbia University.)

Find your way back to Central Avenue, and make a left at Lawn Avenue. In this section ("Lake View") you'll see the imposing **Jay Gould Mausoleum** ⓫, where the infamous nineteenth-century financier is buried. Designed in 1884 by **H. Q. French**, the Greek-style temple with Ionic columns sits majestically on top of a hill, surrounded by enormous weeping beech trees.

Walking left again, following small circular paths, you'll come to the **Whitney Family Monument** ⓬, a polished black granite

structure designed by **Stanford White**. This group of gravesites hidden beneath individual shrubs (a custom from the Near East) includes that of the remarkable Gertrude Vanderbilt Whitney. A sculptor/philanthropist/founder of the Whitney Museum all in one, she created many works that can be seen in various parts of the country, in France, and even right here in Woodlawn (see the Untermyer Memorial, stop 18).

Nearby, across Observatory Avenue, is our next site, the **Warner Mausoleum** ⑬, by noted architect **Cass Gilbert**.

Return to Central Avenue and walk to the "Evergreen" plots. On your left will be the **Pulitzer Memorial** ⑭. Here lie the illustrious newspaperman Joseph Pulitzer (1847–1911) and his family, in front of a simple white stone bench. A black bronze figure by **William Ordway Partridge** (the same sculptor who made the solitary figure in the St. John Memorial, stop 7 above) sits in contemplative mode.

Continue on Central Avenue; on your right, in the "Catalpa" section is the gravesite of the illustrator **James Montgomery Flagg** ⑮. He is perhaps best known for having created the "Uncle Sam Wants You" poster used to recruit soldiers during the two world wars.

Our next stop is further down Central Avenue and to the left, within the "Magnolia" area. Here you'll come to one of the grandest of all mausoleums in Woodlawn, the **Huntington Memorial** ⑯, an imposing temple of granite and marble, majestically situated above a grand staircase. The enormous bronze door features bas-reliefs by **Herbert Adams**, known for his architectural figures, war memorials, and allegorical works. Here lie the railroad magnate/robber baron turned philanthropist Collis P. Huntington, his son Archer, and his daughter-in-law, the prominent sculptor **Anna Hyatt Huntington**, especially noted for her powerful animal and equestrian works. (One of her most dramatic groups dominates the courtyard in front of the Hispanic Society Museum, in Upper Manhattan, see chapter 20.) She also sculpted the **Arabella Huntington Memorial** (commemorating Collis's second wife), which is just to the left of the mausoleum; surprisingly, it is Anna who is buried here, and not Arabella.

To reach the next stop, you have to take a slight detour, up Ravine Avenue (right) to the intersection with Whitewood Av-

enue. On your right you'll find the **Memorial to Henry Russell** ⑰, yet another work by **McKim, Mead & White**. On your left, off Whitewood, is the aforementioned **Untermyer Memorial** ⑱, situated on a beautifully landscaped quarter-acre hillside plot. This garden memorial includes waterfalls, terraces, and a walk leading to the bronze monument by **Gertrude Vanderbilt Whitney**. The unusual monument has a middle section open on three sides, like windows with bronze shutters. Fortunately, these are left open so that one can see the three evocative figures inside: a woman with arms stretched upward, a male figure kneeling beside her, and a young woman turning away.

Continue on Whitewood, turn right at Heather, and proceed (again!) to Central Avenue. On your left, within the "Myosotis" area are several graves to note. The first is the **Cronin Memorial** ⑲, called *Memorial to a Marriage,* a very recent (2002) work by the sculptor **Patricia Cronin**. Nearby is the elegant **Garvan Mausoleum** ⑩, another classical design by **John Russell Pope**. This beautiful temple includes columns and a frieze of mourners by the sculptor **Edward Sanford**. Here lies Francis P. Garvin, a prominent chemist/entrepreneur who helped establish the modern American chemical industry.

The **Piccirilli Memorial** ❶ comes next. Designed by the most prominent of the six Piccirilli brothers, **Attilio Piccirilli**, this bronze image of a mother and child is a tribute to the family matriarch buried here. The Piccirilli brothers were noted stone carvers who operated their family sculpture studio right here in the Bronx. They carved stone decorations and sculptures on many public buildings, private mansions, and monuments in the city. Though some of the work was their own design, they also realized the designs of prominent sculptors like Augustus Saint Gaudens and Frederick MacMonnies.

Nearby, the **Straus Family Mausoleum** ❷, designed by the architect **James Gamble Rogers** in 1928, includes a funeral barge, commemorating the deaths of Isador and Ida Straus. The couple perished together on the *Titanic*'s fateful journey.

Another longish detour takes you to our next site. Follow Myosotis Avenue and turn left at Alpine. Within this section is the modest stone grave of the artist **Walt Kuhn** ❸, prettily set amid evergreens. Kuhn helped organize the explosive 1913 International

Exhibition of Modern Art in New York, which featured works by the French modernists—and to which he personally escorted President Teddy Roosevelt.

Find Alpine again and turn right onto Park Avenue. Here, in the "Oakwood" section, you'll come to the **Archipenko Memorial** ❹, where both the seminal Cubist sculptor **Alexander Archipenko** and his wife, **Angelica Bruno-Schmitz**—a noted sculptor in her own right—are buried. The work of Archipenko, a leading figure in the history of early modern sculpture, is not represented at this site. Having outlived his wife, he decided to place a sculpture of hers, an abstract seated figure, at their common gravesite. (You can see a work by the great master himself later on this tour, at stop 34.)

You are now heading back to the main entrance, to see two not-to-be-missed mausoleums. The first, on the corner of Tulip and Whitewood avenues, is the **Bache Memorial** ❺, a very grand tomb, fit for a king—or, in this case, a pharaoh. In fact, Jules Bache, a prosperous stockbroker/art collector fascinated with world art, demanded that his architect, **John Russell Pope**, pattern his final resting place after the Temple of Isis on the Nile River. The result is a large rectangular temple with great columns carved in papyrus motifs and other symbolic decorations. (There are a few other Egyptian-style mausoleums at Woodlawn, though not on as grand a scale.)

The nearby **Belmont Mausoleum** ❻, off West Borden Avenue, is perhaps the most magnificent of all at Woodlawn. And, no wonder: it is an authentic replica of the Chapel of St. Hubert at the Château d'Amboise in the Loire Valley, originally designed by none other than Leonardo da Vinci! Oliver Hazard Perry Belmont (grandson of Commodore Perry and a banker who developed Belmont Raceway) and his wife, Alva Belmont (a socialite, once married to William Vanderbilt, and later a suffragette), are buried here. Built by the sons of the famous architect Richard Morris Hunt, this is an elegant structure with exquisite stone spires and carvings depicting the life of Saint Hubert, patron saint of hunting.

The nearby **Borden Lot** ❼, off Fairview Avenue, is a nod to antiquity: this Roman sarcophagus on a pink marble plaza is an example of the work of architects **Carriere & Hastings**.

You are now near the entrance (and main office), having made quite a circle. If you're still feeling energetic, you can always check

out further sites. Following are a few recommendations, among the many worth seeing.

In the "Park View" section (off Parkview Avenue) look for the grandiose **Harbeck Mausoleum** ⑧, an unexpected grave that includes its own pipe organ! The structure, designed in 1918 by **Theodore Blake** from the firm of **Carriere & Hastings**, is richly decorated with Biblical scenes.

The **Hudnut Memorial** ⑨, commemorating perfume manufacturer Richard Hudnut, is by sculptor **Alexander Zeitlen**.

The graceful **Irene and Vernon Castle Memorial** ㉚ commemorates this famous early-twentieth-century dance team with an evocative sculpture by **Sally Farnham**, a protégé of Frederic Remington. Though mostly known for her images of western themes and horses, the artist here depicts a dancer, tired after a long day. *The End of the Day* also includes a graceful group of columns surrounding the seated figure.

Take Hickory to Filbert to the **Mori Memorial** ㉛, in the "Clover" section. The figure in this 1927 memorial (designed by **Raymond Hood**) is the work of the illustrious sculptor **Charles Keck**. A student of both Philip Martiny and Augustus Saint-Gaudens (with whom he later collaborated), Keck is especially known for his commemorative portraits of Lincoln, among other notable Americans.

The **Joseph Stella Mausoleum** ㉜, off West Border Avenue, commemorates the Italian-born artist who painted skyscrapers, bridges (his image of the Brooklyn Bridge has become an American icon), and other New York scenes.

From West Border take Filbert, then Hickory to the "Goldenrod" area. The two sites not to miss here are the **Harkness Mausoleum** ㉝ and the **Romney Memorial** ㉞. The Harkness gravesite is one of our favorite spots in the cemetery. This unusually lovely setting includes a little stone chapel (designed by the architect **James Gamble Rogers**) and—of special interest to garden lovers—an intimate walled garden designed by the formidable landscape architect **Beatrix Jones Ferrand**. You will want to linger at this inviting place! Nearby is the Romney Memorial, which features a big bronze pot by **Archipenko**.

The last two sites on our walk are the graves of Josef Stransky ㉟ and Thomas Nast ㊱. Walk along Filbert Avenue and turn right at North Border. In the "Rose Hill" section, on your right,

you'll see the grave of Josef Stransky, a composer who conducted the New York Philharmonic from 1911 to 1923. What distinguishes this plot is that the gravestone is another work of **Attilio Piccirilli**. (As of this writing, the music reproduced on the stone is being re-searched.) To reach the gravesite of **Thomas Nast**, continue on North Border and turn right on Birch Avenue; look for the marker on your right. Thomas Nast, the influential nineteenth-century il-lustrator and cartoonist, created popular Santa Claus images, the donkey and elephant symbols for our two political parties, and many other political cartoons. His tomb is one of the most modest to be found at Woodlawn, with only a simple (if rueful) inscrip-tion.

24

An Art/Nature Walk through
an Elegant River Estate

Wave Hill

HOW TO GET THERE

Subway: 1 or 9 train to 231st Street; switch to BX 10 or 7 bus at northwest corner of 231st Street and Broadway; walk across parkway bridge and turn left; walk to 249th Street, turn right at Independence Avenue, and follow signs to Wave Hill gate. Or A train to 207th Street; switch to BX 100 bus at 221st and Ishman streets (Broadway corner) to 252nd Street; walk to 249th Street, as above.

Car: Take the West Side Highway (Henry Hudson Parkway) up to Riverdale. After the Henry Hudson Bridge toll booths, take 246th Street exit. Drive on the parallel road north to 252nd Street, where you turn left and go over the highway. Take a left and drive south on the parallel road to 249th Street and turn right. Wave Hill is straight down the hill. Limited parking on the grounds and street parking.

NOTE

Wave Hill is free and the estate is open seven days a week, all year, except for Christmas and New Year's Day. But Glyndor House Gallery is open Tuesday–Sunday, 10–4:30; the Wave Hill House Gallery is open Tuesday–Saturday, 10–4:30; and the greenhouses are open only from 10–noon and 2–4.

Wave Hill (675 West 253rd Street at Sycamore Avenue) is one of New York City's less-known gems. Although familiar to some, this rare botanical garden/art-environmental center comes as a real surprise to most first-time visitors. Its picturesque setting high above the Hudson, with remarkable views on all sides, its formal gardens, vast rolling lawns dotted with huge old trees and environmental sculptures, and its acres of woodlands make this 28-acre park a unique spot. And as you stroll by its two stately manor

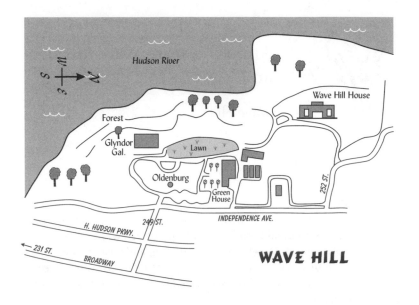

houses set in the plantings, you'll imagine you're enjoying a day at a private estate, miles away from the city.

In fact, in the past Wave Hill was the country home of several prominent New Yorkers. From the time the first of its two houses was built in 1848 by the jurist William Lewis Morris, it was occupied by illustrious people who often entertained members of New York society. As a boy, Teddy Roosevelt spent a summer here with his family, where it is said he learned to appreciate nature—birds in particular. William Makepeace Thackeray visited on occasion; Mark Twain lived here from 1901 to 1903 (and even built a treehouse on the grounds); and Arturo Toscanini occupied the house from 1942 to 1945. In the 1950s it was home to the head of the British delegation to the United Nations, and visitors included the Queen Mother, Anthony Eden, Harold MacMillan, and Konrad Adenauer. Most proprietors of Wave Hill were interested in preserving the incredible natural site from profiteering land developers and in further enhancing it with both formal and naturalistic landscaping. The financier George Perkins, who moved in during the 1890s, was particularly successful in securing Wave Hill's future. (A conservationist, he also led the movement to preserve the palisades and organized the Palisades Interstate Park.) He ex-

panded the estate, adding greenhouses, gardens, orchards, pergolas, and terraces. Working with a landscape gardener from Vienna, he created an English-landscape-style garden, mingling formal with informal plantings, and rare trees and shrubs with more-common species. Many of these plantings still remain. In 1960 the Perkins family deeded the estate to New York City to become an environmental center for the enjoyment of everyone.

Today, Wave Hill (also called Wave Hill Center for Environmental Studies) is and does many things. It sponsors indoor and outdoor art shows (particularly sculpture), horticultural exhibits, chamber-music concerts, drama and arts festivals, and outdoor dance performances. There are ecological programs, lectures, craft workshops, and such special events as hawk watches and maple sugaring. And it is a place in which to enjoy both the thousands of remarkable plant specimens in the formal and wild gardens and the contemporary art scattered throughout the vast grounds. A walk through this peaceful oasis will appeal to nature and art lovers alike, as well as to those who just want to get away from the chaos and noise of the city.

From the moment you walk through the gates, past the small parking areas, and onto the meandering brick walkway, you know you're in a very special place—for the landscape has a feeling of space, with breathtaking views and grand vistas. At the same time, it has intimacy and charm, unlike most institutional botanic gardens. The plantings have been designed on a small scale, so as to create a more personal environment, in keeping with Wave Hill's tradition as a private estate. And there is an atmosphere of peacefulness and ease. On nice days you might well see people sitting in the grass or in comfortable wooden armchairs scattered about the lawn, enjoying the view, contemplating a work of art, reading, or just relaxing. Others may be sketching, photographing, or wandering among the various gardens.

Directly in front of the entrance is a nineteenth-century stone-columned pergola, a perfect lookout point to the Hudson and the palisades. To the right of the entrance is an enchanting flower garden, one of a collection of distinct plantings. This particularly luxuriant one combines old-fashioned varieties with less-familiar plants, creating a carefree, romantic look. You will frequently see people examining the flowers with book in hand, admiring the colors and combinations, which are clearly the work of an artist (in

fact, **John Nally**, who redesigned this garden, had worked as a printmaker). Behind the flowers are the conservatory and greenhouses, with many exotic plants; an enclosed herb garden, with over one hundred varieties; a "wild" garden, with perennials and shrubs of different sizes and shapes arranged in a naturalistic way; an aquatic garden surrounded by shaded, trellised walkways; and more expanses of lawns and forests beyond.

As you wander from one garden to the next, you'll see contemporary outdoor sculptures in the grassy areas. Most of them are temporary exhibits that are shown for only a few months at a time, although two are on long-term loan: **Claes Oldenburg**'s *Standing Mitt with Ball* (1973), a whimsical steel and lead baseball mitt holding a wooden ball; and **Robert Irwin**'s *Wave Hill Wood*, remaining from his 1987 exhibition at Wave Hill. Irwin's group of ceremonial stone markers is set apart. The series of statuary begins at the roadside, continues across a grassy field, and ends in a wooded trail. The wanderer is invited to leave the road and experience both art and nature more intimately. In fact, the works shown at Wave Hill are commissioned and then installed in such a way as to harmonize with their surroundings; their materials and shapes blend with the natural landscape.

The works exhibited indoors are also of an environmental nature. They are shown in the two manor houses, Wave Hill House and Glyndor House. The older of these, Wave Hill House, is a handsome nineteenth-century fieldstone building with white shutters, ivied walls, and a vast terrace overlooking the river. Inside are several gallery rooms. One recent exhibit consisted of bold black-and-white wall drawings of plant life, by **Mike Glier**. Next to the gallery space is Armor Hall, where chamber music is performed frequently. At Wave Hill House you can pick up a map of the area, as well as sundry pieces of literature and brochures relating to exhibits and subjects of horticultural interest. One series of pamphlets gives detailed information on conifers (among the most ancient plants on earth), with a self-guided tour among Wave Hill's varied and rich collection. (All the conifers on the grounds are labeled.)

Glyndor House, the other indoor gallery, is a red brick Georgian Revival–style house built in the 1920s. The exhibition space here is particularly appealing and bright; the airy white-walled rooms with their delicate moldings and gleaming wideboard wood floors

provide an ideal setting. When we last visited, we viewed a con-temporary-sculpture show of natural wood pieces by the abstract artist **Jene Highstein**; his larger pieces were being exhibited out-side on the lawns.

We recommend you visit Wave Hill during the week, if possible, when it is rarely busy. Obviously, the gardens are best seen during the flowering season, but a walk through the grounds on a crisp, clear winter day can be a real joy, too.

For further information on the wide variety of special events at Wave Hill, such as exhibits, concerts, lectures, and classes, call ☎ 718-549-3200.

. . . And in Addition

☞ Near Wave Hill, alongside the Henry Hudson Parkway at 250th Street, is a 15-foot-high environmental work called *Past, Present, Future,* by contemporary sculptor **Vivienne Thaul Wechter**.

☞ The **Bronx Museum of the Arts**, 1040 Grand Concourse at 165th Street, is a contemporary art museum; call in advance for programs and exhibitions, ☎ 718-681-6000.

☞ **Ben Shahn** murals made during the WPA period can be seen at the **Bronx Central Post Office** at 558 Grand Concourse at 149th Street.

☞ **Longwood Art Gallery** at the Hostos Center, 450 Grand Con-course at 149th Street, Mott Haven. ☎ 718-931-9500.

☞ The Bronx Culture Trolley, which leaves from Longwood Art Gallery (see above), will take you on a tour of a variety of cul-tural sites in the borough. ☎ 718-931-9500.

Queens

25

Flushing Meadows

An Outdoor Gallery of Sculpture

HOW TO GET THERE
Subway: 7 train to 111th Street.
Car: Take Queens-Midtown Tunnel and the Long Island Expressway
(Route 495) or the Triborough Bridge and the Grand Central Parkway. Exit
at Shea Stadium and follow signs into park. Parking on premises.

HOURS
The park is open all the time, year round. No admission fee. **Queens Museum:** open Tuesday–Friday, 10–5; Saturday and Sunday, noon–5:30;
closed Mondays. ☎ 718-582-9700.

Perhaps you've noticed the massive metal Unisphere alongside the
Grand Central Parkway or Long Island Expressway, while driving
to Long Island. Or perhaps you've passed some large, looming
structures on your way to a sports event at Shea Stadium or the
National Tennis Center. If you've never ventured into Flushing
Meadows, we invite you to discover an intriguing world—and not
just the world represented by the giant Unisphere. For the vast
grounds (nearly 1,300 acres) at **Flushing Meadows–Corona Park**,
once the scene of two World's Fairs— in 1939 and 1964—are filled
with sculptures, pavilions, and odd abandoned structures from
those events. Some of these relics are surprisingly good works,
others merely forlorn curiosities, but you'll enjoy exploring them,
as well as seeing more recent outdoor sculptures. And in a mall in
the middle of the park you'll find the Queens Museum of Art,
with its worthwhile, albeit eclectic, exhibits and permanent collec-
tions—including its one-of-a-kind enormous physical panorama of
New York City.

For a change of pace, we propose you bike, rather than walk,
from one spot to the next. Bicycles can be rented for a modest fee

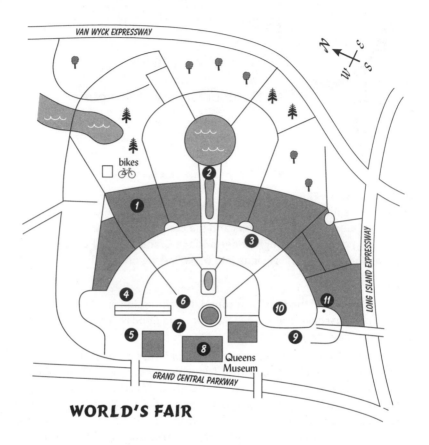

VAN WYCK EXPRESSWAY

bikes

LONG ISLAND EXPRESSWAY

Queens
Museum

GRAND CENTRAL PARKWAY

WORLD'S FAIR

at nearby Meadow Lake, and the flat terrain throughout the grounds is ideal. On your "art bike ride" you will enjoy riding through the vast expanse of lawns, rows of trees, lakes, and recreational facilities—a zoo, a children's farm, game fields, and picnic areas. But you will especially be amused by the odd artworks interspersed here and there.

From the bike-rental booth, take the path across the lawn toward the Unisphere. Our first statue is a traditional one: a bronze George Washington ❶ standing on a pedestal and looking appropriately presidential. It is by **Donald De Lue**, a well-known sculptor of works celebrating patriotic themes. (Another work by De Lue, *Rocket Thrower,* is next on our route.)

Nearby you'll find a small group (unfortunately only here temporarily) of distinctly untraditional sculptures bearing neither artists' names nor titles. On our last visit, these intriguing works included a chopping block, a giant propeller, an egg, and a carved tree within a circle of surrounding trees. (The site for these offbeat works is ideal; it seems a shame that more of the vast grounds are not used as temporary homes for contemporary works of this kind.)

You'll find *Rocket Thrower* ❷, a more realistic statue, east of the Unisphere, where it graced the Court of Nations at the 1964 World's Fair. Its creator, **De Lue**, was an American who specialized in the large symbolic figures that were so popular in the first half of this century. His *Rocket Thrower* is a giant male figure reaching dramatically into the sky to launch an arch-shaped object through a collection of stars that symbolizes space. It suggests reaching into the unknown.

Our next sculpture stands alone in a green field; it is an unusual and evocative memento of the past—the very distant past. Unlike people from other parts of the world, Americans are unused to spotting antiquities in their parklands. Here in Flushing Meadows you'll see the Column of Jerash ❸, a gift from Jordan given to the World's Fair by King Hussein. Built originally by the Romans in 120 AD, it was transported to Queens to ornament the Jordanian Pavilion, now long gone. It remains here in this unlikely spot—a lone but very elegant column from a group of classical ruins known as the Whispering Columns of Jerash for the sounds of the wind rustling among them.

Facing the Unisphere (between Shea Stadium and the Unisphere) is another striking sculpture: *Freedom of the Human Spirit* by **Marshall Fredericks** ❹. It is a green bronze statue of a man and woman reaching up to the sky. Three geese are poised to fly around them. Representational but symbolic in concept, Fredericks's work joins the De Lue and de Rivera works (next on your route) in attempting to capture the optimism of the World's Fair and its theme of exploration and spiritual freedom.

To the left of the museum is **José de Rivera**'s *Free Form* ❺, one of the most interesting sculptures in the park. A polished, curving metal construction, it resembles a giant boomerang. The nonfunctioning sculpture was meant to revolve, and the city hopes to repair its motor soon. It is made of granite and steel (de Rivera did

much of his own forging and hammering). *Free Form* is well named; it soars into the sky like a free-flying bird. With their similar themes, *Rocket Thrower, Freedom of the Human Spirit,* and this de Rivera work make an excellent contrast in styles for the student of twentieth-century sculpture.

The centerpiece of the park is undeniably the Unisphere ❻, the monumental steel globe that still dominates the entire area. Built for the 1964 World's Fair (a gift from U.S. Steel), the Unisphere gives a see-through vision of the earth, its continents in place, with giant latitude and longitude lines forming a grid of steel. While it may not precisely be deemed "art," it is nonetheless a striking construction. It is best viewed from a slight distance, though you will probably enjoy walking (or riding your bike) up to it, to experience its size and design more closely. Among the statistics you might consider are the following: the Unisphere is 140 feet high, 120 feet in diameter, and it weighs 700,000 pounds.

Between the Queens Museum and the Unisphere you'll find an empty pool that once decorated the World's Fair of 1964 and was ornamented by a picturesque fountain, *Armillary Sphere* ❼, designed by the sculptor **Paul Manship**. Manship's fountain was made up of fanciful versions of the twelve signs of the zodiac, but over the years, some of the zodiac figures disappeared. Aries the Ram and Taurus the Bull, each 2 feet high, were just recently recovered and will perhaps be reinstated by the time you take this walk. The fountain was originally donated by the Fair to New York to honor the city's three hundredth birthday. (Unfortunately today it no longer functions as a fountain.)

The **Queens Museum** ❽ is a lively and au courant place that houses a variety of interesting exhibitions and events. Past shows have included Television's Impact on Contemporary Art, Classical Myth and Imagery in Contemporary Art, New British Painting, The Pattern and Decoration Movement, and an exhibition of Keith Haring works. In addition to these current themes, the museum has devoted exhibitions to Remembering the Future: The 1864 World's Fair and to Classical Sculpture from Ancient Greece. Dozens of events take place at the museum, from workshops to films, lectures to celebrations. If you wish to coordinate your Flushing Meadows outing with a particular exhibition, call the museum for information.

No matter what the current exhibition is at the museum, you can always see the Panorama, a must-see exhibition upstairs in the small building. (Children will particularly enjoy this construction, as will any and all New Yorkers or New York enthusiasts.) The world's largest architectural scale model, this extraordinary structure shows all five boroughs of the city in precise and fascinating detail. Built at a scale of 1 inch to 100 feet, it includes every important building in the city and is constantly updated. Originally constructed as the featured exhibit of the New York City Pavilion at the 1964 World's Fair, the Panorama was an immediate success; it still is a major tourist attraction and teaching tool for the city's children (various neighborhoods can be lighted and studied). Over 865,000 buildings are represented, as well as the city's rivers, hills, bridges, and trees. The total panorama covers more than 9,000 square feet. A flyer at the museum will give you many more precise and interesting details.

To the right, a short distance from the museum, you'll find the Time Capsule ⑨, where items from 1964 were saved. Another reminder of the 1964 World's Fair is the **New York State Pavilion** ⑩, now a big, empty, circular space with an intriguing floor that will particularly entice children and residents of New York State. Almost all of an enormous mosaic map of the State of New York still covers the pavilion's floor. It is so detailed that you can probably spot your old hometown or the route you take to the Adirondacks in the still bright mosaic bits that make up this very unusual floor. (There is also an echo here—a reminder of the dilapidated state of the old World's Fair buildings that remain.)

Our final stop is the marble bench ⑪ commemorating the site of the Vatican Pavilion in the 1964 World's Fair. A circular bench and dais made of granite, the pavilion exhibited Michelangelo's *Pietà*. But today it is merely a nice resting spot, which you might welcome after your long bike ride.

. . . And in Addition

☞ **Queens Botanical Garden**, at 43-50 Main Street and Dahlia Avenue, is a pleasant 38-acre park (once a dumping ground), of which about half is dedicated to formal plantings. You'll enjoy the Perkins Memorial Rose Collection (with its more than

four thousand bushes), a rock garden, an herb garden, and a specialized garden for birds and bees. There is even a fragrance garden for the blind. In spring, flowering cherry trees, crabapples, and thousands of bright tulips add their magic, while in fall you can enjoy a wonderful display of colorful chrysanthemums. Queens Botanical Garden is a small but attractive spot to visit, with flat terrain for easy walking. The Garden also sponsors a variety of year-round workshops on such topics as Japanese-style dish gardens and hanging gardens for indoor or outdoor use. ☎ 718-886-3800.

☞ **Queens College, CUNY**, on Kissena Boulevard between Reeves and Melbourne avenues: In the impressive Paul Klapper Library, visit the **Frances Godwin and Joseph Ternbach Museum** with its permanent collection of European art, ancient glass, oriental and Egyptian art, and WPA prints. Changing exhibitions feature drawings, paintings, and sculpture. Hours: Monday and Wednesday, 9–8; Tuesday and Thursday, 9–6; Friday, 9–5. No admission fee. ☎ 718-520-7049.

☞ In addition, Queens College sponsors concerts, theater, film, and lectures, many of which are held at Rathaus Recital Hall. ☎ 718-520-7340.

☞ **Queens Borough Public Library**, at 155-06 Roosevelt Avenue, Flushing, sponsors workshops on crafts and visual art, such as silk screening. ☎ 718-520-9842.

☞ **Queens Borough Public Library Branch in Richmond Hill**, at 118-14 Hillside Avenue: A 1938 mural by Social Realist painter **Philip Evergood** graces the main reading room. Called *The Story of Richmond Hill,* the work illustrates life in Queens in a somewhat caricature-like mode. On the left is an upbeat, jolly, urban scene; on the right, a far more somber one; and in the middle are the city planners and idealists who are caught in between.

☞ At St. John's University (at Grand Central and Utopia Parkways) visit the **Chung-Cheng Art Gallery** in Sun Yat-sen Hall. Here you'll find works by local and Chinese artists, as well as a permanent collection of paintings, calligraphy, and other Asian arts. Hours: Monday–Friday, 10–8; weekends, 10–4. ☎ 718-990-6161.

☞ The **Marine Air Terminal** at La Guardia in Flushing deserves a visit, especially if you're interested in WPA art. Here you'll

see **James Brooks**'s huge (237-foot) mural *Flight* within the rotunda. Completed in 1942, this bold work was painted over during the 1950s, but finally restored in the early 1980s.

☞ **Flushing Town Hall**, 137-35 Northern Boulevard at Linden Place, Flushing: This historic 1862 Romanesque Revival building now houses art galleries and hosts cultural events.

26

Discover Long Island City, Queens' "Left Bank"

The Noguchi Museum,
Socrates Sculpture Park,
P.S. 1 Contemporary Art Center,
and Much More

Noguchi Museum and Socrates Park

HOW TO GET THERE

Subway: N train to Broadway (Queens); walk several blocks (west) toward the Manhattan skyline to Vernon Boulevard.

Bus: There is a shuttle bus on weekends that leaves from midtown. Call ☎ 718-204-7088.

Car: From the Queensboro Bridge, take the first right turn possible (Crescent Street) and another right on 43rd Avenue. Go to the end of 43rd Avenue and take another right on Vernon Boulevard. Turn right off Vernon Boulevard at 33rd Road. Entrance to the Noguchi Museum is on the left at 32-27 Vernon Boulevard. Easy parking on the street.

NOTE

Be sure to pick up the Art Loop, a map of the area that clearly denotes art sites in both Long Island City and Astoria. (It is available at any art location in Queens.) It also lists artists' studios you can visit.

Perhaps the most unlikely setting for an artwalk and for a truly memorable aesthetic experience is a visit to the changing industrial area of Long Island City that lies just south of the Queens end of the 59th Street Bridge. Here, amid old warehouses and unidentifiable blocks of buildings, are several wonderful spots to visit—only a few blocks from one another. You will find yourself in this neighborhood very quickly after you exit from the Queensboro (59th Street) Bridge; and you may be surprised to discover fine art in this decidedly commercial neighborhood.

QUEENS:
THE ISAMU NOGUCHI GARDEN MUSEUM
&
SOCRATES SCULPTURE PARK

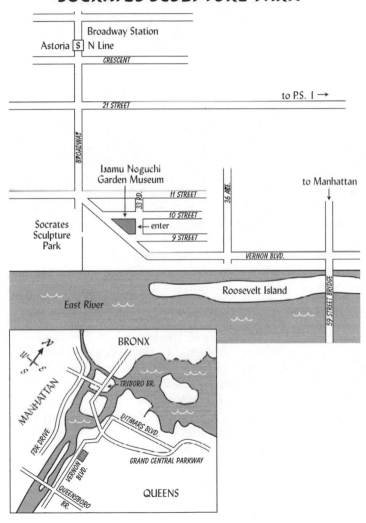

Several of these sites—notably the Isamu Noguchi Museum, Socrates Sculpture Park, and P.S. 1 Contemporary Art Center—have quietly existed here for many years, alongside diners and warehouses. But, ever since the Museum of Modern Art and the Museum for African Art moved temporarily to Long Island City, the area has become a much more vibrant art destination. New art spaces have cropped up, while existing galleries and centers have become more visible. As of this writing, MOMA is scheduled to move back to its Manhattan flagship location in the fall of 2004, after extensive renovation, and it's not clear whether the building of MOMA QNS (a former staple factory) will house a study center for modern art. In any event, Long Island City is especially interesting and amusing to explore.

Your first stop will be the **Isamu Noguchi Garden Museum** (32-37 Vernon Boulevard)—a veritable shrine devoted to the works of one of the twentieth century's most influential and best-known sculptors. In a setting of careful calm and contemplation, including a sculpture garden filled with Noguchi's characteristic Japanese stone figurations, you can see the evolution of his art, from early figurative pieces to his most recent stone monoliths. The experience is an introspective one.

And in one of the curious juxtapositions of art sites in our multifaceted city, you'll find just blocks away, at the **Socrates Sculpture Park**, a collection of contemporary sculpture that is truly astounding in its freewheeling originality—some of it good, some fascinating, some quite awful. This most current collection sits on city-owned land on the banks of the East River. The seminal influences of such sculptors as Noguchi—the willingness to leave subject and representation behind in search of other truths—is evident everywhere, though there is nothing among these giant sculptures that vaguely reflects Noguchi's works themselves. Instead you'll find changing exhibitions of vast and original works and—of particular interest—the artists themselves can often be seen working at their pieces in this unlikely, weedy field. You may wander at will through the towering constructions, waterside assemblages, and huge forms that are temporarily housed here. While the sculptures at the Noguchi Museum are mostly on permanent display, those at Socrates Park change once or twice a year.

The recently renovated Noguchi Garden Museum is about the best-disguised art center we've discovered on our wanderings through the city. Set into blocks of old warehouses, it appears to be another nondescript, rectangular building, but on closer inspection you'll see the angles of a contemporary-style building nestled into its triangular city block. Noguchi wanted a home for his works that would be congenial to their style and to his concepts of art's relationship to its surroundings. "These are private sculptures," he said, "a dialogue between myself and the primary matter of the universe."

And what you will find at the museum are some 350 works that demonstrate the great Japanese sculptor's spiritual presence, as well as his evolving use of stone and other natural materials. The sculpture garden—walled off—brings traditional Asian design to the present. In these delicate stone works, trickling water fountains, abstract shapes, and patterns catch the light and do indeed give you the sensation of being very far away from both Manhattan and the twenty-first century.

Yet Noguchi was, in fact, a quintessentially twentieth-century artist. His search was for abstract realities or what he called "the brilliance of matter" that will turn "stone into the music of the spheres." Everywhere—in the rough stone pillars, the delicate marble pieces, the rounded basalt mounds, the intricate black metal abstractions—you sense the sculptor's preoccupation with pure form and its relationship to the space around it. Under the artist's own direction, the museum has laid out works in a logical progression. In addition to the sculptures themselves, the museum includes many plans, drawings, and photographs of Noguchi's contributions in other places throughout the world. Among the fascinating examples are a photograph of a marble spiral for children ("to show how the idea of play relates to sculpture"), a dance set designed for Martha Graham ("the stage remained my main testing ground for many years"), and whole city plazas in detailed planning drawings—a particularly fascinating addition to the works themselves; they are a testament to his continuing interest in sculpture outside the studio. Among the oddities we enjoyed were paper lanterns and a musical weather vane designed by the artist. But most of all you will come away with a sense of the artist's serenity and spiritual presence that

come through these often highly abstract, monolithic works. Although this is not art that is easy to understand for the layperson, it is nevertheless an experience that will change the way the most unreceptive observer of contemporary art looks at stone. You will have a new idea of how sculpture can both shape its surroundings and become a part of them.

The transposition to today's environmental sculpture is only a few blocks away. A short walk along Vernon Boulevard and the East River to 31st Street will take you to Socrates Park, New York's largest sculpture park. At first you might think this is an unlikely spot for an important outdoor exhibition space, surrounded as it is by warehouses, industrial buildings, and random vacant lots. But the breathtaking views of Manhattan's skyline directly across the river and the waterfront site proved to be a dramatic setting for the large, avant-garde works on display. In these raw, unmanicured 4.5 acres, you will probably see the boldest, most original, and certainly most massive sculptures anywhere in the city—from huge steel abstractions piercing the sky to rough-hewn constructions in fantastic configurations, original structures atop floating barges, and waterfront sculptures.

The brainchild of sculptor **Mark di Suvero**, Socrates Park—which he named in honor of the philosopher, who "had a lot to teach" him, and in honor of the Greek community in nearby Astoria—was created in the mid-1980s from an eyesore lot filled with heaps of rubble. The idea was to provide a space for large-scale outdoor sculptures where the originality, vision, and creativity of the works were to be considered, rather than the fame of the artists. Di Suvero was able to lease the property from the city for a nominal fee. From the beginning, the community was encouraged to participate actively in the project, to make the park an integral part of the community's daily life. Local residents, including teenagers, were hired to clean and tend the lot (tons of rubble had to be hauled away) and to be involved in running the park. As the sign at the entrance says, "Elevation 7 feet, population friendly." And so it is. Socrates Park is a real part of the community, not only used as an exhibition space for outside artists, but also made to be accessible to local would-be artists who may be inspired to add their own unsolicited works to those on display. People come here to walk, to contemplate, to observe, to play. According to di Su-

vero, "you're expected to touch the works," much to the delight of the neighborhood children, who can't resist the temptation to use the place occasionally as a wonderful, almost surreal playground. A visitor may be lucky enough to observe artists at work preparing for future shows. In fact, one of the park's programs—the Outdoor Studio program—asks its artists to create their sculptures right here on site over a few weeks' time, during which they are available to discuss their work with the public. On several of our visits we met informally with some of these sculptors and their assistants, all busy at work nailing down massive wood constructions, hauling huge steel parts, or preparing the soil for a future foundation. Chain saws, tractors, and other heavy equipment are often used to produce the massive works and prepare for shows, and neighborhood residents are invited to help in the construction and installation.

There are one or two exhibits annually, each lasting for several months at a time. The inaugural show, held on September 28, 1986, featured works by sixteen artists including Mark di Suvero, Vito Acconci, Rosemarie Castoro, Lauren Ewing, Mel Edwards, Richard Mock, and Sal Romano. Since then, shows entitled Sculpture: Walk On/Sit Down/Go Through, Artists Choose Artists, Sculptors Working, and Sculpture City have been on view. Some of the works included have been Robert Stackhouse's *East River Bones,* made from skeletons of sunken ships; Cristo Gianakos's *Styx,* a huge double ramp with a platform (perfect for climbing); Jody Pinto's *Watchtower for Hellett's Cove,* a tall wooden structure that looked more likely to be found in the middle of a large field in a town in the Midwest, Malcolm Cochran's *Scrapyard Temple for Socrates,* whimsical granite pillars around which colorful coffee tins, with their labels, have been attached in drapelike fashion; and Alison Saar's *Fanning the Fire,* resembling a totem pole of wood, tin, and nails on top of which a stern-looking woman is holding a fan. Mark di Suvero (whose waterfront studio is literally next-door) often displays his works here.

At each of the park's exhibition openings you are likely to see performances by musicians, actors, or dancers in and around the sculptures. Socrates Sculpture Park is open from 10 a.m. until sunset, seven days a week. There is no admission fee. ☎ 718-956-1819.

P.S. 1 Contemporary Art Center

HOW TO GET THERE

Subway: E or V train to 23rd Street and Ely Avenue; or 7 train to 45th Road.

On leaving Socrates Park, we recommend a visit to **P.S. 1 Contemporary Art Center**, at 46-01 21st Street, also in Long Island City. (This is not within walking distance, but you can·get there by subway.) This alternative space par excellence is housed in a large, brick, nineteenth-century building, which was once a school. Since its renovation in 1976, it has included working studios, as well as galleries for innovative and unusual exhibits and some permanent installations. The thirty or so artists chosen to be in residence come from all over the world and usually stay for about a year. You can take a tour of the studios to see the artists at work and visit the first floor's eight galleries, where exhibitions change about every two months. Some recent shows have featured works by Italian artist Michelangelo Pistoletto and the works of Austrian sculptor Franz West, including sculpture, film, collage, drawings, and assemblages created especially for P.S. 1 in collaboration with other Austrian artists. The permanent displays include **James Turrell**'s *Meeting* (1980–86), which can be seen daily (except in bad weather), immediately before, during, and after sunset; **Alan Saret**'s *Fifth Solar Chthonic Wall Temple* (1976); and **Richard Serra**'s *Untitled* (1976). Gallery hours: Wednesday–Sunday, 12–6. Call ☎ 718-784-2084 for admission fees and reservations, which are necessary for studio tours.

. . . And in Addition

☞ The **American Museum of the Moving Image**, 35th Avenue at 36th Street, Astoria: Amid the movies, television, and video memorabilia and technology there are also works of nonelectronic art: a large, jolly, pseudo-Egyptian **Red Grooms** installation called *Tut's Fever,* and a delightful five-piece jazz band carved of wood and found objects that served as a prop for a 1977 movie. (This is a must visit for kids of all ages.) Hours: Tuesday–Friday, noon–5; Saturday and Sunday, 11–6. There is an admission fee. ☎ 718-784-0077.

☞ The **Fisher Landau Center for Art**, at 38-27 30th Street, Long Island City (not far from the Queensboro Bridge), is a little-

known exhibition space that houses more than a thousand paintings—only some on view at any given time. In this elegant yet stark, white and gray three-floor gallery, you can see an impressive collection of contemporary art from the 1960s to the present. Such masters as **Andy Warhol**, **Willem De Kooning**, **Robert Rauschenberg**, **James Rosenquist**, **Ellsworth Kelly**, **Cy Twombly**, **Kiki Smith**, and **Jasper Johns** are represented, as well as lesser-known artists. Exhibits change every six months, drawing from the Center's vast collection kept in storage below. Once a parachute-harness factory (most new art spaces in Long Island City have been converted from industrial sites), the gallery has been in operation since 1991. It began as a repository for the private collection of Emily Fisher Landau (you can see her portrait by Warhol, in the lobby), a philanthropist in the New York art world. For many years, visitors were only allowed by appointment, but since 2003 the doors have opened to the general public. This once well-kept secret may not be so much longer! Hours: Thursday–Monday, 12–5 (closed Tuesday and Wednesday). No fee. ☎ 718-937-0727.

☞ **Queens Borough Public Library, Astoria Branch**, 1401 Astoria Boulevard: Here, in the children's reading room, you'll find WPA murals created by Polish-born painter **Max Spivak** in 1938.

☞ **Sculpture Center**, after many years on Manhattan's Upper East Side, has recently relocated to 44-19 Purves Street, Long Island City. Once a trolley-repair shop, this dramatic new space (designed by the renowned **Maya Lin** and **David Hotson**) has very high (40-foot) ceilings, an enclosed sculpture yard, and some 6,000 square feet of exhibition space. On view here are unusual works (some very cutting-edge) by emerging—as well as established—artists. Recent exhibits included Architecture of Gender (where seventeen Polish women artists explored myths of womanhood and personal identity); a documentation of natural wells and springs of Manhattan and the Bronx via photography, sculpture, and moss terrariums; a glass outhouse (of all things!) that explored the boundaries between public and private space; and a paper exhibit in which the public was invited to participate actively. The Center also provides lectures, dialogues, film and video screenings,

and workshops. Hours: Thursday–Monday, 11–6. ☎ 718-361-1750.

☞ **Museum for African Art**, 36-01 43rd Avenue, Long Island City: This extensive collection of African sculpture, masks, textiles, and other art is the city's premier African exhibition space. It is here in Long Island City temporarily, while awaiting its new venue in Manhattan. Hours: Monday, Thursday, and Friday, 10–5; Saturday and Sunday, 11–6. ☎ 718-784-7700.

Brooklyn

BROOKLYN HEIGHTS

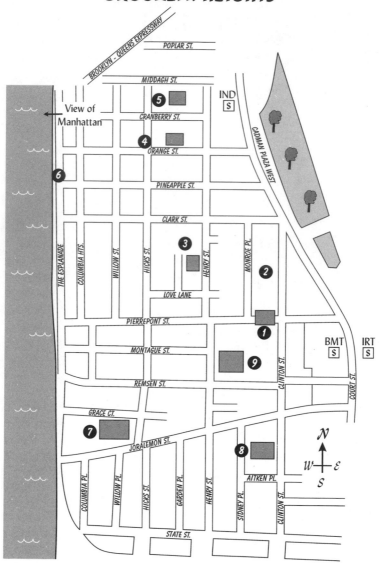

27

Stained Glass in the Churches of Brooklyn Heights

HOW TO GET THERE
Subway: 2 or 3 train to Clark Street.
Car: Take the Brooklyn Bridge and get in the right lane; take the first exit, move directly to left lane, and take Cadman Plaza exit (if you stay right, you will get on the Brooklyn-Queens Expressway). Go straight through the first traffic light, and look for a parking space. You are in the northern part of Brooklyn Heights.

SUGGESTED TIMES
Sundays between 10 and 2, or weekdays during lunch hour. Most of the sites on this walk are closed at other times. Bear in mind that services may be going on, which should not prevent you from quietly viewing the church windows. To be sure of church and workshop hours, you might wish to make a few phone calls before setting out.

Brooklyn Heights is an extraordinarily charming part of New York City. It is a small jewel, both in its riverside setting and its architectural style. A walk here is always fun, whether you are a history buff or a riverboat watcher. But we found that one of the more unusual ways of enjoying this unique spot is to visit some of its landmark churches with their remarkable stained-glass windows.

There are a dozen churches in the fifty-block historic region of Brooklyn Heights, and half of them date to the 1840s, when Gothic Revival style dominated architecture. Along with widespread growth in religious fervor and in church building came a fascination with stained-glass windows. In case you want to know a little bit about stained glass before you set out, here are a few notes about the history of this art form.

Stained glass came to this country with immigrants from Europe, who were accustomed to its beauty in their churches. But the quality of glass made in this country was for a long time

inferior to that made in Europe. The best windows were imported, until American art glass became more common (between 1865 and 1900). Most of it was stock production; both colors and designs were premade and shipped off to new churches. This glass, still seen throughout the country, was chemically produced opaque or opalescent glass, a milky-textured, somewhat iridescent glass that transmits very little light but both reflects and refracts light. It was, however, thoroughly American. In fact, much "stained glass" was actually painted glass; studios of glass painting were fashionable through the 1870s.

It was not until several American artists turned their attention to making "art" from glass in the European tradition—but with American taste—that stained glass became a full-fledged art form. John LaFarge, William J. Bolton, and William Holman Hunt were the new leaders in the field. All of them supplied windows for the churches of Brooklyn Heights, as you will see when you take this walk.

LaFarge, who perfected the opalescent glass technique beginning in 1875, precipitated the American revival in stained glass. Rather than trying to re-create the traditional medieval technique, he went on to create a new technology and style. His opaque designs were done mostly in a kind of Art Nouveau genre. In all, he created about three hundred windows. Later in his life he experimented with inserting real glass jewels into his windows (to provide translucent color in the otherwise wan productions). William J. Bolton, who worked with his brother John, had begun experimenting with this art form in 1842. His stained glass was much bolder in color than that produced by his contemporaries, as you will see at St. Ann's and the Holy Trinity Episcopal Church on this walk.

But it was Louis Comfort Tiffany who transformed glass windows into a totally new art form in the United States. He opened his first workshop in 1878, experimenting with brilliant glass fragments, rather than the milky opaque glass then most fashionable. He created new colors (gold luster, Mazarin blue, aquamarine) and popularized their use in brilliantly colored scenes in his typically decorative Art Nouveau style. He used over five thousand different varieties and colors of glass. Tiffany's designs were not always original; some were based on paintings by Old Masters (such as Dore, Raphael, and Ingres). You'll recognize his most

common themes: peacocks, sailing ships, balustrades, and wisteria clusters. Frequently, faces were painted in. His landscape windows (of which you will see several on this walk) were a particular trademark: many used landscape as religious symbolism. Tiffany became a style setter; to have a Tiffany window or two was highly desirable, and churches by the dozen commissioned him. His workshops defined the public taste, as did his famous lamps and other glass objects (which were made from leftover glass pieces from his windows). You'll see examples at the First Unitarian Church, among others, on this walk.

Other artists, like Holman Hunt and Otto Heinigke, shared in the stained-glass phenomenon, but at the same time, workshops began factory-producing masses of inferior windows, which all but swamped the market. In fact, many churches designed for plain glass (such as Colonial churches) were refitted for opalescent scenes, which darkened the interiors and did not fit in with the architectural styles (see the First Unitarian Church, for example). It was not until the early 1900s that the secrets of European leaded stained glass were well understood by American craftsmen. The neo-Gothic architectural movement—which required real stained glass like its European ancestors—brought the traditional methods to American church windows (see the Cathedral of St. John the Divine in Manhattan, for example).

The tremendous surge in the building of churches in Brooklyn Heights took place just as the opalescent-glass craze swept through. You will see different examples of both opalescent and painted glass on this walk, as well as a sample of modern stained glass (Our Lady of Lebanon Cathedral). So, without further comment, find the corner of Montague and Clinton streets on a bright Sunday morning and visit **St. Ann and the Holy Trinity Episcopal Church** ❶.

The most remarkable feature of this imposing, English Gothic church is its fabulous collection of sixty stained-glass windows. (This church was known as Holy Trinity until it recently merged with St. Ann's.) Created by **William J. Bolton** with the help of his brother **John**, during the period 1844–47, they are among the oldest such windows in the country and are considered to be a national treasure. Bolton's use of bold color—unlike the more sentimental, flowery glasswork of the time—attracted the architect **Minard Lafever**, who was then involved in the monumental

Trinity Church. Lafever thought Bolton's stained-glass windows would complement the Gothic traceries he was planning for this church. The Priory Studio—where the Bolton brothers designed, cut, painted, and fired the glass windows—was small, crowded, and not well equipped for such an undertaking, but they managed to complete their work successfully anyway.

The windows are considered by art historians to be among the best in the country. Their deep primary colors—particularly the reds and blues—are intensely vibrant, and their themes are depicted with feeling. Together they illustrate the story of the Bible in glass: on the clerestory windows are scenes from the Old Testament, while on the gallery windows are depictions of the New Testament. On the side aisles you'll see representations of the ancestors of Christ, including the Tree of Jesse. At the tops of the windows, the colors and forms seem brighter and the designs conform to the shapes of the stone Gothic traceries.

To get an even better and closer view of the windows, we recommend you walk up the stairs (on either side) to the balcony. On both stairwells you'll notice some charming windows in a different style, whose attribution is not known. The stained glass seen up close creates an effect reminiscent of graphic art, with many small lines visible.

While viewing the interior of the church, you shouldn't miss the impressive carved reredo (the decorative wall behind the altar). There is also a bust of a certain John Howard Melish by **William Zorach** located in the vestibule.

Unfortunately, with the years, the exterior of this fine church has suffered: the spire that Minard Lafever designed was removed in 1904 during the construction of the BMT subway, and the porous brownstone needs restructuring. Some of the windows are undergoing restoration. ☎ 718-875-6960.

Go left on Pierrepont Street, then cross over to see the **Church of the Savior** (First Unitarian Church) ❷, the dramatic sandstone Gothic edifice on the corner of Pierrepont and Monroe Place. This church has historical interest. In the early nineteenth century, a group of Unitarian merchants had come to New York from New England to seek their fortunes. Ostracized and criticized for their liberal beliefs, they decided to build a church on the site of a British fort dating from American Revolutionary times. They engaged **Minard Lafever**, the same architect who later designed

Holy Trinity Church. The imposing Unitarian church, with its tall pinnacles and high central gable, was consecrated in 1844, making it the oldest church building in Brooklyn Heights. A series of illustrious and socially active ministers presided over this church, which has a long history of social activism.

To celebrate its fiftieth anniversary (in the 1890s), the church decided to commission the master stained-glass artist **Louis Comfort Tiffany** to create a new set of windows. This decision was reached after some controversy from the church members: some felt that the galleries within the sanctuary, which divided the upper and lower windows, were not well set up for stained glass. When the new stained-glass windows were installed, the galleries still remained. The problem of accommodating both galleries and windows is apparent to visitors today; if you are walking around, you might find it difficult at first to see the lower windows because of the obstructed view. However, if you sit down in a nearby pew, or if you walk up to them, you can see them well.

The ten opalescent glass windows (eight are from the Tiffany studio) that make up this fiftieth anniversary series all embody the Art Nouveau style with its subtle colors, romantic nature scenes, and heroic figures draped in flowing garments. You might be able to spot some of the windows described next. Each of them has a name (bestowed by its donor) and a different theme. Some depict natural scenes: the Frothingham Window, the church's first landscape window, shows naturalistic forest views inspired by landscape frescoes found in the Church of San Vitale in Rome, while the Jessup-Stevenson Window depicts a romantic spring landscape with the inevitable flowering magnolia gracing the foreground. Others embody purely religious themes, such as the Woodward Window, a Tiffany window that shows the angel Raphael and the archangel Gabriel standing side by side. The White and Switzer windows are among those that embody Unitarian themes. The two non-Tiffany windows of this group, the Farley and Lord windows, were made by **Alexander A. Locke**, who had studied with John LaFarge.

The lovely rose window—enlivened with pure reds (due to the donor's curious dislike of blue!)—was added much later, in 1946, to celebrate the church's centennial. It pictures Christ proclaiming the eight Beatitudes, which are rendered in the eight surrounding panels. Designed by **Charles J. Connick**, another prominent artist

of this genre, it was planned carefully so as not to clash with the existing windows. ☎ 718-624-5466.

Leaving the Unitarian church, stay on Pierrepont, bearing right, turn right on Henry, go halfway up the block, and cross the street to 124 Henry Street, where you will find the **First Presbyterian Church** ❸. Built in 1846, the First Presbyterian Church is an imposing brownstone building housing nine **Tiffany** glass windows and several by other stained-glass artists. The high steeple rises 90 feet above the street to crown this sedate building. Sightlines for viewing the magnificent windows are unfortunately also interrupted here by the balcony construction, but nonetheless these are must-see windows for the stained-glass enthusiast. The geometric windows made of small squares of lovely shades of blue, green, and brown are particularly charming, not only as a contrast with the scenic and portrait windows, but as decorations in their own right. (They remind us of Paul Klee's *Magic Squares.*) Tiffany's windows here are very nice; in particular you'll find a river scene that is reminiscent of the many landscapes by nineteenth-century American painters—it is the *River of Life* on the south wall. Religious symbolism in landscape was common in Tiffany's windows. Other windows on the south wall include *The Children's Window* by **Maurice Cottier**, made in 1893, and three Tiffany works: *At Evening Time It Shall Be Light, Gratitude,* and *Mary and Martha.* Over the pulpit, and of particular interest, is a mosaic glass design, Tiffany's *Alpha and Omega* window, which was a gift to the church by the nineteenth-century landscape artist **Albert Bierstadt** and his wife. On the north side, windows by Tiffany depict St. John, the Fisherman, the Guardian Angel, and the Angel of Victory. The courtyard contains several Celtic crosses. ☎ 718-624-3770.

Leaving the Presbyterian Church on Henry Street, turn left, and make another left onto Orange Street. The **Plymouth Church of the Pilgrims** ❹ is on Orange Street, between Hicks and Henry. This famous Congregational church has an illustrious history dating back to 1847, when it was founded by the influential and eloquent Henry Ward Beecher, who presided at its pulpit for some forty years. His fiery ministry was decidedly nontraditional and controversial. It included such dramatic episodes as the public "auction" of a slave girl to arouse antislavery sentiment throughout the nation. He also spoke out passionately for women's rights and temperance. Subsequent speakers who were heard here read

like a who's who of abolitionists and other advocates of social reform: Wendell Phillips, John Greenleaf Whittier, William Lloyd Garrison, Horace Greeley, Clara Barton, Booker T. Washington, Mark Twain, Charles Dickens, and Martin Luther King Jr., among others. Abraham Lincoln worshiped here (his pew, no. 89, is marked).

This large church, designed by the English architect **J. C. Wells**, resembles a massive New England meeting house, with its austere dark-red brick exterior and lack of decoration. There is no steeple or tower. The spacious interior (which can hold some two thousand people) includes a plain rectangular auditorium and a balcony supported by graceful cast-iron columns surrounding the hall. The white walls and 80-foot-high ceiling add to the feeling of spaciousness.

There are two sets of windows to be seen at this site. In the sanctuary are nineteen memorial stained-glass windows that, with their deep, rich colors, add interest and life to the otherwise stark interior. These interesting windows, designed by **Frederick Stymetz Lamb**, are unlike most church windows in that they represent the more-secular theme of the History of Puritanism and Its Influence upon the Institutions and People of the Republic, with overtones of political, religious, and intellectual liberty. But to see the more-remarkable stained-glass windows in this church, you must go to the adjoining Hillis Hall, the social center (open after 12 on Sundays, or by inquiring). Here you'll see a collection of five **Tiffany** windows; the most impressive (in the center of the wall) represents the life of Christ. (Be sure to ask that the lights be turned on for better viewing of the windows, as they rest against a rather dark wall.)

If you can, wander around through the arcade in the rear connecting the church proper with the parish house. (On our first visit we were lucky enough to meet up with a pastor who, most obligingly, showed us through all the nooks and crannies.) You'll see a curious needlepoint version of **Da Vinci**'s *Last Supper* as well as sundry portraits of past and present ministers.

Other things to see include portraits of Abraham Lincoln and Harriet Beecher Stowe (Henry's equally famous sister), as well as a fragment of Plymouth Rock brought from Massachusetts in the 1840s. Upstairs, tucked away, is a nice but unidentified Renaissance painting of the Madonna and Child.

The handsome arcade garden—which is kept locked from the outside and can be entered only from inside the church compound—is centered around an imposing statue of Henry Ward Beecher in characteristic pose, by **Gutzon Borglum**. ☎ 718-624-4743.

After your visit, go right onto Hicks Street, turn the corner to Cranberry Street, and you'll find the **Church of the Assumption** ❺. This Roman Catholic church is worth a stop. Its interior reveals an eclectic mixture of tastes and styles. It has decorative French-royal-style symbols such as the fleur-de-lis motif adorning the altar and dome, a painted ceiling, and various statuary throughout. The stained-glass windows here are relatively modern. In our view, the windows on the second tier are more interesting than the somewhat ordinary ones at eye level. The overall interior is light and attractive. ☎ 718-625-1161.

As you leave the church, turn right, walk a couple of blocks toward the river, turn left at Columbia Heights, and walk one short block to the wonderful Esplanade ❻. This 3,000-foot pedestrian walkway overlooking Lower Manhattan Harbor provides picture-postcard-perfect views of the skyline, including the Statue of Liberty and the Brooklyn Bridge. As you stroll along with other walkers and occasional joggers, you might find it difficult to realize that you are on a cantilevered terrace perched over three levels of busy highways and the Brooklyn docks below. This is a fine spot to take a breather. There are benches and a constantly changing scene for people-watchers and for river-viewers.

Walk to the end of the Esplanade, go left on Remson Street to Hicks Street, where you'll turn right. In one block you'll find **Grace Episcopal Church** ❼. The entrance is a little way down Grace Court, under one of many surrounding ancient trees. Designed in 1847 by **Richard Upjohn**, Grace Church is an imposing yet charming Gothic Revival building of sandstone. Its interior contains carved moldings and open wood vaulting. The stone piers replaced the original wooden ones in 1909.

Although most of the stained glass is unremarkable, there are three by **Tiffany** and two by **Holman Hunt**. The typically subdued brownish and greenish tones of the stained glass of Grace Church make a subtle contrast with the brown wooden vaulting. There is a particularly lovely rose window in this church; it seems more in the early European glass tradition than in the pictorial

nineteenth-century style that was so popular in America. ☎ 718-624-1850 or ☎ 718-624-4030.

Leaving Grace Church, turn right on Hicks, then left on Joralemon Street, and right on Sidney Place. At Aitken Place you'll see **St. Charles Borromeo Church** ❽. This deep-red-painted church, built in 1869, has a charming interior with decorative wood trim, as well as many statues of saints and stations of the cross. Though the stained-glass windows are unremarkable, there are a series of small colored-glass panels behind the altar that are unusually nice. And best of all is the ceiling. Divided into many sections by dark brown arches and moldings, it contains a series of pretty, stencil-like painted designs. The light-colored walls bear portraits and statuary. While the stained-glass windows are rather ordinary, the overall feeling of this interior is harmonious and bright due to the nice architectural proportions and detailing. ☎ 718-625-1177.

Turn right on Sidney Place, and at Joralemon Street go left to Henry Street. Turn right on Henry to Remsen Street, where you'll find **Our Lady of Lebanon Cathedral** ❾. An entirely different artistic flavor permeates this very unusual church. Though it was also designed by **Richard Upjohn** (as the Congregational Church of the Pilgrims), it was acquired by Maronite Christians of the Lebanese community in 1944. The amalgam of Upjohn's architecture and Middle Eastern artistic traditions creates a most unusual, but warm and engaging, interior. Upjohn, already well known for Gothic Revival churches, turned his attention to a Romanesque Revival design here, and this late-1846 building has a wide, spacious interior with slender columns and semicircular arches. Though the steeple disintegrated many years ago, the church still has a graceful overall design. The unusually brilliant colors are certainly incongruous in Upjohn's church, but they do suggest another time and place. So too do the charming mural of the Mediterranean over the altar and the calligraphic designs reminiscent of Arabic arabesques that edge the borders of the walls and ceilings. Curious additions are the west and south portals made from the ocean liner *Normandie,* which burned at its Hudson River pier in 1942.

While the windows of this church are certainly the brightest on our tour, they are perhaps the least suggestive of the American stained-glass tradition; instead, they represent an attempt to re-create a different and more ancient style of glasswork. There is little

use of lead in them. The glass seems to be fused without it, though the areas are cut into tiny squares to resemble mosaic work. ☎ 718-624-7228.

. . . And in Addition

☞ **Brooklyn Historical Society**, at 128 Pierrepont Street, Brooklyn Heights, conducts Saturday and Sunday afternoon historic tours of the neighborhood, for which reservations are accepted. The Society also sponsors exhibitions and lectures. ☎ 718-222-4111.

☞ Also in or near Brooklyn Heights are several notable sculptures: Henry Ward Beecher by **John Quincy Adams Ward** can be seen at the south end of Cadman Plaza, the **Brooklyn War Memorial** with two classical figures by **Charles Keck** is at Cadman Plaza's north section, and at the intersection of Court and Montague streets you'll find **Anneta Duveen**'s bust of Robert F. Kennedy.

☞ Antique shopping on Montague Street.

☞ If, after seeing the Brooklyn Heights churches described here you would like to see more stained-glass windows, visit the following places in Manhattan (all contain windows by **Tiffany**): **Temple Emanu-El**, Fifth Avenue and 65th Street; **St. Michael's Episcopal Church**, Amsterdam and 99th Street; **YWCA**, 53rd Street and Lexington (610 Lexington Avenue); **Collegiate Reformed Church**, West End at 77th Street; **Congregation Shearith Israel**, Central Park West at 70th Street (for geometric, abstract **Tiffany** windows); the **Church of the Holy Cross**, 42nd Street between Eighth and Ninth avenues (note the **Tiffany** panels).

☞ Other windows of artistic interest are to be found at 714 Fifth Avenue near 56th Street. Here in the landmark **Coty** building you'll find three **René Lalique** windows made in 1912.

☞ **Federal Building**, 225 Cadman Plaza East (near the Brooklyn Bridge): In the large, ceremonial courtroom on the second floor (where new citizens are sworn in) you'll find some restored 1937 WPA murals by **Edward Laning**, who also painted the murals in the New York Public Library. Originally intended for the immigrants' dining hall at Ellis Island, these are appropriately entitled *The Role of the Immigrant in the Industrial*

Development of America; and, in fact, they depict in dramatic scenes the newcomers of that era working hard in coal mines, on farms, and along railroad tracks.

☞ The **Urban Glass Workshop**, 647 Fulton Street (corner of Rockwell Street): Its blazing kilns and hot liquid glass turning into extraordinary art objects before your eyes make this a not-to-be-missed stop. The workshop has a variety of programs and artists at work, as well as a small exhibition space. When we last visited, a number of artists and students were turning and twisting the molten glass or blowing it into unusual shapes. This form of sculpture dates back to ancient Egypt and reached high points in medieval Italy and nineteenth-century France. Today the techniques used produce three-dimensional works that vary from luminous neon glass tubes to sand-blasted objets d'art. The Workshop offers a variety of seminars, classes, exhibitions, and events. ☎ 718-625-3685.

☞ **Chase Manhattan Bank**, at 4 Metrotech Center (between Flatbush Avenue and Willoughby Street), has a distinctive high-tech lobby installation by **Nam June Paik**. There are 429 television sets displaying quickly changing video images. There is also a fluorescent installation, stretching 40 feet, by sculptor **Dan Flavin**. Also at Metrotech is a sculpture called *Corrugated Rollers,* by **Ursula von Rydingsvard**.

☞ **Rotunda Gallery**, 33 Clinton Street: Contemporary Brooklyn artists are featured in this historic site. ☎ 718-875-4047.

28

Two Brooklyn Delights

A Botanical Garden Walk and a World-Class Museum

HOW TO GET THERE
Subway: 2 or 3 train to Eastern Parkway; or C train to Franklin Avenue and shuttle to Botanic Garden.
Car: Take the Manhattan Bridge, whose continuation in Brooklyn is Flatbush Avenue; stay on Flatbush all the way to Grand Army Plaza at Prospect Park, and take the rotary three-fourths of the way around to Eastern Parkway, which borders the park. The Botanic Gardens are immediately after the Central Library building. There is a large parking area (small fee).

The **Brooklyn Botanic Garden**, at 1000 Washington Avenue, is one of those surprises you happen upon in New York. In the midst of busy urban sprawl, around the corner from a dreary stretch of Flatbush Avenue (but very near the lovely Prospect Park), you enter the iron gates of the Brooklyn Botanic Garden. There you find yourself in an enchanting, colorful, and completely intriguing world of planned gardens, elegant walkways, weeping cherry trees, and the many sights and smells of the world's most inviting gardens. The area was reclaimed from a waste dump in 1910. It takes up some 50 acres (but seems actually much larger), and you can walk among them quite randomly, from the Japanese paths along a lake to the formal rose gardens, from the Shakespeare Garden to the excellent conservatories. As you will see in the description that follows, there are many pleasures in these 50 acres, particularly if you take this outing in the spring.

Every season highlights a different area or style of garden, but surely April, May, and June are the most colorful times to come, when the ornamental trees, luxuriant roses, and many spring flowers are in bloom. But the rock garden is ablaze with flowers during

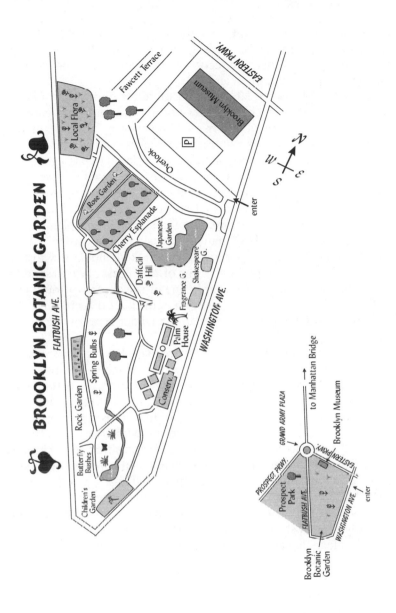

BROOKLYN BOTANIC GARDEN

FLATBUSH AVE.

Local Flora

Fawcett Terrace

Brooklyn Museum

EASTERN PKWY.

Overlook

P

Rose Garden

Cherry Esplanade

Japanese Garden

enter

Daffodil Hill

Shakespeare G.

Fragrance G.

Rock Garden

Spring Bulbs

Palm House

Conserv.

Butterfly Bushes

WASHINGTON AVE.

Children's Garden

N
W E
S

to Manhattan Bridge

GRAND ARMY PLAZA

PROSPECT PKWY.

Prospect Park

FLATBUSH AVE.

Brooklyn Museum

EASTERN PKWY.

enter

WASHINGTON AVE.

Brooklyn Botanic Garden

the entire growing season, and the roses bloom with different species through September. A fragrance garden, labeled in Braille for the blind, is another fine section of the gardens; it, too, is open during the spring, summer, and fall.

All of the plants are labeled, and there are more than twelve thousand of them. The conservatories and outdoor gardens among them include plants from almost every country in the world. If your taste is for literary references, you will enjoy the Shakespeare Garden, where plantings are related to passages from the bard's works. If you want to meditate, you might choose to sit along the banks of the Japanese Garden's lovely walkways. If you are a horticultural fan, there is a Local Flora section and many interesting displays of temperate, rain forest, and desert plants.

Sometimes described as "many gardens within a garden" (there are fourteen specialty gardens, many linked along a winding stream), the Brooklyn Botanic is one of the nicest place to spend a day in the city. (You can even eat in one of the gardens.) You'll find it a unique blend of intimacy and grandeur that brings to mind the fine gardens of England rather than the wilder acres of the Bronx Botanical Garden or Central Park.

At the main entrances to the Botanic Garden (on Washington Avenue) you can pick up a very useful map, which will point you in the right direction. A good place to begin your walk is the Herb Garden, near the parking lot. This charming contoured plot contains over three hundred carefully labeled herbs that have been used for medicine and cooking since the Middle Ages. Intricate Elizabethan knots form an intriguing pattern amid the plantings and add a unique element to this garden. From here you can take a lower or upper walkway. The upper path will lead you to the Overlook, bordered by gingko trees, and to the grassy terrace known as the Osbourne section, where a promenade of green lawns with stylishly shaped shrubs and freestanding columns await you. The pleasant, leafy lower lane will take you past groupings of peonies, crabapple trees, and wisteria to the Cherry Esplanade. We recommend that you see this garden in late April or early May, when the deep pink blossoms of the Kwanzan cherry trees are a breathtaking dreamlike pastel. The trees are arranged in rows alongside tall, Norwegian maples whose dark-red leaves create a wonderful contrast in color.

The adjacent Cranford Rose Garden, with its nine hundred varieties (over five thousand bushes) is the third largest such garden in the country. In this acre of pure enchantment you can identify the roses and study them carefully or simply enjoy the overall quality of their rare beauty.

On the hillside behind a wooden fence is the Local Flora section, an unusual and less-frequented garden. In these two secluded acres, the nine ecological zones found within a 100-mile radius of the Botanic Garden have been re-created in diorama-like form. Serpentine rock, dry meadow and stream, kettle pond, bog, pine barrens, wet meadow and stream, deciduous woodland, border mound, and limestone-ledge habitats are displayed with their corresponding flora and rock formations. This rare outdoor classroom is meant for serious observers and nature lovers (school groups are not invited) who want to spend time carefully examining the hundred or so plant varieties indigenous to this area, such as the many ferns, phlox, grasses, magnolias, pines, rhododendrons, larches, oaks, heather, persimmon trees, mosses, and dogwoods found here. If you wish to study the plants further, you can pick up a guide called Local Flora Section, available at the bookstore, since the plants in this garden are not labeled.

From the Local Flora section walk down the hill, past the hedgewheel, a whimsical composition of eighteen different hedging plants (boxwoods, viburnum, holly, and yew) to the lovely rock garden on your right. Here, rounded glacial boulders define the site that is planted with contour evergreen shrubs, different types of ground cover, and flowering plants that provide a vivid palette of color for much of the year. Along the path are clumps of spring bulbs, honeysuckles, and forsythias. You'll walk past a bed of barberries that contain twenty specimens with dainty red and yellow buds. A stream meanders by, flanked by weeping willows, adding to the effect of a romantic English garden.

Eventually you will come to the conservatory complex called the Steinhardt Conservatory. Here, three new, beautifully designed greenhouses contain a rich collection of tropical, temperate, and desert plants, including some 3,000 pounds of cacti and succulents brought from the Arizona desert. Throughout the year, you can enjoy the wonderful flower displays as well as the permanent collection of palms, ferns, and exotic specimens that grace

these pavilions. We particularly liked a grotto (in the Tropical Pavilion), carved out of granite and filled with ferns, and the Aquatic House, containing two pools and various plants according to natural habitat. You can view the deeper pool from two perspectives: at the Aquatic House, where you look down on it, or from windows in the Exhibition Gallery on the lower floor, where these unusual aquatic plants can be examined from an angle people rarely see. One gallery is devoted to bonsai, and you can admire the prized collectors' items (some date from the 1920s) in their many varieties, from the most formal upright to surprisingly naturalistic ones. The curious and intricate art of dwarfing plants is carefully explained and described. The resulting "tray" gardens are real miniature versions—down to the last detail—of regular pines, bamboos, maples, or elms. While you are within the conservatories don't miss the Exhibition Gallery in the central lower level. It features horticultural displays and art exhibits relating to plants in an atriumlike space. On a recent visit we enjoyed seeing a show called My Garden, a group of alabaster flowers in sensuous configurations by the English sculptor **Diana Guest**.

Outside the conservatories, next to two reflecting pools, is the elegant Victorian Palm House, once the main conservatory. This lovely old building (now used for special gatherings) adds a dash of turn-of-the-century glamour to the complex. Nearby is the Administration Building, the focus of the many educational and research programs conducted by the Botanic Garden. Workshops, lectures, exhibits, concerts, films, and classes on just about anything relating to plants are held here. In addition, there is an Herbarium (which includes some 250,000 dried plant specimens), a plant and bookshop, and a horticultural reference library.

Just outside, the Magnolia Plaza, a terrace where over eighty magnolia trees bloom in May, is formally designed with concentric circular and linear paths. The path to your right (as you face the plaza) will take you to the Fragrance Garden, a delightful, intimate spot that is a pleasure to the senses. Here, plants labeled in Braille can also be identified through touching and smelling.

You'll find the Shakespeare Garden off to the east of the pathway. Here the tiny signs not only identify the plants but also indicate Shakespeare's references to each flower. This is great fun for those of us who remember our plays and sonnets, and for those who don't—for there is a guide available at the bookshop. It also

includes a full map, noting where to find such flowers and apt quotations as "I think the king is but a man, as I am, The violet smells to him as it doth to me" (*Henry V*), "For though the chamomile, the more it is trodden on, the faster it grows, yet youth, the more it is wasted, the sooner it wears" (*Henry IV, Part 1*), and "What's in a name? That which we call a rose by any other name would smell as sweet," (*Romeo and Juliet*). In addition to the many plants of note, the garden itself is laid out in a charming, orderly fashion surrounded by a serpentine wall. An oval brick path, a fountain, and a bench contribute to the impression of an English cottage garden of Shakespeare's times. Be sure to pick up the guide, with its many nice illustrations of Elizabethan gardens, before you get to this pretty spot, for it will add to your pleasure.

And, finally, you will come to what is arguably the highlight of a visit to the Botanic Garden: the exquisite Japanese Hill and Pond Garden. Designed by **Takeo Shiota** in 1914, this prize garden reflects the religious and natural symbolism inherent in Japanese gardens, in which various elements are combined to form a harmonious blend of beauty and peace. The Japanese garden is regarded as a holy site, as well as a place for quiet reflection where the visitor can be at one with nature. And, incredibly, in the heart of Brooklyn, one of the city's most populous areas, this garden provides just that. Walk past the massive Komatsu stone lantern (dating from the seventeenth century) and enter the circular viewing pavilion, which welcomes the visitor, as it represents the home of the host. Before you is the breathtaking pond surrounded by a magical tableau of hillside cascades, grottoes, paths through shaded pine groves, and carefully planted shrubberies. A brilliant red torri, a wooden gateway indicating the presence of a nearby temple, stands in the pond, its dramatic image mirrored in the reflecting water. In spring, flowering quince, tree peonies, and weeping Higan cherry trees add even more splashes of color. As you view this rare spot, you will be eager to wander about and explore the garden. Your walk will take you around the pond; through winding paths flanked with flowering shrubs and trees, including junipers, hollies, and yews that are shaped like sculptures; past the cavelike grottoes; and up the hill to the Shinto shrine found within a quiet grove of evergreens.

Although the garden is relatively small, it is beautifully designed to give the impression of spaciousness as well as intimacy. To leave

the Japanese Garden you must retrace your steps to the entrance, which will put you near the Herb Garden, where you began your circular walk.

From May to August, the Botanic Garden is open Tuesday–Friday, 8–6; and weekends and holidays, 10–6. From September to April, it is open Tuesday–Friday, 8–4:30; and weekends and holidays, 10–4:30. There is no entrance fee. The Conservatory's hours are Tuesday–Friday, 10–4; and weekends and holidays, 11–4. There is a small entrance fee. For information, call ☎ 718-623-7200.

Almost next-door is one of the great museums of New York City. The **Brooklyn Museum** (200 Eastern Parkway) is a treasure-trove of great art and is rarely as crowded as its neighbors in Manhattan. Just recently renovated with a magnificent new entrance and galleries, it is not to be missed!

Before you enter, note the many sculpted figures that decorate the outside of the Brooklyn Museum. Representing everything from classical ideals to ancient heroes, these giant sculptures were made by leading sculptors of the past, including **Daniel Chester French**, **Charles Keck**, **Adolph Weinman**, **Karl Bitter**, and **Herbert Adams**, among others. Of particular interest—in addition to the thirty sculptures around the cornices—are the Daniel Chester French figures on either side of the entrance. Representing Brooklyn and Manhattan, these two colossal, classically robed figures were intended to adorn either end of the Manhattan Bridge.

The museum is noted for its great collections of primitive Egyptian, Greek, Nubian, and Coptic art, as well as its world-class collection of European art from the Renaissance to the Post-Impressionists. The wonderful American department includes an extensive survey of decorative arts—including pewter, silver, glass, and ceramics—twenty-five historically furnished rooms, and a comprehensive collection of American paintings from the eighteenth to the twentieth centuries. (There is a great collection of **Winslow Homer** watercolors.)

You'll find contemporary art as well. Recent exhibitions have included **Judy Chicago**'s *The Dinner Party,* and a show, called BAM! BAM! BAM! Catching the Next Wave for Twenty Years, relating the visual arts to the New Wave Festival at the nearby Brooklyn Academy of Music.

Notable additions to the museum corridors are five WPA murals rescued from other sites. These large, abstract works by pio-

neer American modernists **Ilya Bolotowsky**, **Balcomb Greene**, **Paul Kelpe**, and **Albert Swinden** were painted between 1936 and 1937 for a housing project. With the emphasis in WPA art on Social Realism, the choice of abstract art for a public project was a daring one; they are believed to be the first such murals in the United States.

The museum also sponsors film and dance programs, art classes, craft demonstrations, and lectures. Hours: Wednesday–Friday, 10–5; Saturday and Sunday, 11–6; closed Mondays and Tuesdays. ☎ 718-638-5000.

. . . And in Addition

☞ Rotunda, the **Brooklyn War Memorial**, Cadman Plaza West: changing exhibitions in this historic building. ☎ 718-875-4031.

☞ Also in the classical style is the **Soldier and Sailors Memorial Arch** in Grand Army Plaza, not far from the Brooklyn Museum, at the intersection of Flatbush Avenue and Eastern Parkway. Here you'll find a great arch modeled after the Arc de Triomphe in Paris and decorated with exuberant sculptures by **Frederick MacMonnies**. Among its many heroic ornaments are bronze horses Victory and The Army; the entire construction was dedicated to the defenders of the Union in the Civil War. Of particular interest on the arch is the city's only sculpture by **Thomas Eakins**, better known as one of the country's leading realist painters and an early proponent of the art of photography. You'll find Eakins's work inside the arch: two bronze reliefs—one of Lincoln and one of Grant—each on horseback.

☞ There are additional sculptures in and around **Grand Army Plaza**, including a recent bronze portrait head of John F. Kennedy by a Brooklyn sculptor, **Neil Estern**.

☞ Adjacent to the Brooklyn Museum is one of New York's most beautiful open spaces, **Prospect Park**. Here you'll find a variety of sculptures at the various entrances and within the park itself. At the entrance to the Prospect Park Zoo is a lioness and three cubs by **Victor Peter**, a French sculptor. Another **Daniel Chester French** work, a Lafayette memorial, can be seen at the 9th Street entrance to the park. The 3rd Street entrance is flanked by a pair of heroic panthers by **Alexander P. Proctor**.

Frederick MacMonnies is well represented here by a statue, across from Grand Army Plaza, of James Stranahan (a founder of Prospect Park); *Horse Tamers,* which stand on two pedestals designed by **Stanford White**, at the Park Circle entrance to the park; as well as the great arch mentioned earlier.

In the center of the park is a group of oddly chosen great composers' busts, including Edvard Grieg, Carl Maria Von Weber, Mozart, and Beethoven, by lesser-known sculptors. You'll find these sculptures in the Flower Garden, which also contains a bust of Thomas Moore, the Irish poet, by **John G. Draddy** (who also produced religious works for St. Patrick's Cathedral). Also near the Flower Garden is a *World War I Memorial,* including tablets by **Daniel Chester French** and realistic bronze figures by **Augustus Lukeman**.

☞ A major work is the Bailey Fountain, north of the great arch. This elaborate creation includes a variety of nude bronze figures representing Triton, Neptune, Wisdom, and so on. It is by **Eugene Savage**, and its style has been described by some art historians as "grotesque."

☞ The subway station at the Botanic Garden also has art to enjoy: *IL7/Square* by **Millie Burns**, which reflects the botanical theme at ground level.

29

Green-Wood Cemetery

Obelisks, Temples, and Artistic Gravestones

HOW TO GET THERE
Subway: M, R, or N train to 25th Street (Brooklyn); walk up the hill one block to main Green-Wood Cemetery entrance at 5th Avenue and 25th Street.

Green-Wood Cemetery is one of the jewels of Brooklyn. Founded by Henry Evelyn Pierrepont as a nondenominational cemetery in 1838, its rolling terrain with flowering trees covers 478 acres. There are vast lawns and four glacial ponds, as well as many serpentine pathways that lead from one site to the next. A treat for bird-watchers, botanists, and art lovers, as well as history buffs, Green-Wood is a must-see destination.

This historic cemetery is the final resting place for notable Americans, from political leaders to Civil War generals to sports figures to artists and writers. In the following walk we guide you to some major sculptural and architectural sites, in addition to the burial monuments of some of the twenty noted American artists buried here.

Since many of the specimen trees flower in late spring, this walk is particularly appealing in May, but any time of year is recommended. Pick up a map at the office next to the entrance gate. You can locate some 225 gravesites with its help, but there is a mazelike quality to finding them. (It took us hours!) So we have distilled the following walk to about twenty-five comparatively easy-to-find spots. In this case we have used the official map numbers to simplify your walk.

Green-Wood, like many fine cemeteries of its type, is filled with eye-catching mausoleums and statuary. Long before the existence of public parks, people strolled and picnicked in these green acres,

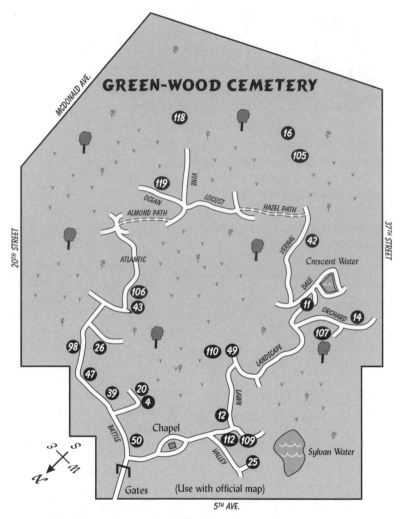

GREEN-WOOD CEMETERY

(Numbers correspond to official Green-Wood Cemetery map.)

and this garden cemetery became a Sunday-outing destination. Imitations of historical architectural styles, such as Moorish Revival and Classical Greek columned mausoleums, are interspersed with dramatic statuary. And great views, including the Statue of Liberty, can be seen from the many high points in these acres (one

being where Minerva salutes from the grave of Charles Higgins, creator of India ink).

Those visitors who enjoy stories of intrigue, romance, and tragedy will find more than enough material here. (For some of these stories, see a book called *Permanent New Yorkers,* by Judi Culbertson and Tom Randall, Chelsea Green Publishers.)

We recommend the following walk, with additional detours for those with time and energy to extend the route. Note that the cemetery is open 8–4 daily. ☎ 718-768-7300.

We begin at the wonderful Gothic Revival gates that were designed by **Richard Upjohn** and built between 1861 and 1863. (Architect Upjohn was noted for his church designs in Greek and Gothic Revival styles, among them Trinity Church in Lower Manhattan.) The entrance gates are marvelous to look at, with their 106-foot-tall central tower, steep slate roofs, cast-iron bannerettes, columns, brilliant sandstone (mined in New Jersey), and four reliefs. Passing through the gates, we make a left turn onto Battle Avenue. Here, on your right, is our first stop, a memorial to David Stuart (coal and steel magnate and father of Isabella Stuart Gardner), by **Augustus Saint-Gaudens** and **Stanford White** ⑳. The reliefs depict two robed angels as musicians.

Continue on to the small Syringa Path, to the loop of Bayside Avenue, where two graves are of interest to us. Here Nathaniel Currier ❹, the great printmaker, is buried, and in the same circle is the heroic bronze statue honoring DeWitt Clinton ⑳, the governor and senator of New York and father of the Erie Canal. This statue was cast by **Henry Kirke Brown**, with the base design by **Richard Upjohn**.

Opposite DeWitt Clinton is the (unnumbered) grave called "little Frankie," carved by **Daniel Chester French**.

Retrace your steps to Battle Avenue, to find a Greek Revival mausoleum with fine Ionic columns honoring John Anderson ㊳, a mysterious figure in tobacco, involved in a sensational murder case in the 1840s. Continue on Battle Avenue, past the intersection, for a short distance. On your left is the not-to-be-missed Egyptian pyramid honoring Albert Parsons ㊼. Like the Greek Revival temple, the faux-Egyptian pyramid was a popular style in the mid-nineteenth century.

Beyond, you'll come to the intersection with Border Avenue, where you'll find some steps to a scenic lookout and the *Soldiers*

Monument to the New York Troops �98, honoring the city's contribution to the Civil War. If you descend these steps you'll find two additional Greek Revival mausoleums: the first, dedicated to Marcus Daly ㉖ of Anaconda Copper, and the second (at the intersection of Meadow Avenue and Atlantic Avenue), honoring Peter Gilsey ㊸.

Across the way on Atlantic Avenue is one of the more amusing gravesites, this one dedicated to **William H. Beard** ㊸, a nineteenth-century artist noted for his paintings of bears and other animals. Guess what lurks on top of his monument?

Continue some distance on Atlantic, past Grove Avenue. Here a small pathway called Almond Path borders a hillside with many picturesque mausoleums cut into the hill. If you walk around the hill on Grove to Ocean Avenue, you'll find the burial site of the stained-glass maker and painter **John LaFarge** ㊙. Not far away is the grave of contemporary artist **Jean Michel Basquiat** ㊕.

For those with extra stamina, follow Vine Avenue to Sassafras Avenue, to see the grave of **John Kensett** ㊙, Hudson River painter. You can also detour to see a monument to the American sculptor **Solon Borglum**.

Turn back toward Locust Avenue and follow it to Hazel Path until its intersection with Vernal Avenue, and turn right. Here is a wonderful example of Moorish Revival architecture in the tomb of Commodore Cornelius Garrison ㊷, a leading industrialist of the mid-1800s.

Continue on Vernal to its intersection with Dale, and turn left to Thorn Path. Here, in a circle, is the burial place of **Samuel F. B. Morse** ⑪, artist and inventor of the telegraph.

From Thorn Avenue you'll find Orchard Avenue, from which you'll take Amaranth Path to Landscape Avenue. Here is the grave of **George Bellows** ⑩, leading American painter of the early twentieth century. Nearby, again on Orchard Avenue, is an evocative grave showing an empty marble chair, dedicated to one Mary Adsit ⑬.

Retrace your steps on Orchard to the intersection with Landscape Avenue, which you will take, passing many small paths, to Vista Avenue. Find Crocus Path; here, on a hill are two interesting gravesites: the impressive open-air church honoring Henry E. Pierrepont ㊾, and the nearby site dedicated to the American painter **William M. Chase** ⑩.

Turning homeward, take Lawn Avenue to its intersection with Landscape Avenue, to find the grave of Charles Tiffany ⓬, founder of Tiffany & Company, as well as that of his son **Louis Comfort Tiffany**, the noted glass designer.

Just across Landscape Avenue on your left is the grave of the leader of the Hudson River painters, **Asher B. Durand** �112. Also, off Landscape Avenue, is the grave of another American painter, **George Catlin** �109, who was unequaled in his depiction of Native Americans. Don't miss the lovely ponds in this vicinity.

Return to Landscape Avenue, turn right into Valley Avenue to find our last gravesite of note, which consists of terra-cotta gargoyles, gables, and evangelists, dedicated to John Matthews ⓖ, the "soda fountain king." (In 1886 this site was celebrated as the "mortuary monument of the year.") This extravaganza is an example of High Victorian style.

Your final stop is Green-Wood's lovely chapel, with its pretty stained-glass windows. This early-twentieth-century building was patterned on **Christopher Wren**'s Thomas Tower at Christ Church in Oxford and was designed by the architects of Grand Central Terminal.

While we have focused on the arts and architecture, there are numerous gravesites that will appeal to those with other interests. Feel free to explore them at your leisure!

Staten Island

30

Snug Harbor

Gardens and
Contemporary Art on Staten Island

HOW TO GET THERE
Staten Island is easily reached by public transportation, but you will need a car if you want to see in one day the many additional sites listed here. Snug Harbor is located on the north shore of the island at Richmond Terrace and Snug Harbor Road, conveniently only 2 miles from the Staten Island Ferry terminal. The Snug Harbor trolley or the S40 bus will get you there. From Manhattan, the best route is by ferry and bus. From Brooklyn, Queens, or Long Island, you should drive via the Verrazano Narrows Bridge (take Bay Street with the harbor on your right, until you find yourself on Richmond Terrace at the ferry terminal; Snug Harbor is on your left, after 2 miles). From New Jersey take the Staten Island Expressway (I-278) to Clove Road/Hyland Boulevard exit; at the traffic light turn left at Clove Road, right at Richmond Terrace, and right at Snug Harbor. For specific auto routes, call ☎ 718-448-2500 from 9 a.m. to 5 p.m. Monday–Friday.

HOURS
The grounds are open seven days a week (except major holidays), from 8 a.m. to dusk. They are also open in the evening for occasional special events. Guided tours are offered free, by appointment. We recommend a visit in the springtime or early summer, when the fine gardens are at their best.

Snug Harbor on the north shore of Staten Island is a find for jaded New Yorkers, art and garden lovers, and anyone else who wants to spend a stretch of time in an unusual and harmonious setting. Originally founded in 1801 as a hospital for retired sailors, its beautiful and expansive grounds and buildings are landmarks. The first of its historic buildings was erected in 1831. There are both large

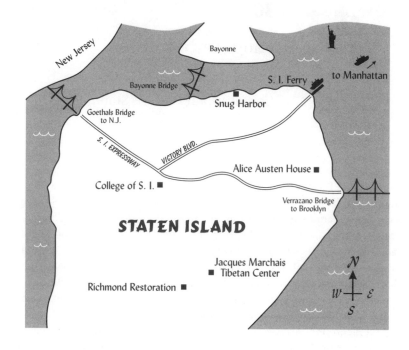

public structures in a variety of architectural styles—ranging from
Italianate Revival to Beaux-Arts—and a row of small Gothic Re-
vival houses once built to accommodate the tradesmen who
served the sailors' home. The grounds include the Staten Island
Botanical Garden, an inspiring Chinese Garden, a conservatory, a
concert hall, exhibition space, and much, much more. All the
buildings are prettily set on an 80-acre tract of land just across the
road from the shoreline and surrounded by a few pieces of con-
temporary sculpture. Unlike many such cultural centers, Snug
Harbor has an informal air. It is a place that has walkways and by-
ways and open doors; its gardens are invitingly simple and its signs
of do's and don'ts minimal. There are no citylike aspects to Snug
Harbor; you might be in a place far removed from the bustle and
commerce of New York when you wander around here. But Snug
Harbor is, indeed, a busy metropolitan center that includes top at-
tractions (like the Metropolitan Opera and Shakespeare in the
Park) among its offerings.

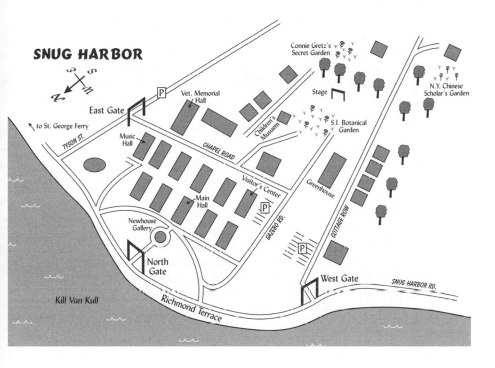

As you enter at the main gate (follow signs on Richmond Terrace), you will find yourself on a pathway with the parking lot to your left. Walk through the parking lot to the Visitors' Center in one of the main buildings, where you can pick up a map and other material on the Snug Harbor complex of buildings and gardens.

On leaving the visitors' desk, walk (directly before you) to Chapel Road to see the wonderful row of five small Victorian cottages. These once housed the baker, gardener, engineer, and farmer who helped to run Snug Harbor in the nineteenth century. Built between 1885 and 1890, the cottages have undergone renovation and are now used for Snug Harbor staff and visiting artists. The pathway (called Cottage Row) is adjacent to Snug Harbor's most impressive recent addition: **The New York Chinese Scholar's Garden**.

Modeled after the scholar's gardens of the Ming Dynasty (1368–1644), this exquisite 1-acre garden is the only outdoor example of its kind in the country. Its designer—one of China's eminent landscape architects—along with an army of artisans (one hundred

in China doing preparatory work on carvings and tiles, and more than forty here) created courtyards, pavilions, a tea house, and lotus ponds with waterfalls and rocks, reminiscent of the famous Garden for Lingering in Suzhou. This is indeed a place for lingering. Following the footsteps of fifteenth-century Confucian scholars who strolled about similarly enclosed spaces, you come upon one inviting spot after another bearing such evocative names as the Garden for Dwelling on Poetic Pleasure, the Hall for Listening to Pine, and the Chamber to Rest Head over Glowing Waters, or the Meandering Cloud Wall. (Plaques displaying these and other delightful descriptions are rendered in elegant calligraphy throughout the garden.)

This profoundly beautiful garden takes some time to savor, for there are many intimate spaces and details to discover—from wood carvings, intricate mosaics, and tracery windows in geometric or floral patterns to delicate magnolia blossoms, pruned apricot trees, and bamboos and pines typical of Chinese scroll paintings. The plantings are spare and carefully chosen, and they complement the many stunning stones shaped like exotic sculptures (some 2,500 tons of Tai Lake stone were imported from southern China). Within the garden walls you have a feeling of complete tranquility and separation from the outside world (and the bustling city!), as you contemplate earth and sky or light and shade, in the Taoist tradition.

The New York Chinese Scholar's Garden is open Tuesday–Sunday, 10–5. There is an admission charge.

Almost directly across Cottage Road you'll find the **Connie Gretz Garden**, another of Snug Harbor's many offerings. To reach it you must pass over a moat and through a castlelike structure leading to the formal garden. As you meander through this half-acre maze of intricate pathways and hedges, you eventually reach the walled secret garden, reminiscent of the one described in the classic novel by the same name. Children of all ages and adults alike will find this spot irresistible.

We now take you to the **Staten Island Botanical Garden** itself. Retrace your steps back to the cottages along Cottage Road.

Opposite the cottages are the greenhouse and the particularly charming flower gardens. The landscape of the entire park is Victorian in feeling, and so are the garden areas. Among the high points of this landscape are the trees, including wonderful willows

and a superb collection of flower gardens. The Botanical Garden, which moved to the site in 1975, has put in a variety of small gardens: a formal English perennial garden; a butterfly garden (whose plants are specifically nourishing to butterflies); a Victorian rose garden; an herb garden, featuring medicinal and culinary plantings; a "white" garden, which experiments with vertical plantings; a bog garden; and—inside the conservatory—the Neil Vanderbilt Orchid Collection. Any garden enthusiast will enjoy the way these small treasures of plantings are arranged—each (in its own season, of course) is a treat. A variety of tours, lectures, and demonstrations are available, but you can also enjoy wandering on your own.

Of particular charm near the gardens is the Chinese-style pagoda built by **Charles Locke Eastlake** of England. This little pavilion is a concert site and an additional Victorian touch to the landscape. At the end of the garden is a dark-green lattice-work enclosure, which we found particularly appealing. It is planted with charming flowers, and you can sit on the white wrought-iron benches and enjoy a summer's day.

You are now in an area called South Meadow. We suggest turning toward the old dark-red buildings to the east. These house, among other things, the **Staten Island Children's Museum**, a cheerful place that features all sorts of hands-on exhibitions for the small fry of the family. There are numerous workshops and events with modest admission charges.

Near the museum is an old and charming building known as **Veterans' Memorial Hall**. This is the site of many concerts—from chamber music to jazz. Built in the style of a nineteenth-century parish chapel, the Hall provides an intimate space for small events. In front of the Hall is Chapel Road, once again, and here are the first of the major Greek Revival buildings of the complex. These pale cream, mostly renovated, buildings house a variety of Snug Harbor's organizations: there is the Great Hall, the Music Lab, and, in the next row, the Main Hall. Art Lab, the art school found at Snug Harbor, also has shows of visual art. Among recent exhibits was an all-island high school show and individual exhibitions in its Atelier Gallery. These grand buildings are both architecturally and historically interesting.

The Main Hall's rotunda and ceiling contain murals from 1884 that have been renovated; these are Victorian-style paintings with Italianate motifs.

In the Main Hall you'll find the **Newhouse Gallery**, one of Snug Harbor's main attractions. The Newhouse Gallery is Staten Island's principal art space and, as such, is an important part of the cultural center.

Adjacent to the Main Hall is a former seamen's dormitory, now housing the **Noble Maritime Collection**. Named after the artist John Noble, this museum and study center features a permanent exhibit celebrating the history and traditions of Snug Harbor. In addition to galleries and exhibitions, there are classes, printmaking workshops, and a library.

. . . And in Addition

☞ **Historic Richmond Town**, 441 Clarke Avenue: This is New York City's only historic village restoration. It sits on the greenbelt area of the island and can be reached by bus or car from Snug Harbor. It consists of twenty-six buildings that have been restored; eleven of them can be visited inside. They represent various historical periods of New York's past, ranging from the seventeenth through the nineteenth centuries. Among the attractions are the oldest standing schoolhouse in America, a general store, exhibitions of crafts and restoration techniques, and a historical museum. While there is little art visible as such, the atmosphere is pleasantly historic, and there are many interiors with genuine artifacts and decorations of the past. This is probably a place best enjoyed by families with children. ☎ 718-351-1611.

☞ **Alice Austen House**, Clear Comfort, 2 Hylan Boulevard, Rosebank: Overlooking the Port of New York in a particularly fine location is the Alice Austen House, a historic site that also houses an exhibition of works by the pioneer documentary photographer **Alice Austen**. This Victorian house, set in a nice green garden with a view of the Statue of Liberty, is the only museum in the country that commemorates a single photographer's life and pictures. ☎ 718-390-5100.

☞ The **Jacques Marchais Center of Tibetan Art**, 338 Lighthouse Avenue, Richmond: In the most unlikely setting imaginable— on a suburban Staten Island street—you'll find this very unusual center devoted to the arts of Tibet. One of the largest

private collections of Tibetan art in the country, the center includes a small garden in Tibetan style, artifacts, musical instruments, and many, many works of art—all housed in two stone buildings built to resemble a Tibetan monastery. Works from other Asian countries are also exhibited in the chock-full, rather small buildings. ☎ 718-987-3478.

☞ **Borough Hall**, St. George: Thirteen murals by **Frederick Stahr** depict Staten Island's history; they were created under the WPA art projects in 1940.

☞ The **College of Staten Island**, a branch of City University, has a new campus, which it is endowing with art both indoors and out. Visitors can enjoy a good-size collection of sculpture in the large grassy areas between buildings and in the Wooded Park, as well as a number of artworks in various media indoors in the Center for the Arts and other buildings.

Among these works are a wood and granite boulder, *Ark* by **Daniel Wurtzel**, on the Great Lawn, as well as a concrete sculpture called *Borromini's Task*, by **J. Isherwood**, and a steel-wire cone called *Red Inside*, by **N. Ketchman**, both in the Wooded Park. A fiberglass relief by **Red Grooms** is in the Sports Center. In the Center for the Arts there are silkscreens and lithographs by **George Segal**, **Jean Dubuffet**, **Robert Rauschenberg**, **Helen Frankenthaler**, and **Edouard Manet**, among others. (Some artworks are hung in the Mezzanine Lounge, and others are in the Gallery itself.) For a complete listing of this growing collection and information on how and when to see it, you can telephone the Public Relations office of the college at ☎ 718-982-2364 or ☎ 718-982-2328.

☞ **Siah Armajani's** waterfront bridge and tower near the St. George Ferry Terminal is a not-to-be missed art experience. With this recent (1996) work, Armajani—one of today's leading sculptors of public art—has added real panache to the area. Consisting of a 65-foot bridge and a 65-foot-tall tower topped with gold glass in a lighthouse vein, the structure is made of gray wood and steel, with splashes of yellow, orange, and green reminiscent of the sun's rays.

From this site you can enjoy spectacular vistas, as you walk from the terminal to the plaza still undergoing development. Now somewhat solitary, the esplanade is expected to house art fairs and farmers' markets in the future.

Additional Art Sites

31

Art Neighborhoods around the City

57th Street and the Upper East Side, the Lower East Side, and Williamsburg

New York is generally considered to be the art capital of the world, due to its abundance of museums and galleries, as well as its many working artists. Several neighborhoods stand out as centers of artistic activities, with numerous galleries and events.

In chapter 6 you'll find a walk around the city's preeminent gallery neighborhood, Chelsea, and in chapter 4 we take you on a stroll through Soho and Tribeca; but these are not the only art neighborhoods in town.

57th Street and the Upper East Side

HOW TO GET THERE

Subway: N, R, or W train to Fifth Avenue and 59th Street.

Fifty-seventh Street and the nearby Upper East Side have long been home to some of the most serious and elegant galleries in the city. Old and modern masters are well represented on 57th Street at such galleries as **Marlborough, Pace Wildenstein,** and **Mary Boone**. Several buildings on that street house multiple galleries (take the elevator from floor to floor). Visit 41 East 57th Street at Madison Avenue to see more than twenty galleries in a single building. Among other gallery buildings are those at 24 West 57th Street, 724 Fifth Avenue, and 745 Fifth Avenue. Walk up Fifth Avenue from 57th Street to 80th Street to see numerous galleries dealing in great art (among them, **Knoedler, Hirschel and Adler,** and **Leo Castelli**).

While you're on the Upper East Side, visit the **Frick Collection** (Madison and 70th Street) and the **Whitney Museum of American Art** (Madison and 74th Street).

The **Seventh Regiment Armory** (640 Park Avenue and 67th Street) frequently has exhibits of arts and antiques that are beyond the ordinary, with dealers from all over the world participating. Don't miss the **Tiffany Room** (at one end of the main floor) where you can see beautiful stained glass and mosaics. ☎ 212-879-9713.

The Lower East Side

HOW TO GET THERE
Subway: F or V train to Lower East Side/Second Avenue.

This densely populated, colorful, and vibrant area, roughly bordered by Houston and Canal streets and the East River—give or take a few blocks here and there—is newly fashionable in the art world.

Like most other neighborhoods in our rapidly changing city, the Lower East Side is continuously evolving. And one of the latest changes here—one that could eventually have real impact on New York's cultural scene—is the recent addition of a group of brand-new art galleries, just opened in the past few years. Though hardly rivaling the established—and very elegant—galleries of Chelsea, Soho, and the Upper East Side, these tiny spaces (some as big as a minute) are bringing new interest to an area better known for its bustling little shops, street life, delis, and bodegas. The galleries bear such unlikely names as **Freakatorium**, **Outlaw Art Museum**, and **Raken Leaves**, and you may not recognize the artists' names; but if you are open to new and unusual art experiences ("wearable art," anyone?), you will enjoy the cutting-edge scene.

Unguided walking tours to more than twenty galleries, artists' studios, and other creative spaces are offered on the last Sunday of each month, from noon to 6 p.m. Of course you are welcome to visit at other times, too; but bear in mind that the galleries are normally closed on other Sundays and keep their own separate schedules during the week. The walk covers several blocks, extending from 1st Street, just north of Houston, to Grand and from Chrystie Street east to Clinton. And, as you walk from one place to the next, you can take in the neighborhood's lively street atmos-

phere, from the many street vendors offering a wide array of eth-
nic delicacies, to the rows of leather goods hanging outside the lit-
tle shops on Orchard Street, to the charming old synagogues
(many now used as alternative spaces) mixed in with trendy bou-
tiques, chain stores, markets, and outdoor cafés.

You can pick up a self-guided walking tour and numbered map
at any of the galleries listed. (Phone numbers of each are also in-
cluded.) They recommend you begin at 44 East 1st Street (not to be
confused with First Avenue), where you'll find the **Raken Leaves**
and **Julius Klein** galleries. Walk east to the end of the block and
turn right at First Avenue, and right again at Houston. On your
right, between Chrystie and Forsythe streets is a wonderful out-
door artifacts exhibition space, **Irreplaceable Artifacts**, a jumble
of garden ornaments and statuary and iron grates, all for sale. On
your left is the Sara Delano Roosevelt Park, created in the 1930s
where blocks of tenement houses had previously existed. (On the
south end of this park is the M'Finda Kalunga Garden, formerly an
African burial ground and now a lovely little naturalistic garden.)

Walk down on Forsythe Street and turn left at Stanton Street, to
number 57, the **Shalom Newman Gallery**. Go back to Forsythe
for one more block, to Rivington. Here you'll find quite a number
of galleries—from **The Scene** (#42) to **Rivington Arms** (#102),
Participant (#104), and **ABC No Rio** (#156), among others. Turn
south on the famous Orchard Street, where, in addition to great
bargain shopping, you'll find **The Red Threads** (#81), almost
down to Canal Street. Retrace your steps one block to Broome,
turn right, and walk to **LESX** (#48). Turn left onto Ludlow, an-
other street filled with boutiques, galleries, and activity. **Art Fiend
Foundation** and **Lincoln Mayne** are both at number 123, next
door to **Zito Studio Gallery** (#122).

Turn right onto Essex Street, where the **Outlaw Art Museum** is
located (#161). Also on Essex Street is perhaps the tiniest of all the
galleries—**Chuchifritos**, inside the Essex Street Food Market
(#120).

Go around the corner, turning right onto Stanton (again), to
several more galleries: **Prosper** (#127), **Denise Carbonell** (#154),
and **Viking Etiquet Carlucci** (#161). At the end of Stanton go
right onto Clinton, to **Freakatorium** (#57).

These are just some of the art galleries in the neighborhood—at
least as of this writing. You will no doubt discover others, as you

explore this rapidly changing Manhattan neighborhood. For information on tours on the last Sunday of every month, call ☎ 646-602-2338.

. . . And in Addition

If you have any energy left after your tour, you might check out these additional sites, all in the vicinity:

☞ **Henry Street Settlement**, 466 Grand Street: This is a multi-arts facility that focuses on emerging artists. There are three exhibitions and performance spaces. ☎ 212-598-0400.

☞ **Lower East Side Tenement Museum**, at 90 Orchard Street, is a National Trust Historic Site that documents the lives of immigrants in the Lower East Side between the mid-nineteenth century and the 1930s. Though not really an "art site" as such, you will find it a fascinating glimpse into a slice of the city's history. You may find it hard to imagine that some seven thousand people from more than twenty countries actually inhabited this five-story building, and in the most crowded conditions. To visit the museum you must take a guided tour (several different ones are offered). Hours: daily, 10–7. There is an entrance fee; reservations are recommended. ☎ 212-431-0233.

☞ **Maccarone**, at 45 Canal Street (between Orchard and Ludlow streets), a large gallery with two floors of exhibition space, often has interesting shows, too. A recent show featured collages made from an odd assortment of found objects. Hours: Tuesday–Sunday, noon–6. ☎ 212-431-4977.

☞ **Museum of Chinese in the Americas**, at 70 Mulberry Street, holds interesting shows concerning the Chinese experience in the New World. Hours: Tuesday–Sunday, noon–5. ☎ 212-619-4785.

☞ **Angel Orensanz Foundation Center for the Arts**, at 172 Norfolk Street, is housed in an extraordinary nineteenth-century synagogue and is now one of the oddest and most interesting sites you can visit in this area. **Orensanz** is a sculptor and multimedia artist who has transformed the aging building into a haven for art and events. His art, as well as the astonishing ambience, surround the visitor. Ring the bell or make an appointment. ☎ 212-529-7194.

Williamsburg (Brooklyn)

HOW TO GET THERE
Subway: L train to Bedford Avenue.

One of the city's newest art venues, with many young artists showing off their works, the center of this hopping area is filled with tiny galleries and boutiques. Pick up a map called Wagmag, available at any gallery in the neighborhood. It indicates where galleries are located—primarily between North 9th Street and South 3rd Street and between Kent Avenue and Havemeyer Street.

You'll also find information about a number of artistic events in Williamsburg, including **Four Walls**, which has a series of one-night art events in a former garage; and the **Crest Hardware Show**, an annual event with two hundred artists who take over the hardware store, mixing their artworks and installations with their tools.

Also, don't miss **Roebling Hall**, a cutting-edge multi-artist gallery.

. . . And in Addition

☞ Not far away, on the other side of the Brooklyn Navy Yard, is one of the city's newest parks and a delightful art venue: **Empire-Fulton Ferry State Park**. Here, beneath spectacular views of Manhattan, are changing exhibitions of sculpture arranged by the Brooklyn Waterfront Artist Coalition and set in 9 acres of waterfront park situated between the Manhattan and Brooklyn bridges. The entire region surrounding this park is, as we write, evolving into more and more of an artistic area.

☞ The **Brooklyn Bridge Park**, a new 70-acre site stretching from the Manhattan Bridge to Atlantic Avenue, is soon to be completed. Designed by **Michael Van Valkenburgh**, it promises interesting environmental design and spectacular views.

☞ In downtown Brooklyn, the newest attraction is the **Metrotech Center**, which includes a Commons that has become the latest site for changing outdoor exhibits, another Public Art Fund project. Several of the Metrotech building lobbies include art from time to time.

32

Restaurant and Hotel Lobby Art

There are many reasons to visit restaurants in New York besides the obvious one of being hungry. Among them, as any New Yorker can tell you, are the atmosphere, the people you'll be likely to see there, the music, the location, the cost, and whether it's where everyone is going. You might add to that list by noting the following Manhattan restaurants that display art worth seeing on their walls.

Not all art, as we've discovered, is in galleries and museums. In fact, restaurants are a good place to see unusual art you won't see elsewhere: personal collections, odd finds, original works given by the artist to the restaurant, or works on loan. Our wanderings took us in and out of dozens of restaurants and eateries, sometimes just to look, sometimes for a meal, too.

This brings us to the best way to see the art mentioned in this outing. If you visit these spots at off-hours (11 a.m. or 4 p.m., for example), you are most likely to be invited in courteously to look around. You can also, of course, eat or have a drink during regular hours, although it may be more difficult to view the artworks during busy lunches or dinners.

Most restaurants are proud of their art and like to show it, so don't be embarrassed to ask. You can phone ahead to find out a good time for visiting. Almost all the following eateries were hospitable—with or without food. So we leave to you the best method for seeing the finds on these restaurant walls. You might wish to see them over a leisurely dinner, or if you just want to pop in and out, go right ahead. Needless to say, the life of restaurants is often uncertain in our trendy city. As of this writing, all the following were alive and well.

Trattoria Dell'Arte

You might think that dining in a room filled with body parts might sound odd, if not downright macabre, but it is anything but that at **Trattoria Dell'Arte**. Located on Seventh Avenue at 57th Street, directly across the street from Carnegie Hall, this stylish Italian bistro was designed with flair and wit by **Milton Glaser**. His offbeat décor features **Milton Steckel**'s grand anatomical sculptures—classical in style and of heroic proportions—which are prominently displayed on the walls. You might well find yourself seated below a giant plaster ear or torso or nose. Indeed, the emphasis here is definitely on noses, of which there are many in all shapes, sizes, and configurations.

The upstairs dining room sets the scene for a whimsical collection of pictures by well-known illustrators, depicting famous noses throughout the ages. This amusingly incongruous grouping includes, among others, Caesar, Lorenzo de Medici, Verdi, and Jimmy Durante.

In the downstairs dining area you can also enjoy some tasteful prints scattered about in nooks and crannies. The imaginative art, helpful staff, and savory Italian food will all put you in good spirits. ☎ 212-245-9800.

Café des Artistes

Café des Artistes, located in a historic turn-of-the-century building at 1 West 67th Street, has to be one of New York's most romantic and gracious restaurants. Its dark wood walls, lead-paneled windows, and sparkling tables create an ambience of old-world charm and sophistication. But what makes the décor special are the lush, wall-to-wall bucolic murals by the American painter and illustrator **Howard Chandler Christy**, installed when the café opened in 1917. Fetching sylvan nymphs frolic and dance playfully within woodlands and glades. The overall romantic effect of these saucy yet innocent nudes is somewhat reminiscent of eighteenth-century French painting, particularly Francois Bouchet, who often depicted elegant pastoral scenes with lovers dallying in rustic landscapes. Many of these idealized figures resemble the so-called Christy Girl, whom the painter made famous in the pages of *Harper's* and *Scribner's* magazines.

If you plan to visit the restaurant just to see the murals, a good time is either late morning or between 3 and 5. (Because the restaurant is close to Lincoln Center, many pre-theater diners arrive early.) If you eat there, you'll discover that the menu—a very ambitious one—is a combination of French bistro fare and nouvelle cuisine. ☎ 212-877-3500.

San Domenico

San Domenico, at 240 Central Park South, is one of New York's most notable Italian restaurants. And it comes as a wonderful surprise to discover that it also contains an impressive art collection—in fact, all twentieth-century works, with the exception of one painting by the nineteenth-century Italian **Massimiliano Lodi**. On the walls of this sophisticated, refined ristorante—where the simplicity of the décor sets off its artworks—you will find a remarkable number of prints by the Greek-born Italian surrealist painter **Giorgio de Chirico**—perhaps more works by this artist than you will see anywhere else.

The compelling metaphysical landscapes with figures, antique statuary, and plunging lines of perspective are unmistakably de Chirico. Don't miss additional de Chiricos in a downstairs dining area. This collection is truly a find for enthusiasts of this modern master.

You will also notice four intriguing circular Venetian-glass sculptures tastefully displayed so as to add just a bit of shimmer to the décor. These abstract translucent glass and stainless-steel works by the contemporary Venetian artist **Livio Seguso** were created on the famous island of Murano, where glass has been handblown for centuries.

San Domenico features specialties from Bologna, one of Italy's most famous gastronomical regions. On the menu you are likely to find original dishes you may not have sampled before. ☎ 212-265-5959.

Atelier

Atelier, in the Ritz-Carlton Hotel at 50 Central Park South, is filled with painting and sculpture, including a wall of prints by **Fairfield Porter** and **Anton Refregier**, abstract paintings by **Laurie**

Fendrich, and contemporary glass sculpture. Here you can also enjoy a modern French menu. ☎ 212-521-6125.

Carlyle Hotel

Two side-by-side cafés in the well-known **Carlyle Hotel**, at Madison and 76th Street, house murals that many New Yorkers know and love. To the left of the entrance you'll find the **Bemelmans Bar**. **Ludwig Bemelmans** (of *Madeleine* fame) was an accomplished artist and writer of note, as well as the creator of the classic children's story. He was invited to spend some time living in the hotel and giving free rein to his imagination on the walls of the bar. What the hotel got from Bemelmans is a charming panorama of imaginary figures in Central Park (people in cages, animals running free), among the many, whimsical, cartoonlike designs. The overall scene is reminiscent of children's books in the days before Action Jackson or Ninja Turtles. You might call and ask if you can bring your children (off-hours) for a quick look at this world of long-necked, well-dressed giraffes, pastel trees, and odd creatures cavorting in beautiful sunlit greenery. You can have a pleasant grown-up style drink here among Bemelmans's designs, but you might find them disturbing after a few drinks!

Across the hall is a companion bar, the **Café Carlyle**, another distinctively decorated café, where the walls were painted by the French artist **Marcel Vertes**. Delicate and soft, Vertes's style makes you think of 1920s Paris, its young, poetic women smelling roses and dreaming in their pastel surroundings. Jean Cocteau described Vertes's women as "pretty, gracious, charming, adorable, soft, tender, graceful," words that should give you an idea of Vertes's style of painting. ☎ 212-744-1600.

21

It is a curious setting for Wild West art, but **21**, the posh nightspot at 21 West 52nd Street, happens to own one of the city's largest collections of **Frederick Remington** works. Remington, probably the best-known artist of cowboys and the romantic Old West that this country has produced, specialized in dynamic action scenes of Indians, cowhands, rodeos, and war. Remington was actually an Easterner who went west to ride through Indian territory. His

drawings, paintings, and sculptures brought him acclaim back east. It is one of those odd quirks of the art world that the great outdoor artist who adored wide-open spaces should be so memorialized in a quintessential New York restaurant/club. Actually the collection is to be found in the comfortable living room on the ground floor of 21, and you can just walk in and enjoy the more than thirty paintings and drawings, which have titles such as *Turn 'im Loose, Bill* and *Pony Tracks*. ☎ 212-582-7200.

The Four Seasons

The Four Seasons, at 99 East 52nd Street, is a legendary restaurant in the **Seagram Building**. It has several art treasures of note. The interior, designed by architects **Philip Johnson** and **William Pahlmann**, is noted as one of the first landmark modern restaurants in the city. The Four Seasons Bar Room Grill, with its deep-toned brownish color and woody textures is a perfect setting for a **Richard Lippold** sculpture. Made of glittering brass rods dipped in gold, this large work is suspended above the bar, catching flickering light on its hundreds of thin, shining forms—like some sort of celestial body descending from the sky. Visitors must eat here in order to see the art. ☎ 212-754-9494.

La Grenouille

A favorite culinary/art stop of ours is **La Grenouille**, located in an elegant townhouse at 3 East 52nd Street. This famous restaurant has long (since 1962) been known for its stylish French cuisine and its beautifully decorated dining room filled with exquisite and lavish bouquets. It also happens to have—upstairs on the second floor—an enchanting private dining room filled with works of art. For this was once the studio of French painter/illustrator **Bernard Lamotte**, who lived and worked here during the 1940s. When we visited we were given a private tour by Charles Masson, who owns the restaurant with his mother, and who remembers the artist well. (As a boy, Masson studied painting with Lamotte and became a good friend.) Lamotte, a native of Paris, had come to New York to pursue his career. His studio became a cultural salon for artists, actors, musicians, and writers—indeed it was a favorite meeting place for Antoine de Saint Exupery (who wrote his masterpiece,

The Little Prince, in this very room), Salvador Dali, Charles Boyer, and Greta Garbo, among other habitués. Lamotte called his studio "Le Bocal," or "the fishbowl," for its lively ambience. In 1987, twenty-five years after the Massons had created La Grenouille, the studio was finally converted into a special dining room for private parties. Today this handsome room is filled with Lamotte's elegant impressionistic-style paintings that evoke life in Paris, tastefully displayed on whitewashed brick walls. As you walk around the room, you feel you're viewing a private collection in the intimacy of someone's small, private French château. At the back is a tiny room full of sketches, brushes, and other art accouterments left virtually intact.

If your visit to La Grenouille is to be art oriented rather than culinary, we recommend you come between 11 a.m. and noon or between 3 and 5 p.m. ☎ 212-752-1495.

Union Square Café

The **Union Square Café**, at 21 East 16th Street (off Fifth Avenue), is a bustling, bilevel restaurant well known for its excellent food and the large and eclectic collection of contemporary art on its walls. Small works by such artists as **Richard Polsky, Frank Stella**, and **Claes Oldenburg** are among many hung throughout the restaurant; a big, splashy mural by **Judy Rifka** is over the bar. There are painted sculptures (**Gail Starr**), collage (**Robert Kushner**), photographs, silkscreens, and prints. You are welcome to walk around and see the art in this relaxed but crowded and popular place. But be careful not to bump into the waiters dashing about. You may borrow a list of all the art if you ask. ☎ 212-243-4020.

Michael's

Michael's restaurant, at 24 West 55th Street, is—with or without the food—one of the best settings for recent art in the city. The food is terrific, the spaces are well designed for pictures, and the informality of the place makes walking around and looking not only possible but actually encouraged. With a helpful guide (the maître d'), you can see a variety of art mostly from the recent past. Included are a number of **Richard Diebenkorn** lithographs from the Ocean Park series; two bright-colored **David Hockney** prints

from the Acatlan series; a collection of odd sculptures by **Robert Graham**—both nudes (along the wall) and a construction set in front of the windows; a charming **Marcel Duchamp**; seven tiny and fascinating pictures by the composer **John Cage**; two life-size concrete and bronze sheep by **Jean Francois Lalande**; and a nice **Helen Frankenthaler** work. Quite a few **Jasper Johns** pieces are among the prize acquisitions of the owner, Michael McCarthy, who is said to have the other half of his collection in his West Coast restaurant. The food, by the way, is California style and moderately expensive. If you go for a late lunch, you can stay after most of the diners have left and take your time looking at the pictures. If you just want to visit, go between 11 a.m. and noon or between 4 and 5 p.m. ☎ 212-767-0555.

The Mandarin Oriental Hotel

The **Mandarin Oriental Hotel**, at 60 Columbus Circle (60th Street entrance), is one of the city's newest hotels, with a contemporary/Asian aura evoked by numerous design elements and pieces of art. Most striking is glasswork by **Dale Chichuli**, including a dramatic chandelier sculpture in the entrance and an abstract glass sculpture in the center of the thirty-fifth-floor Sky Lobby. If you like glass sculpture, don't miss either of them.

You'll find works of art in three major areas open to the public: the ground-floor lobby, the reception area, and the thirty-fifth-floor Sky Lobby. There are paintings, sculpture, and photography by **Victor Pasamor**, **Dirk DeBruyker**, **Babs Armour**, **Valerio Adami**, **Suk Ja Kang-Engles**, **Nancy Lawrence**, and many other contemporary artists. Note **Richard Mafong**'s silver, gold, and copper Mandarin robes.

The interior of this hotel also features various Oriental motifs and lots of black marble. There are lotus designs, Asian calligraphy, sweeping curves, curlicues, ovals, and antique embroidered Mandarin robes. In addition to the art, you can enjoy some of the best overhead views of Central Park in the city. ☎ 212-805-8800.

Café Loup

This cozy French bistro, at 105 West 13th Street and Sixth Avenue, has a number of small works of art scattered about in virtually

every possible wall space. Here you'll find an impressive series of art photographs by **Berenice Abbott**, **Henri Cartier-Bresson**, **Brassai**, **Irving Penn**, and **Joel Meyerowitz**. There are also lithographs by **Adolph Gottlieb**, **Dorothy Dehner**, and **George Tooker**. A major wall is devoted to a large collage by **Nancy Grossman**. The atmosphere in **Café Loup** is very friendly, and the restaurant is pleased to let you wander about to look at the art in its collection. The staff will show you a list of the works displayed. ☎ 212-255-4746.

Gershwin Hotel

The **Gershwin Hotel**, at 7 East 27th Street, has certainly one of the most eclectic and original new hotel lobbies. Its large Pop Art–filled lobby will surely catch your eye, and you'll enjoy the scene—including celebrities and hipsters—as well. Art is everywhere, from the huge hanging beehive-like structures outdoors to the constructions and paintings and **Andy Warhol** images on four large black-and-white silkscreen flags within.

Additional Arty Restaurants

☞ **Lily's** restaurant and bar, in the **Rogers Middleton Hotel** at 501 Lexington Avenue at 47th Street, is a sprightly newcomer that is more décor than art, but is a charming venue. Note the interesting sculptures by the hotel's owner in the lobby, too. ☎ 212-838-0844.

☞ **Danube**, at 30 Hudson Street (between Duane and Reade streets), is a Tribeca, Viennese-style restaurant that has been described as a "temple to Klimt." ☎ 212-791-3771.

☞ **King Cole**, at the **St. Regis Hotel** at 2 East 55th Street, is a **Maxfield Parrish** fan's delight. You'll enjoy his great mural (28 feet long) illustrating the old nursery rhyme of the restaurant's namesake. ☎ 212-753-4500.

☞ **Sardi's**, at 234 West 44th Street, is a must for fans of theatrical art and memorabilia, with its amusing array of caricatures on the walls. ☎ 212-221-8440.

☞ **Layla**, at 211 West Broadway, will give you the impression you have entered Marrakesh, complete with an exotic décor of tilework in brilliant colors and bold patterns. ☎ 212-431-0700.

☞ **Cholita Bar and Grill**, at 139 Smith Street, Brooklyn, is a Peruvian restaurant with an Inca-inspired décor; there are a trapezoidal archway, Chimu warrior statues, and masks, among other decorations. ☎ 718-254-9933.

☞ **Wallsé**, at 344 West 11th Street, is a quiet Austrian restaurant featuring paintings by **Julian Schnabel** (a regular at the restaurant). ☎ 212-352-2300.

33

Underground Art

Surprising Subway Stations around the City

New York's underground is definitely a surprise. In many stations throughout the boroughs, mosaics, sculpture, murals, ceramic tile, steel, and glass all can be seen in works by leading and emerging contemporary artists. There is nothing like descending into the dark, gloomy passageways of our vast subway system and coming upon an unexpected delight of well-lit art.

The Arts for Transit program was created in 1985 to embellish subway stations and commuter rail stations with works of art. Some 120 commissioned works have been completed, with about 80 more to come. Among the best-known artists represented thus far are **Elizabeth Murray**, **Nancy Spero**, **Vito Acconci**, **Romare Bearden**, **Roy Lichtenstein**, **Faith Ringgold**, **Tom Otterness**, and **Mary Miss**. Many of the works are mosaic, which is basically the medium of the subway system and is especially durable.

How should you negotiate this labyrinth? Our suggestion is to purchase a day pass to the MTA system (available below ground at any station), which will enable you to explore as you like. We have grouped the art we recommend by borough, but we have only touched on the many examples. For a full listing, write for the free MTA booklet (describing its art program): Arts for Transit, 347 Madison Avenue, New York, NY 10017-3739; or call ☎ 212-878-7000.

Uptown (Above 59th Street)

Dyckman Street, 125th Street, 207th Street, 215th Street, 225th Street, and 231st Street (1 train): three works by **Wopo Holup**, including reliefs, ceramic tiles, and murals

Third Avenue and 149th Street (2 or 5 train): **José Ortega**'s *Una Raza, Un Mundo, Universo,* a brilliant horizontal ceramic mosaic abstraction

125th Street and Lenox Avenue (2 or 3 train): **Faith Ringgold**'s *Flying Home, Harlem Heroes, and Heroines,* glass-mosaic murals with figures flying above familiar landmarks

American Museum of Natural History/81st Street, at Central Park West (B or C train): *For Want of a Nail* is a mixed-media (ceramic tile, wall mosaic, granite, etc.) representation of many animals, extinct and otherwise, by a design team from the MTA. There are spirals, circles, time lines, and all sorts of natural history like that exhibited in the museum.

72nd Street and Broadway (1 or 9 train): **Robert Hickman**'s *Laced Canopy,* a barrel-vault skylight featuring Verdi's *Rigoletto* in laminated glass

Lincoln Center/66th Street (1 or 9 train): **Nancy Spero**'s twenty-two brilliantly multicolored glass women in mosaic, called *Artemis, Acrobats, Divas, and Dancers,* in keeping with the theme of performing arts

Lexington Avenue and 59th Street (4, 5, or 6, train; N, R, or W train): **Elizabeth Murray**'s *Blooming* (appropriately named, since Bloomingdale's department store is just above) is a 120-foot-wide mural of Italian mosaics depicting dramatic tree branches and swirling fantasies.

Fifth Avenue and 59th Street (N, R, or W train): *Urbane Oasis* by **Ann Schaumberger** includes seventeen glass-mosaic friezes and a granite-composite floor inspired by the flora and fauna of Central Park, with penguins!

Carnegie Hall Station, at 57th Street and Seventh Avenue (N, R, Q, or W train): **Josh Scharf**'s *Carnegie Hall Montage,* in which the names of great performers (including Marian Anderson, Leonard Bernstein, and the Beatles) are inscribed on small, white porcelain tiles

53rd Street and Fifth Avenue (E or V train): *53rd Street ArtStop* is a group of porcelain-enamel murals on the downtown-platform walls. These works were provided by several museums and cul-

tural institutions in the area, including MOMA, the Museum of American Folk Art, the American Craft Museum, and the New York Public Library.

Times Square Station, mezzanine, between the shuttle to Grand Central Terminal and the north entrance to the IRT: **Roy Lichtenstein**'s *Times Square Mural,* a 6-foot-high, 53-foot-long panel depicting the history of New York transportation, in porcelain enamel on steel

Times Square Station, Seventh Avenue and 41st Street entrance: **Jack Beal**'s *Coming on Spring,* a neo-Mannerist mosaic

Times Square Station: **Jacob Lawrence**'s *New York in Transit,* a richly colored mosaic mural that pictures subway riders and vignettes of city life is located on the stairway wall between the N, Q, W, R, and S mezzanine.

Grand Central Station tracks passages

45th Street cross passages (tracks 102, 107, 114–116): Native American and Australian works

47th Street cross passages (tracks 12–15, 19, 32–37, 40–42): mythic images from Africa and Europe

Northeast passages to 48th and Park Avenue: a series of Asian images from China, Tibet, India, and Nepal

Grand Central Terminal North: glass mosaic, patinated bronze, glass tiles, and glass reliefs by **Ellen Driscoll**, called *As Above, So Below*

34th Street/Herald Square (B, D, F, N, Q, R, V, or W train): many artists, including **David Provan** (kinetic aluminum sculpture), **Nicholas Pearson** (aluminum spheres), and **Michele Oka Doner** (bronze-colored tile art)

Penn Station (Long Island Railroad): **Andrew Leicester**'s 1974 ceramic wall murals in terra cotta, *Ghost,* in five separate locations, and his porcelain-enamel murals above the escalator

Penn Station: **Andrew Leicester**'s *Day and Night,* broken terracotta columns and sculptures suggesting the past of Penn Station can be found in five locations, including above the escalator;

overhead at the Seventh Avenue end of the station is a **Maya Lin** clock, which uses sliding discs to evoke an eclipse.

33rd Street (6 train): **James Garvey**'s *Lariat Seat Loops* are sinuous polished-bronze loops entwined around columns, forming seat rests for weary travelers.

23rd Street (N, R, or W train): delightful mosaics by **Keith Goddard**, depicting historical hats

Downtown

Union Square/14th Street (N, Q, R, or W train; 4, 5, or 6 train; L train): Artist **Mary Miss** and architect **Lee Pomeroy** have tackled three different subway stations at this site, and they have managed to elucidate the various levels and eras with bright-red-enameled frames in 115 separate places; some have faceted mirrors showing the technical aspects of the subway's wiring and fixtures, while others show the concrete arches and architecture from these 1904, 1914, and 1930 stations.

14th Street and Eighth Avenue (A, C, E, or L train): **Tom Otterness**'s *Life Underground* is easily recognized by his typically whimsical bronze animals.

Astor Place (6 train): **Milton Glaser**'s *Untitled* is a porcelain-enamel mural, on station walls.

Broadway and Lafayette (F, V, S, or 6 train): **Mel Chin**'s *Signal* is a stainless-steel and glass sculpture with electric light. Look at the mezzanine column bases and station walls.

Canal Street (A, C, or E train): **Walter Martin** and **Paloma Muñoz** have created sculptured birds on railings and ledges and on a token booth, called *A Gathering.*

City Hall/Brooklyn Bridge (4, 5, or 6 train): *Cable Crossing* by **Mark Gibian** consists of a spidery web of cables stretching across the ceiling of the station, reminiscent of the beautiful Brooklyn Bridge.

Fulton Street/Broadway/Nassau (A or C train; 4 or 5 train): A rare historic decoration in the subways, these glazed terra-cotta murals

were made for a hotel lobby in the early twentieth century, then reinstalled in 2000. They depict marine subjects in large, golden semicircles.

Brooklyn

Prospect Park (B, Q, or S train): **Susan Tunick**'s *Brighton Clay Re-Leaf No. 1,* using leaves in a ceramic-mosaic mural

Flatbush Avenue/Brooklyn College (2 or 5 train): **Muriel Castanis**'s *Flatbush Floogies* are elegant, patinated-bronze relief murals showing female forms suspended from above, much like angels.

Botanic Garden Station, at Franklin Avenue and Eastern Parkway (2, 3, 4, or 5 train; S train): **Millie Burns**'s *IL7/Square* reflects the Botanic Garden's theme of nature and landscape.

36th Street/Sunset Park (D, M, N, or R train): *An Underground Movement; Designers, Builders, Riders;* and *A Celebration of the Working People* are three brightly colored mosaic murals (including dancing Rockettes) by **Owen Smith**.

Myrtle Avenue (J, M, or Z train): At this elevated station in the heart of Brooklyn, **Verna Hart**'s *Jammin' under the El* suggests the neighborhood's lively cultural mix.

Beverly Road and Cortelyou Road stations (Q train): **Patsy Norvell**'s *Garden Stops* is an outdoor installation (stations are elevated) with garden trellises, columns featuring abstract flowers, and decorative squares from the original stations' fencing.

Broadway Junction/Eastern Parkway (J, L, or Z train) and Broadway Junction/East New York (A or C train): **Al Loving**'s brilliant glass murals of geometric designs and curlicues decorate the entire complex, including the upper mezzanine.

Church Avenue (2 or 5 train): **Louis Delsarte**'s *Transitions* are colorfully vibrant wall murals of people strolling in the Caribbean Day Parade.

Brighton Beach (B or Q train): Six sleek sculptures on this elevated platform are by **Dan George**; these abstract works present the Homeric myth of Dionysus and the Pirates.

Brooklyn Museum/Eastern Parkway (2 or 3 train): As of this writing, renovation of this station is taking place; it will include about seventy-eight architectural fragments from demolished buildings around the city, including 3–dimensional gargoyles and cherubs and other designs of terra cotta and stone.

Bronx

Intervale Avenue, mezzanine (2 or 5 train): **Michael Kelly Williams** is represented with two whimsically abstract glass-mosaic murals in shades of blue.

Tremont Avenue (B or D train): **Frank Leslie Hampton**'s *Uptown New York, 2000* is a glass, stone, and marble mosaic mural depicting a typically urban scene of a tenement with a clothesline.

Westchester Square/East Tremont Avenue (6 train): Noted artist **Romare Bearden**'s *Untitled* of 1982 is a faceted-glass triptych to be found over the stairway.

161st Street/Yankee Stadium (4 train; B or D train): **Vito Acconci** has made *Wall-Slide,* a stone, tile, and fiberglass installation, which can be seen throughout the station.

Queens

Cypress Hills/111th Street (J or Z train): **Kathleen McCarthy**'s *Five Points of Observation* are wire-mesh sculptures, including a striking human face.

Woodside/61st Street (7 train): **John Cavanaugh**'s *Commuting/Community* are porcelain-enamel murals; and **Dimitri Gerakaris**'s *Woodside Continuum* are handcrafted steel and stainless-steel railings.

23rd Street and Ely Avenue (7 train): **Elizabeth Murray**'s *Stream,* in the passageway, is a colorful mural.

33rd Street, 40th Street, and 46th Street (7 train): **Yumi Heo**'s urban scenes

Choosing an Outing

Flower Gardens, Indoor and Out

Parks: From Vest-Pocket to Grand

Historic Houses and Old New York

If You Prefer a Guided Tour

Crafty Outings

Waterfronts, Waterfalls, and Waterviews

Of Special Interest to Children

Outdoor Sculpture, Sculpture Gardens, and Cemeteries

Discovering Ethnic Art

Mostly Contemporary Art

"Unofficial" Public Art Indoors

Thematic Walks

Hops, Skips, and Jumps

Index of Artists and Places to See Their Works

About the Authors

Marina Harrison and Lucy D. Rosenfeld are lifelong friends and the authors of seven guidebooks together, including *Gardenwalks, A Walker's Guidebook, Art on Site,* and *Guide to Green New Jersey.* They have enjoyed discovering new sites in our ever-changing city and hope this book conveys their enthusiasm for public art and gardens!